Watercolor

Watercolor

BY WENDON BLAKE PAINTINGS BY CLAUDE CRONEY

Cincinnati, Ohio

The Complete Watercolor Book. Published by North Light Books, an imprint of F&W Publications, 1507 Dana Avenue, Cincinnati, Ohio 45207.

Copyright © 1989 by Don Holden, all rights reserved. First published in 1978 as *The Watercolor Painting Book* by Watson-Guptill Publishers.

No part of this publication may be reproduced or used in any form or by any means-graphic, electronic, or mechanical, including photocopying, recording, taping, or information storage and retrieval systems-without written permission of the publisher. First published in 1978 as *The Watercolor Painting Book* by Watson-Guptill Publishers.

Manufactured in Hong Kong.

94 93 92 6 5 4

Library of Congress Cataloging-in-Publication Data

Blake, Wendon. [Watercolor painting book] The complete watercolor book/by Wendon Blake. p. cm. Originally published as: The watercolor painting book. Bibliography: p. Includes index. ISBN 0-89134-315-6 : 1. Watercolor painting — Technique. I. Croney, Claude. II. Blake, Wendon. Watercolor painting book. III. Title. ND2420.B56 1989 89-32534 751.42'2 - dc20 CIP

Photographs on pages 4-5 and paintings on pages 12-17, 20-21, 66, and 75 are by the author. All other paintings are by Claude Croney.

Editor: Mary Cropper

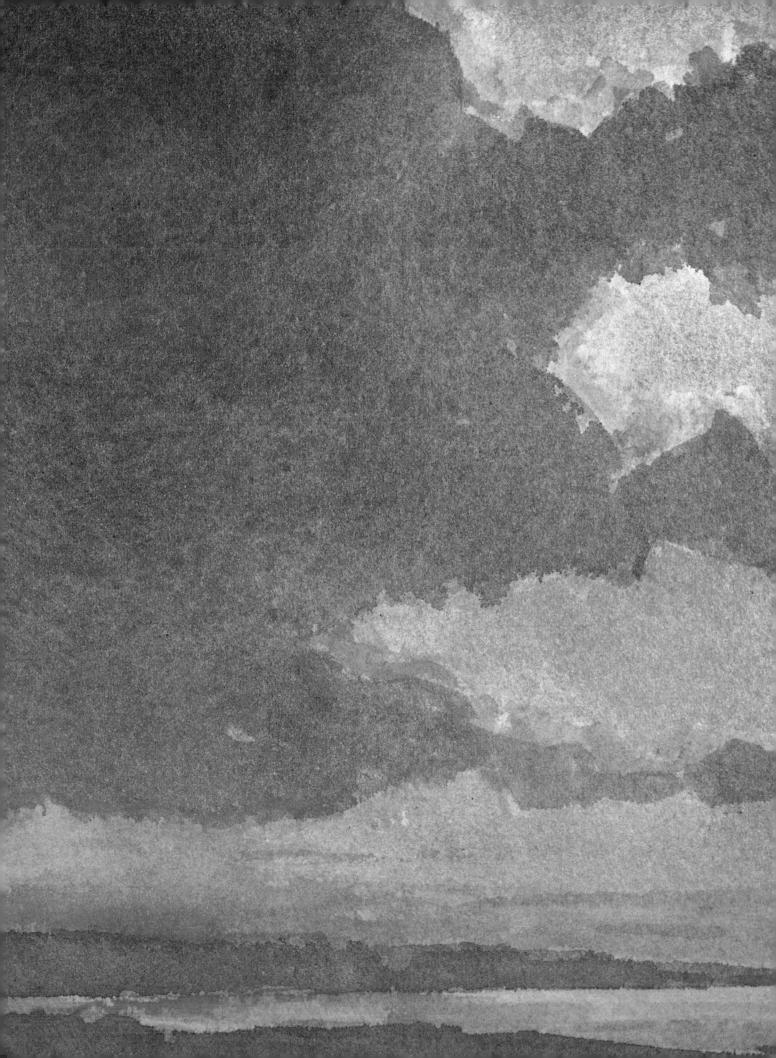

CONTENTS

The Basics

Choosing and Using Color 2 Basic Painting Equipment 4 Selecting Paper 7 Getting Organized 10 Cleanup Suggestions 11 Flat Washes 12 Graded Washes 14 Painting Wet-In-Wet 16 Drybrush for Texture 18 How to Correct Paintings 20 Preserving Watercolors 22

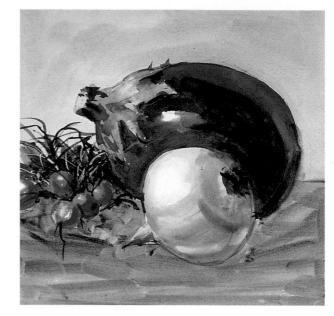

Beyond the Basics

Learning to Model Form 24 Try a Still Life of Fruit 28 Capture the Colors of Flowers 33 Painting Flowers Outdoors 37 Try an Outdoor "Still Life" 42 Show the Soft Colors of Spring 46 Painting the Rich Colors of Summer 49 Make Autumn Colors Vivid 52 Interpreting Winter's Subtle Colors 56 Some Technical Tricks 60 Analyzing Lighting 62 Understanding Aerial Perspective 63 Improving Your Composition 64 How the Three-Value System Works 66

Landscape Subjects

Selecting Landscape Subjects 68 Mixing Colors for Landscapes 69 Constructing the Shapes of Trees 72 Capture the Forms of Evergreens 76 Suggesting the Detail of a Meadow 81 Paint Majestic Mountains 85 Modeling Hills with Drybrush 89 Make a Lake Sparkle with Light 93 Convey the Movement of a Stream 98 Shaping Snow and Ice 102 Add Clouds for Interesting Skies 106 Cool Colors Make Sunsets Glow 110

Seascape Subjects

Selecting Seascape Subjects 116 Mixing Colors for Seascapes 117 Painting the Transparency of Waves 120 Expressing the Power of Surf 123 Tidepools: A Study in Contrast 126 Simplifying the Detail of a Marsh 130 Capture the Magic of Moonlight 135 Use Subtle Colors for Rocky Shores 139 Shape Dunes with Light Patterns 143 Interpreting the Mood of the Coast 147

Bibliography 151

Index 152

INTRODUCTION

Why Paint in Watercolor? Artists who paint in watercolor are fanatical about their medium. Watercolor seems to inspire a kind of passion once you master it—that unites watercolorists into a kind of unofficial worldwide "society," like people who are in love with wine or sailing or horseback riding. Ask the watercolorist to define the magic of his medium and he'll probably talk about three unique qualities: transparency, speed, and spontaneity.

Transparency. As it comes from the tube, watercolor is a blend of finely powdered color, called pigment; a water-soluble adhesive called gum arabic, which will glue the pigments to the watercolor paper; and just enough water to make these ingredients form a thick paste. You squeeze a dab of this paste from the tube onto the palette, load a brush with water, touch the tip of your brush to the dab of color, and swirl the brush around on the mixing area of your palette to form a pool of liquid color. That pool is essentially tinted water, as clear and transparent as the water you drink, merely darkened by a touch of color. The color on your palette is like a sheet of colored glass. You can see right through it to the white surface of the palette. And when you brush the liquid color onto the paper, the light in your studio shines through the wash, strikes the white surface of the paper, and bounces back through that layer of color like sunlight passing through stained glass. A watercolor painting is literally filled with light. That's why watercolorists love to paint the effects of light and atmosphere in outdoor subjects such as landscapes and seascapes.

Speed. As soon as the water evaporates, a stroke or wash of watercolor is dry. But that stroke or wash actu-

ally begins to dry as soon as the liquid color hits the paper. For a minute or two-as long as the wet color remains shiny-you can push the paint around or blend in more liquid color. But as soon as the surface of the paper begins to lose its shine, the liquid color is beginning to "set up." At that stage, you'd better stop and let it dry. From that point on, you run the danger of producing unpleasant streaks or blotches if you keep working on the damp color. If you try to introduce a brushload of fresh color into that damp surface, you're most likely to produce a distinctive kind of blotch, which every watercolorist knows and dreads-called a fan because of its peculiar, ragged edge. In short, watercolor forces you to be quick. You have to plan your picture carefully: Decide exactly what you want to do, work with decisive strokes, then stop. Everv painting is exciting-a race against time, a challenge to your decisiveness and your control of the medium. Watercolor is for people who like speed and action.

Spontaneity. Because of this rapid drying time, you're forced to wield the brush quickly and freely. Like a general planning an attack, you must do all your thinking before you sound the charge. Once the action begins, there's no turning back. As soon as the brush touches the paper, the challenge is to get the job done with a few bold, rapid strokes. This is why a good watercolor has such a wonderfully fresh, lively, spontaneous feeling. A century after the picture was painted, the viewer can still share the artist's pleasure in the sweeping action of the brush.

Permanence. Yes, a watercolor *will* last a century or more, even though it's nothing more than tinted water on a fragile sheet of paper. If you work

with non-fading color—such as the colors recommended in this book and keep your painting away from moisture, that delicate veil of color on the paper will last just as long as a tough, leathery coat of oil paint on a canvas.

Painting in Watercolor. At first glance, watercolor looks like the simplest possible painting medium. You can paint a picture with one or two brushes, a dozen tubes of color, a jar of water, and a piece of paper no larger than the page you're now reading. Futhermore, a watercolor can take very little time to paint. It's rare for a watercolorist to spend more than a few hours on a picture – and many of the world's greatest watercolors have been painted in as little as an hour. But don't be deceived. Watercolor may look easy, but the professionals agree that it's the most challenging of all painting media.

Mastering Watercolor. There are two basic challenges in watercolor painting. First, because the liquid color flows across the paper as freely as a wave washing over a beach, it takes a lot of practice to learn how to control the fluid paint so it goes where you want it to go and stays there. Second, because watercolor dries so rapidly—as soon as the water evaporates—vou must learn to plan every step before you touch brush to paper, so you can work quickly and decisively. Learning to paint in watercolor is like learning to play a musical instrument. The whole secret is frequent practice. You must be prepared to paint (and perhaps spoil) scores of watercolors before you'll feel that the medium begins to obey your command.

> –Wendon Blake New York, 1989

THE BASICS

CHOOSING AND USING COLOR

Tubes and Pans. Watercolors are normally sold in collapsible metal tubes about as long as your thumb and in metal or plastic pans about the size of the first joint of your thumb. The tube color is a moist paste that you squeeze out onto the surface of your palette. The color in the pan is dry to the touch but dissolves as soon as you touch it with a wet brush. The pans, which lock neatly into a small metal box made to fit them, are convenient for rapid painting on location. But the pans are useful mainly for small pictures - no more than twice the size of this page-because the dry paint in the pans is best for mixing small quantities of color. The tubes are more versatile and more popular. The moist color in the tubes will quickly yield small washes for small pictures and big washes for big pictures. If you must choose between tubes and pans, buy the tubes. Later, if you want a special kit for painting small pictures outdoors, buy the pans.

Color Selection. All the pictures in this book were painted with just eleven tube colors. True, the colors of nature are infinite, but most professional watercolorists find they can cope with the colors of nature using a dozen tube colors-or even fewer. Once you learn to mix the various colors on your palette, you'll be astonished at the range of colors you can produce. Six of these eleven colors are *primaries*-two blues, two reds. two yellows - which means colors that you can't create by mixing other colors. Just two are secondaries - orange and green-which means colors that you can create by mixing two primaries. You can mix a rich variety of greens by combining various blues and yellows, plus many different oranges by combining reds and yellows. So you could really do without the secondaries. But it does save time to have them. The last three colors on your palette are *neutrals*: two shades of brown and a gray.

Blues. Ultramarine is a dark, soft blue that produces a rich variety of greens when blended with the yellows, and a wide range of grays, browns, and brown-grays when mixed with the neutrals. Cerulean blue is a light, bright blue that's popular for skies and atmospheric effects. At some point, you might like to try substituting phthalocyanine blue for cerulean; phthalocyanine is more brilliant, but must be used in small quantities because it tends to dominate any mixture.

Reds. Alizarin crimson is a bright red with a hint of purple; it produces lovely oranges when mixed with the yellows, subtle violets when mixed with the blues, and rich darks when mixed with green. Cadmium red light is a dazzling red with a hint of orange, producing rich oranges when mixed with the yellows, coppery tones when mixed with the browns, and surprising darks (not violets) when mixed with the blues.

Yellows. Cadmium yellow light is bright and sunny, producing luminous oranges when mixed with the reds and rich greens when mixed with the blues. Yellow ochre is a much more subdued, tannish yellow that produces subtle greens when mixed with the blues and muted oranges when mixed with the reds. You'll find that both cadmiums tend to dominate mixtures, so add them just a bit at a time.

Orange. Cadmium orange is a color that you could create by mixing cadmium yellow light and cadmium red light. But it's a beautiful orange and convenient to have ready-made.

Green. Hooker's green is optional you can mix lots of greens—but convenient, like cadmium orange. Just don't become dependent on this one green. Learn how many other greens you can mix by combining your various blues and yellows. And see how many other greens you can make by modifying Hooker's green with the other colors on your palette.

Browns. Burnt umber is a dark, subdued brown that produces lovely brown-grays and blue-grays when blended with the blues, subtle foliage colors when mixed with green, and warm autumn colors when mixed with the reds, yellows, and oranges. Burnt sienna is a bright orange-brown that produces a very different range of blue-grays and brown-grays when mixed with the blues, plus rich, coppery tones when blended with the reds and yellows.

Gray. Payne's gray has a distinctly bluish tone, which makes it popular for painting skies, clouds, and atmospheric effects.

No Black, No White. You may be surprised to discover that this color list contains no black or white. Once you begin to experiment with color mixing, you'll find that you don't really need black. You can mix much more interesting darks-containing a fascinating hint of color-by blending colors such as blue and brown, red and green, orange and blue. And bluebrown mixtures make far more interesting grays than you can create with black. Your sheet of watercolor paper provides the only white you need. You lighten a color mixture with water, not with white paint; the white paper shines through the transparent color, "mixing" with the color to produce the exact shade you want. If some area is meant to be *pure* white, you simply leave the paper bare.

Planning Your Colors. Watercolor, unlike oil paint, doesn't allow you to mix a batch of color, brush it over the painting surface, wipe it off, and try again. Once that mixture is on the watercolor paper, it's there to stay. As you'll see later, there *are* ways of correcting an unsuccessful color mixture, but these are strictly emergency measures. That first wash of color should be the right one. The only way to make sure it's the right one is to know what each color on your palette can do, so you can plan every color mixture in advance.

Testing Your Colors. The best way to find out what your colors will do is to plan a simple series of tests. If you use the color selection recommended in this book, you'll have eleven colors on your palette. Make a "test sheet" for each of these colors. Take three full-size sheets of watercolor paper and cut them into quarters, which will give you a dozen small sheets, one for each color on your palette-plus an extra sheet that you can put aside for a small painting later on. At the top of each sheet, write the name of one of the colors on your palette. Then, using one of your big brushes – either the large round or the large flat-paint a series of color patches about 1" (25 mm) square in several rows across the sheet.

Mixtures. Start with the color whose name is written at the top of the sheet. Mix it with a little water for the first patch, with more water for the second, and with a lot of water for the third. Then mix that color with each color on your palette. Label each mixture so you can go back to the test sheet later on and see how you got all those fascinating colors. It's particularly interesting to try each mixture two or three times, varying the proportions of the colors. In other words, if you're mixing ultramarine blue and cadmium yellow light, first try a mixture in which the blue and yellow are added in equal quantities; then try more blue and less yellow; finally, try more yellow and less blue. Painting these test sheets is the quickest way to learn about your colors. The whole job won't take you more than a few hours and will save you countless days of frustration when you're actually painting.

Color Charts. It's worthwhile to do these test sheets methodically. Label each mixture with some code that you'll be able to decipher months later. For example, if the mixture is ultramarine blue and cadmium yellow light, you might just use the initials UB-CYL. Now these are more than just test sheets; they're color charts that you can use for years, tacking them on your studio wall and referring to them when you're planning the color mixtures in a painting. Eventually, all these color mixtures will be stored in your memory, and you can put the charts away in a drawer. But while you're learning, the charts are a great convenience. (They also look very professional and will impress your friends!)

Color Mixing. When the time comes to mix colors for a painting, here are a few tips to bear in mind. Dip your brush into the water first, then pick up a bit of moist color from the palette with the tip of the brush and stir the brush around on the palette until you get an even blend of color and water. Then pick up a bit of your second color on the tip of your brush and stir this into the mixture. If you need a third color, stir this into the mixture after you've blended the first two colors. The point is to add the colors to the mixture one at a time so you can judge how much you're adding and see the mixture change gradually. Try to stick with mixtures of just two or three colors; mixtures of four or more tend to turn muddy.

Mixing on the Paper. Because watercolor is fluid and transparent, you'll discover interesting ways of mixing color right on the paper. One method is the wet-in-wet technique. You can wet the surface of the paper with clear water and quickly brush two or three colors onto the shiny surface; allow them to flow and merge by themselves, with just a little help from the brush. This produces lovely, irregular color mixtures, with one hue blurring into another like the interlocking blues and grays of a cloudy sky. Another way to mix directly on the paper is to put down one color, allow it to dry, then paint a second veil of color over the first. The underlying color will shine through the second wash, and the two will "mix" in the eye of the viewer. A wash of blue over a dry patch of yellow will produce green, but this will be quite a different green from a mixture of the same two colors on your palette. One transparent color over another produces an optical & mixture.

Testing Optical Mixtures. Just as you've made test sheets to see what happens when you mix one color with another, it's worthwhile to make some more test sheets to see what kinds of optical mixtures you can create. The quickest way to do this is to take one of your flat brushes and make a long, straight stroke of one color. Let it dry. Then cross this long stroke with a short stroke of each color on your palette. Make each short stroke just long enough so that you can see how it looks on the bare white paper and then how it changes as it crosses the underlying stripe of color. Make one of these "stripe charts" for each color on your palette, and you'll discover a great variety of optical mixtures that you'd never find any other way.

BASIC PAINTING EQUIPMENT

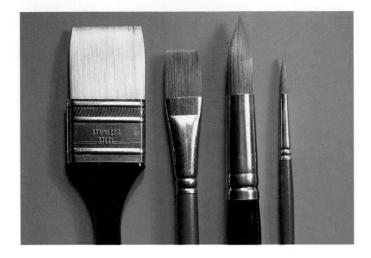

Brushes. Starting from the left, the first brush is a big flat nylon brush that's ideal for painting skies and other large areas. Next is a flat brush that's a blend of natural and synthetic hairs. The bigger round brush is made of synthetic hairs designed to do the same job as the more expensive sable. And the small round brush at the right is also a blend of natural and synthetic hairs.

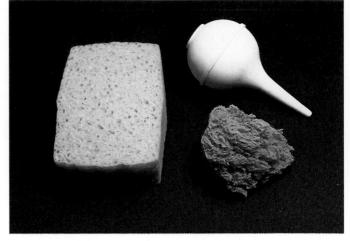

Sponges and Syringe. A large synthetic sponge is invaluable for wetting your paper, sponging off areas you want to repaint, and cleaning up spills. The smaller natural sponge (which is more expensive) will do the same jobs and has a silky texture that treats the paper more gently. The rubber syringe—available wherever you buy pharmaceutical supplies—is wonderful for picking up fresh water and squirting it onto your palette for color mixtures *or* just for moistening your colors.

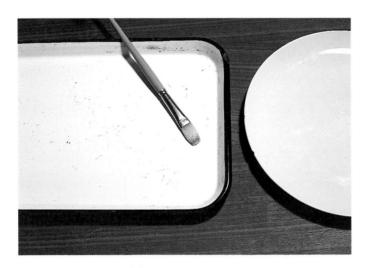

Improvised Palettes. Your kitchen probably contains a palette that will do almost as well as the one you can buy in the art supply store. At the left is a white enamel kitchen tray and at the right is a white porcelain dinner plate. (Both are slightly battered, but they'll soon take more punishment in the studio.)

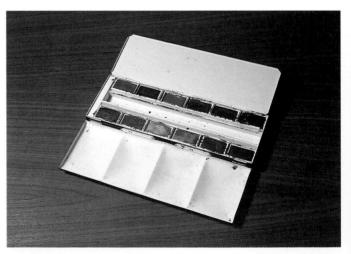

Portable Box for Pans. The traditional portable paintbox is made of tin and coated with white enamel on the inside. The lids open to give you some "wells" and a flat surface for mixing color. This particular box holds little rectangular pans of dry color, and its small size makes the box ideal for painting small pictures outdoors. You can buy a similar box that holds tubes for bigger paintings, but a large water-color palette is more useful.

Watercolor Palette. The most versatile palette is made of white molded plastic (like this one) or lightweight metal coated with tough white enamel paint. Along the edges of this palette are compartments into which you squeeze your tube colors. The center of the palette is a large, flat mixing area. At the end of the painting session, you can simply mop up the mixing area with a sponge or a paper towel, leaving the color in the compartments for the next painting session.

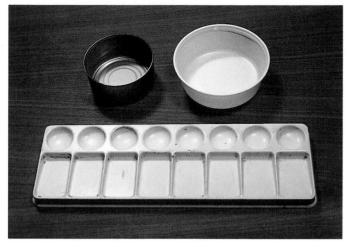

Studio Palette and Containers. Designed primarily for use indoors, the palette in the foreground has circular "wells" into which you squeeze your tube colors, plus rectangular compartments for individual mixtures. The compartments slant down at one end so that the mixtures will run downward and form pools into which you can dip your brush. It's also a good idea to save containers such as the tuna tin and the margarine container, which are perfect for mixing really large washes.

Hardboard and Tape. A simple way to support your watercolor paper when you're painting is to tape the sheet to a piece of hardboard, or plywood, which will resist warping when it gets wet. The board will be too hard to take tacks, so use drafting tape that's at least 1" (25 mm) wide or even wider if you can find it. If available, buy hardboard or plywood that's made for outdoor use; it's more resistant to moisture.

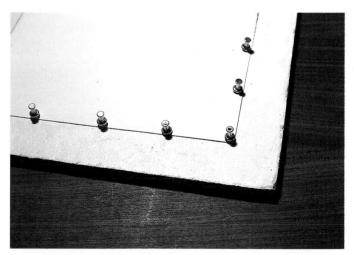

Fiberboard and Tacks. Another support for your watercolor paper can be a sheet of lightweight fiberboard that's soft enough to take thumbtacks (drawing pins) or pushpins such as the ones you see here. This particular board is $\frac{3}{4}''$ (about 18 mm) thick, and it's been painted with two coats of white enamel housepaint to make the surface more resistant to moisture. Be sure to cut your board just a bit larger than the size of your watercolor paper. Round Brushes. The basic tool for watercolor painting is a round softhair brush. A cluster of carefully selected animal hairs is cemented into a metal cylinder (called a ferrule), which, in turn, is clamped onto the end of a cylindrical wooden brush handle. The cluster of hairs is shaped something like a bullet: thick and round at the ferrule, then gradually tapering to a sharp point. It's important to have the biggest round brush you can afford. In most art supply catalogs, this is usually a number 12 sable, which is about 5/16" (roughly 8 mm) in diameter at the point where the hairs enter the ferrule. Some dealers stock a number 14 sable, which is even bigger: roughly 3/s" (about 10 mm) in diameter at the end of the ferrule. For detailed work, you should have another round sable that's about half the diameter of the big one-usually a number 7 in art supply catalogs.

Saving Money. You'll probably be shocked by the price of a top quality sable brush. The animal hairs are rare and costly, the brushes are made by hand, and the price seems to go up every year! For these reasons, the most expensive sables are generally bought by professionals. However, there are other softhair brushes that will do the job. First of all, there are less expensive grades of sable, which your art supply store may carry. Second, there are blends of natural and synthetic hairs, which lots of artists like just as well. And several manufacturers have now come up with a kind of synthetic sable that behaves very much like natural sable but costs a lot less than the real thing.

Flat Brushes. For large areas of color, such as skies and expanses of water, a large flat brush is extremely useful. This is a flat, squarish body of soft hairs set into a broad metal ferrule at the end of a thick wooden handle. The most useful flat brush is at least 1" (25 mm) wide where the hairs enter the ferrule; and if you're going to paint really big pictures, try to find a flat brush that's even bigger-11/2" or 2" (38-50 mm). For bold brushwork on a smaller scale, get a $\frac{1}{2}$ " (12 or 13 mm) flat brush. Once again, don't be discouraged by the price of top quality sable. Cheaper sable or synthetic will do just as well.

Other Brushes. Many watercolorists carry one or two oil painting brushes-the kind made of white hog bristles-in their kits. Because these bristles are stiffer than the sables and synthetics, the oil brushes make a bolder, rougher stroke. But bristle brushes are most commonly used for scrubbing out a passage that needs to be lightened or corrected. You might like to try working with a 1" (25 mm) bristle brush, later adding another one that's half that size. For delicate line work, many watercolorists like a very slender sable called a rigger, originally developed for sign painters. And for wetting large areas with clear water, it's sometimes helpful to have a 2" (50 mm) nylon housepainter's brush.

Testing Softhair Brushes. When you buy a softhair brush, it's important to test the brush before you walk out of the store. A good art supply store generally has a jar of water near the brush rack for just this purpose. Test out several brushes before making a final choice. Dip the brush into the water and swirl the brush around carefully with a gentle, circular motion. Make sure you don't squash the hairs against the bottom of the jar. Then remove the wet brush from the jar, hold the handle at the far end, and make a quick whipping motion with a snap of your wrist. A good round brush should automatically assume a smooth bullet shape, sharply pointed at the tip. A good flat brush should form a neat, squarish shape, tapering in slightly toward the forward edge. If the round brush assumes an irregular tip rather than coming to a neat point, try another. If the hairs of the flat brush don't come neatly together after this test but retain a ragged shape, don't buy it. Keep testing brushes until you find one that behaves properly.

How Many Brushes? Although a professional watercolorist often has a drawer full of brushes, accumulated over the years, you really need very few. You can paint watercolors for the rest of your life with just four brushes: two round ones and two flat ones. Others may be fun to have, but they're certainly optional. When you buy your two biggest brushes—the large round and the large flat-these can be inexpensive synthetics or blends. Then, when you buy your two smaller brushes-one round and one flat-you might invest in top quality sables, which are less expensive in this size. If you prefer, the small round brush can be sable and the small flat one might be a blend of natural and synthetic hairs.

Watercolor Paper. You can paint a watercolor on any thick white drawing paper, but most watercolorists work on paper made specifically for watercolor painting. The best watercolor papers have a texture-the professionals call it a *tooth*—that responds to the stroke of the brush as no ordinary paper can. Good watercolor paper also has just the right degree of absorbency to hold the liquid color, which is more apt to wander off in some unpredictable direction when you work on ordinary drawing paper. So stick to watercolor paper and buy the best you can afford.

Textures. Watercolor papers are manufactured in three surfaces: rough, cold-pressed, and hot-pressed. The rough surface has a very pronounced tooth, best for large pictures and bold brushwork. The cold-pressed variety – which the British call a "not" surface-still has a distinct tooth, but a far more subtle texture, which most watercolorists prefer. The coldpressed surface is a lot easier to work on, particularly for beginners. Hotpressed paper is almost as smooth as the paper on which this book is printed. The surface has very little tooth, and the liquid color tends to run away from you. Hot-pressed paper is mainly for experienced painters who've learned how to control it.

Paper Weights. When it gets wet, watercolor paper swells and tends to buckle – or cockle, as the British say. That is, the paper tends to develop bulges or waves. The thicker the paper, the less pronounced (and the less irritating) these waves or bulges will be. The *thinnest* paper that's convenient to paint on is designated as 140-pound, which is the weight of a very heavy drawing paper. The *thickest* paper you're likely to use is 300-pound, which is as stiff as cardboard. No, a

single sheet of paper won't weigh 140 pounds or 300 pounds. That's the weight of a *ream* of paper, or 500 sheets. In other words, a 140-pound sheet comes from a stack of 500 sheets weighing 140 pounds.

Buying Paper. It's most economical to buy watercolor paper in individual sheets, which are most often 22" x 30'' (55 cm x 75 cm). When a watercolorist talks about a "full sheet," this is usually the size he means. You can then cut this sheet into halves or quarters, which are all convenient sizes for painting. For small pictures you can even cut the sheet into eighths. You can also buy a small stack of watercolor paper in a pad. bound on one edge like a book. And you can buy a stack of paper in a block, which is bound along all four edges to keep the paper from curling up as you paint, but you pay a lot extra for the binding. You save a lot of money by buying sheets, cutting them up, and then tacking or taping them to your own drawing board.

Handmade Versus Machine-

made. At one time, watercolor papers were normally made by hand. Such paper was called "100% rag" because it was made entirely of shredded rags. Today, all but a few of the great handmade paper mills have disappeared. Some art supply dealers stock rare, expensive handmade papers, which are still the best-if you can afford them. But most watercolorists now paint on machine-made papers that are chemically pure cellulose fiber, actually as permanent as the allrag stock. The best machine-made papers are called *moldmade*, a slow, careful process that produces a painting surface that comes reasonably close to the handmade stock. Moldmade paper is still expensive, though not as costly as the handmade variety.

Testing Watercolor Paper. Assuming that you're not ready to invest in handmade paper—most people don't-it's best to work on moldmade paper, which is still far better than the *ordinary* machine-made papers. If you look carefully at the surface, you'll see that the less expensive machine-made papers have a mechanical, repetitive texture that has much less "personality" than the more random texture of the moldmade. But a good art supply store may have several brands of moldmade paper, differing in absorbency, texture, and toughness. Buy one or two sheets of each (perhaps one cold-pressed and one rough), cut them into quarters or eighths, label them so you know which is which, and paint pictures on them all. After a few months of experimentation, you'll know which sheet vou like best.

What to Look For. See how absorbent the paper is. One sheet soaks up the liquid color, while another seems to resist it-the color stays on the surface and needs more stroking to force it into the hills and valleys of the sheet. At first glance, the more absorbent paper may look better, but some artists do like the less absorbent kind. (You can also make it a bit more absorbent by sponging the surface with clear water.) Speaking of toughness, you'll also find that some papers will take more punishment than others. The more absorbent papers are usually softer, which means you can't scrub out and repaint easily. The tougher surfaces will take more vigorous brushwork and are easier to scrub out and correct. Watch the texture, too. If you like to work on a large scale with big, ragged strokes, you may like the rough surface better than the cold-pressed, which lends itself to smoother washes and more controlled brushwork.

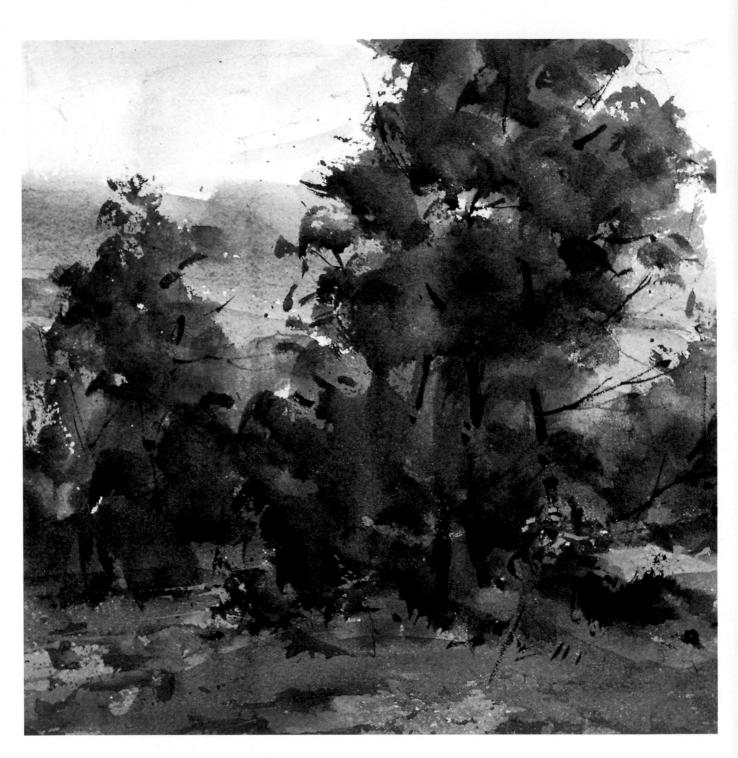

Cold-Pressed Paper. The most popular surface is cold-pressed called "not" in Britain—which has a distinct texture but isn't nearly as irregular as the rough sheet shown on the facing page. In this close-up of a tree from another painting, you can see that the liquid color goes on smoothly, and the brushstrokes don't look ragged. Cold-pressed stock is the "all-purpose" paper that most watercolorists prefer because it's most versatile. It takes everything from big, smooth masses of color to tiny details. And you can still work with big, free strokes, if that's your style.

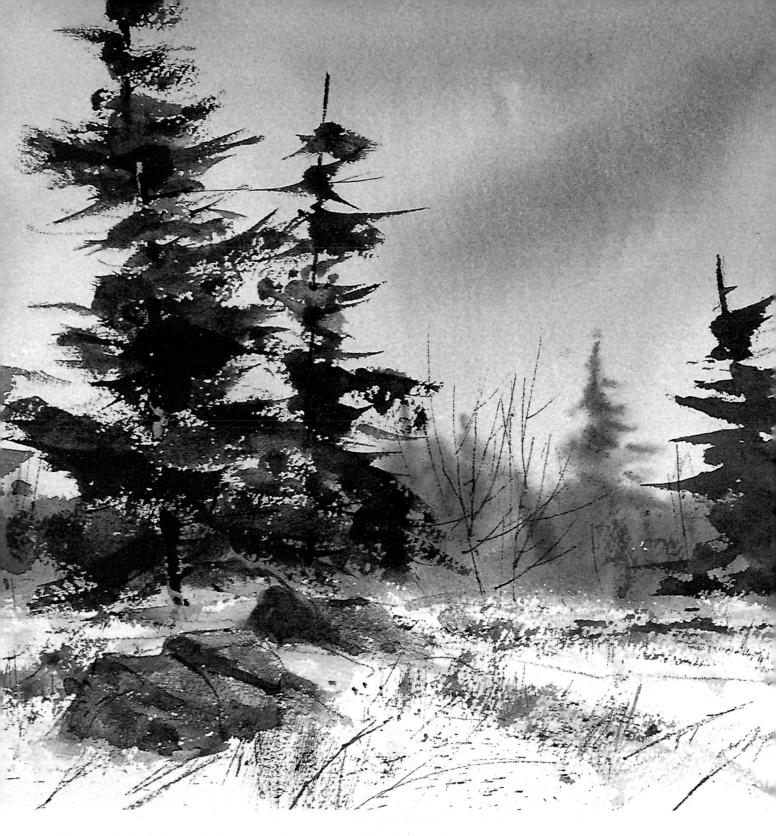

Rough Paper. The surface of your watercolor paper will obviously have a strong influence on the character of your brushwork. On rough paper, the brushstrokes have a ragged, irregular quality that's just right for suggesting the rough texture of trees and the

flickering effect of foliage against a light sky. In this life-size close-up of a section of a landscape, you can see how the texture of the paper literally breaks up the brushstrokes. If you like to work with bold, free strokes, you'll enjoy working on rough paper. **Studio Setup.** Whether you work in a special room you've set aside as a studio or just in a corner of a bedroom or a kitchen, it's important to be methodical about setting up your painting equipment. Let's review the basic equipment you'll need.

Brushes. It's best to buy just a few brushes—and buy the best you can afford. You can perform every significant painting operation with just four softhair brushes, whether they're expensive sable, nylon, or some blend of natural and synthetic hairs. All you really need are a big number 12 or 14 round, smaller number 7 round, a big 1" to 2" (25-50 mm) flat, and a second flat about $\frac{1}{2}$ " (12-13 mm) wide.

Paper. The best all-purpose watercolor paper is moldmade 140-pound stock in the cold-pressed surface (called a "not" surface in Britain), which you ought to buy in the largest available sheets and cut into halves or quarters. The most common sheet size is $22" \times 30"$ (55 cm x 75 cm). Later, you may want to try the same paper in a rough surface.

Drawing Board. The simplest way to support your paper while you work is to tack or tape the sheet to a piece of hardboard or fiberboard, cut just a little bigger than a full sheet or half sheet of watercolor paper. You can rest this board on a tabletop, perhaps propped up by a book at the back edge, so the board slants toward you. You can also rest the board in your lap or even on the ground. Art supply stores carry more expensive wooden drawing boards to which you tape your paper. At some point, you may want to invest in a professional drawing table, with a top that tilts to whatever angle you find convenient. But

you can easily get by with an inexpensive piece of hardboard or fiberboard, a handful of thumbtacks or pushpins, and a roll of drafting tape, 1" wide to hold down the edges of your paper.

Palette or Paintbox. Some professionals just squeeze out and mix their colors on a porcelain dinner plate or a white enamel tray-which you can probably find in a shop that sells kitchen supplies. The palette made specifically for watercolor is white metal or plastic, with compartments into which you squeeze tube colors. plus a mixing surface for producing quantities of liquid color. For working on location, it's convenient to have a metal watercolor box with compartments for your gear. But a toolbox or a fishing tackle box-with lots of compartments – will do just as well. If you decide to work outdoors with pans of color, buy an empty metal box equipped to hold pans, then buy the selection of colors listed in this book. Don't buy a box with pans of color preselected by the manufacturer.

Odds and Ends. You'll need some single-edge razor blades or a knife with a retractable blade (for safety) to cut paper. Paper towels and cleansing tissues are useful, not only for cleaning up, but for lifting wet color from a painting in progress. A sponge is excellent for wetting paper, lifting wet color, and cleaning up spills. You'll obviously need a pencil for sketching your composition on the watercolor paper before you paint: Buy an HB drawing pencil in an art supply store or just use an ordinary office pencil. To erase the pencil lines when the watercolor is dry, get a kneaded rubber (or "putty rubber") eraser, so soft that you can shape it like clay and erase a pencil line without abrading

the delicate surface of the paper. Find three wide-mouthed glass jars big enough to hold a quart or a liter of water; you'll find out why in a moment. If you're working outdoors, a folding stool is a convenience—and insect repellent is a *must*!

Work Layout. Lay out your supplies and equipment in a consistent way, so everything is always in its place when you reach for it. Directly in front of you is your drawing board with your paper tacked or taped to it. If you're right-handed, place your palette and those three wide-mouthed jars to the right of the drawing board. In one jar, store your brushes, hair end up; don't let them roll around on the table and get squashed. Fill the other two jars with clear water. Use one jar of water as a "well" from which you draw water to mix with your colors; use the other for washing your brushes. Keep the sponge in a corner of your palette and the paper towels nearby, ready for emergencies. Line up your tubes of color someplace where you can get at them quickly-possibly along the other side of your drawing boardwhen you need to refill your palette. Naturally, you'd reverse these arrangements if you're left handed.

Palette Layout. In the excitement of painting, it's essential to dart your brush at the right color instinctively. So establish a fixed location for each color on your palette. There's no one standard arrangement. One good way is to line up your colors in a row with the *cool* colors at one end and the *warm* colors at the other. The cool colors would be gray, two blues, and green, followed by the warm yellows, orange, reds, and browns. The main thing is to be consistent, so you can find your colors when you want them.

Developing Good Habits. After the excitement of painting, it's always a letdown to have to clean up. Fortunately, you can clean up quite quickly after painting a watercolor—the job takes a lot longer if you're working in oil. It's essential to develop the right cleanup habits, not merely to keep your studio looking shipshape, but because the watercolorist's tools and equipment are particularly delicate and need special care. Here are the most important steps in your cleanup.

Sponging. After a day's painting, you'll certainly leave little pools and spatters of color in all sorts of odd places. Your drawing board or drawing table will have a fair amount of dried color around the edges, which you should sponge away with an ordinary household sponge. (Don't waste an expensive natural sponge on this task.) If you don't sponge off your drawing board and other work surfaces, there's always the danger that some of this color will dissolve and work its way onto fresh white paper during your *next* painting session. You should also sponge off the color that's accumulated on the mixing surface of your palette, since you obviously want to start with a fresh surface the next time you paint. There's no need to wash away what's left of the little mounds of tube color around the edges of the palette; at your next working session, you can simply wet them and use them again. However, these little mounds often get covered with traces of various color mixtures; it's a good idea to wash away these mixtures with a brush, exposing the original pure color.

Washing Brushes. Your most fragile and most expensive tools are your brushes. These take very special care. At the end of the painting day, be sure to rinse each brush thoroughly in *clear* water – not in the muddy water in the jars. If a brush seems to be stained by some tenacious color such as phthalocyanine blue, stroke the hairs gently across a bar of soap (not laundry soap) and lather the brush in the palm of your hand with a soft, circular motion. The color will come out in the lather, except with white nylon brushes, which may stain slightly. When all your brushes have been rinsed absolutely clean, shake out the excess water and then shape each brush with your fingers. Press the round brushes into a graceful bullet shape with a pointed tip. Press the flat brushes into a neat square with the hairs tapering in slightly toward the forward edge.

Storing Brushes. Place the brushes in a clean, dry, empty jar, hair end up. Leave the brushes in the jar until they're absolutely dry. You can store them in this container, unless you live in some climate where moths or other pests are a threat to natural fibers. If you're worried about moths, it's best to store the brushes in a drawer or a box. Make sure the hairs don't press up against anything—and sprinkle mothballs or moth-killing crystals among the brushes.

Care of Paper. Watercolor paper has a delicate surface and should be carefully stored. Don't just leave a stack of unused paper out where dust can discolor it or a sweaty hand can brush up against it. Store the paper flat in a drawer, preferably in an envelope, a flat box, or a portfolio, so the paper isn't battered or scraped every time it goes in or out of the drawer. Keep the paper away from moist places such as a damp basement.

Care of Colors. When you're finished painting, take a damp paper towel or a cleansing tissue and wipe off the "necks" of your color tubes to clean away any traces of paint that will make it hard to remove the cap the next time you paint. Do the same inside the cap itself. There's nothing more frustrating than wrestling with that tiny cap when you're desperate for a fresh dab of color, halfway through a painting. Also wash away any paint that might cover the label on the outside of the tube, so you can quickly identify your colors. Searching for the right color among all those filthy tubes can be just as maddening as wrestling with the cap. You'll get more color out of the tube-and save money-if you always squeeze the tube from the very end and roll up the empty portion as you work.

Safety Precautions. Be especially careful about putting away sharp instruments—and always keep them in the same place. If you bought a knife with a retractable blade, as suggested earlier, be sure to retract the blade before you store the knife in the darkness of your paintbox or toolbox. You don't want that sharp blade waiting for you when you grope around for the knife. Keep razor blades in a small envelope or in a box - or just wrap a piece of tape over the sharp edge. Keep pushpins or thumbtacks in a little envelope or box-or simply push them into the edges of your drawing board. Finally, there's always a certain amount of color on your fingertips while you're painting, so don't smoke or eat while you work. Keep those colors out of your digestive tract.

FLAT WASHES

Step 1. The basic way to apply watercolor is called the *flat wash*. Mix up a pool of color on your palette and paint an area that's the same tone from end to end. It's not darker at one end and lighter at the other end—that's why it's called *flat*. It's best to start with a simple pencil drawing that clearly defines the big shapes that will be filled by the washes, as you see here. An HB pencil will give you a line that's firm but easy to erase when the picture is done. Don't press too hard, making a groove in the paper. Let the pencil ride gently over the surface.

Step 2. The drawing board is tilted up slightly at the back. (You can just put a book under the top edge.) Then a big flat brush paints a series of horizontal strokes, starting at the top, working downward, and overlapping one another just a bit, so the wet strokes melt together. The wet color literally rolls down the paper. A pool tends to form along the lower edge of each new stroke; in a sense, you're guiding this pool down over the sheet as you add the next stroke. But you don't want the pool to remain at the lower edge of the completed wash, or the wash will turn too dark in that area. So rinse vour brush, flick out most of the water with a snap of your wrist, and use the tip of the damp brush (like a sponge) to soak up the excess color. This painting begins with a single flat wash that covers the entire sheet, leaving two strips of bare paper. The wash is ultramarine blue with a hint of burnt sienna and Hooker's green.

Step 3. Now each big shape in the painting is covered with a single flat wash, painted the same way as the large wash that covered the sheet in Step 2. The artist waits for each area to dry before an adjacent shape is painted-with one exception, as you'll see in a moment. The whole painting is done with a large flat brush. The strip of cloud is ultramarine blue with just a hint of alizarin crimson and burnt sienna. The biggest mountain is this same mixture-with less water. The small mountain in the distance is alizarin crimson and ultramarine blue. The dark strip of wooded land at the base of the mountain is a two-step operation: The darker area is painted with ultramarine blue, cadmium yellow, and burnt sienna; then, while the dark wash is still damp, the lighted top is painted with cadmium yellow and ultramarine blue. The two wet tones melt together where they meet. Finally, the angular corner of the flat brush paints the foreground trees with ultramarine blue, Hooker's green, and burnt sienna.

Step 4. In the final stage, the details in the foreground are added-leaving the other shapes simple and untouched. The sharp leading edge of the flat brush builds up the reflections in the water with straight horizontal and vertical strokes of ultramarine blue, Hooker's green, and burnt sienna. As you can see, that sharp edge is capable of making very precise strokes. In the same way, the sharp edge of the brush-and the angular corner as well-make crisp vertical and diagonal strokes in the foreground to suggest the detail of the trees at the lower edge of the painting. These rich darks are a mixture of phthalocyanine blue, Hooker's green, and just a speck of cadmium red.

GRADED WASHES

Step 1. Unlike a flat wash, a graded wash is dark at one end and light at the other. Once again, start with a simple but clearly defined pencil drawing that outlines the major shapes. The drawing board is tilted up slightly at the back end so the wash will roll downward toward you. Mix a pool of liquid color on the palette-enough color so that you won't have to stop and mix more in the middle of the wash! Starting at the top, paint the wash in a series of overlapping stripes. But now you add a bit more water to each stroke, so the wash gradually becomes lighter as you move down the paper. This painting starts with a graded wash that covers the whole sheet-a mixture of ultramarine blue and alizarin crimson. But this graded wash is doubly interesting because the artist not only adds more water as he works downward, but also adds a bit more crimson in the middle and a bit more blue at the bottom, where the wash becomes slightly darker again.

Step 2. That big wash might have been painted with a flat brush-but now you can see that the artist is actually working with a big round brush. As he paints the trees, you can see the rounded, springy strokes that distinguish the round brush-in contrast with the flat, angular strokes of the flat brush. He paints the foliage with a much darker graded wash that combines ultramarine blue, alizarin crimson, and a hint of burnt sienna. It's obvious that the artist adds more water to the strokes as the brush works downward. In the gaps between the big strokes, the pointed tip of the brush draws trunks and branches. When the trees are dry, the artist turns the drawing board upside down and paints a graded wash in the foreground, using the same mixture that appeared in Step 1.

Step 3. When the entire surface of the painting is bone dry, the small, distant mountain is painted with a small graded wash of ultramarine blue, alizarin crimson, and a little burnt sienna-with a bit more blue in the strokes at the top of the shape. Leaving a dry strip to suggest light on the water, the round brush paints a graded wash that moves *horizontally* across the foreground-darker at the right and lighter at the left. The brushwork is irregular, suggesting the movement of the water. The colors are the same ones that appear in the trees. When this last graded wash is dry, the mass of weeds in the immediate foreground is blocked in with rough strokes of alizarin crimson and burnt sienna, subdued by a touch of ultramarine blue.

Step 4. As you saw in the preceding demonstration, the artist saves the last details and finishing touches for the final stage. Now the tip of a smaller round brush builds up the reflections and the swampy debris in the water, working with the tree mixture in the area just below the trees-and then switching to a blend of ultramarine blue and burnt sienna for the precise, slender strokes that suggest the weeds in the immediate foreground. The darker strokes of the weeds allow the warm, underlying tone to break through the gaps. There's an interesting lesson here: If you place just enough detail in the foreground (without overdoing it), viewers will think they see a lot of detail in the distance. By the way, there's no law that says you have to paint flat washes with a flat brush and graded washes with a round brush. It's a matter of personal taste. Try both techniques with both brushes.

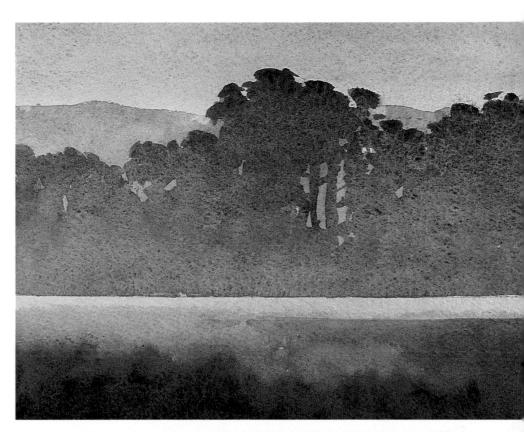

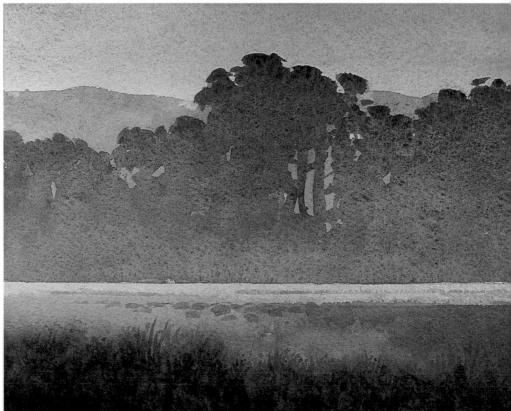

PAINTING WET-IN-WET

Step 1. As you discovered when you painted a series of overlapping strokes to create flat and graded washes, a stroke of watercolor blurs when it hits wet paper. The technique called wetin-wet takes advantage of this phenomenon. This is going to be a painting of woods, so the preliminary drawing defines the rough shapes of the foliage, paying particular attention to the breaks in the trees. A big flat brush (it could also be a soft natural sponge) covers the entire sheet with clear water. While the surface of the paper is still shiny, the big flat brush applies broad strokes of cadmium yellow, alizarin crimson, and ultramarine blue, which blur together and produce subtle mixtures. A paper towel blots away the color that spreads over the breaks in the foliage-which must remain bare paper.

Step 2. When Step 1 is bone dry, the artist switches to a more selective wet-in-wet technique. The flat brush makes big strokes of burnt sienna and ultramarine blue, sometimes letting the sienna dominate and sometimes letting the blue dominate. While these strokes are still wet, the brush picks up various mixtures of alizarin crimson and cadmium yellow, adding the new mixtures to the old strokes here and there to create new blends on the paper. In this technique, the paper isn't completely wet; only some areas-the areas where the artist wants the color to go-are wet. The brush paints wet color into wet color. When Step 2 is dry, you can see Step 1 shining through, creating a feeling of golden light between the leafy masses and suggesting distant trees.

Step 3. It's time to start building up the details of the tree trunks and branches. On the dry surface of the paper, the point of a large round brush draws the big trunks with a mixture of phthalocyanine blue and burnt sienna. The brush indicates a few big branches (not too many) and then moves into the foreground to darken the shadows on the ground. The brush blocks in some shadowy masses of foliage. Now look closely and you'll see a very subtle wet-in-wet technique. While the dark trunks and foliage are still wet, the artist uses the tip of the brush and adds an occasional stroke of water to blur an edge or lighten a tone-and then adds more color to the wet color. You can see where the trunks are darkened by touches of very heavy burnt umber (practically no water) and the shadowy foliage is brightened by touches of alizarin crimson.

Step 4. So far, the sky is still bare paper. The artist dampens these patches with clear water, which he allows to soak in for a few seconds. Then the artist uses a round brush to add a few strokes of cerulean blue and a bit of yellow ochre, which spread on the wet surface to suggest a blue sky with a few wispy clouds. When the sky is dry, he uses the very tip of the brush to add the smaller branches and some leaves silhouetted against the light. Finally, to suggest some colorful leaves amid the darker foliage, the round brush rewets the central area of the woods and the very point of the brush adds tiny touches of cadmium red and cadmium yellow to the damp color. These delicate touches almost disappear into the wetness, but you can see them in the woods on the right-hand side of the picture.

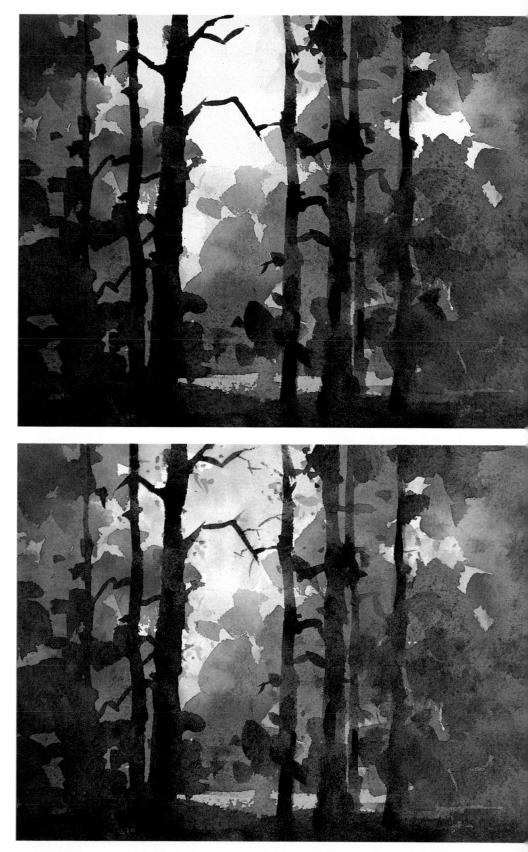

DRYBRUSH FOR TEXTURE

Step 1. Some rough textured object, such as this old, dead tree stump, is ideal for developing your skill with drybrush. This may also be a good time to try out rough paper, which heightens the effect of drybrushing. The preliminary pencil drawing defines the general shape of the tree stump, indicates some of the bigger cracks, and suggests some roots that will be painted out later because they're distracting. The sky here is a mixture of ultramarine blue, alizarin crimson, and yellow ochre painted with a large brush. Then the artist works in the trees along the horizon with a mixture of Hooker's green and burnt umber, with a bit of Payne's gray. The grass is Hooker's green, yellow ochre, and burnt sienna. The artist scratches the lines in the distant trees with the tip of a brush handle while the color is wet.

Tips About Drybrush

1. If the brush is too wet, wipe it on a paper towel, a cleansing tissue, or a newspaper.

2. The angle of the brush makes a difference. If you work with the side, the stroke is more ragged; if you work with the tip, the stroke is a bit smoother.

3. Speed makes a difference, too. A fast stroke is apt to deposit more color than a slow stroke.

4. And pressure makes a difference. The harder you press, the darker the stroke.

Step 2. It's usually best to work from light to dark. The lighter areas of the wood are burnt sienna and ultramarine blue, leaving some bare paper on the left side of the stump for the lights. The artist uses this same mixture for the shadow side of the broken branch. While the light area is still damp, the artist adds a dark mixture of Hooker's green and burnt umber to the right side of the stump so the dark and light areas fuse slightly. This is the same mixture the artist uses for the other darks on the stump. At this point, the brush carries a lot of color, but it's not too wet; thus the strokes have a drybrush feeling.

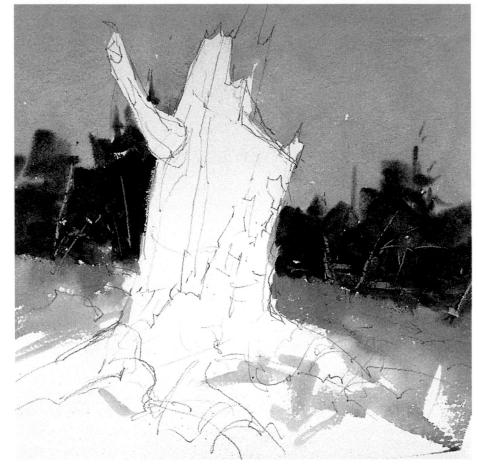

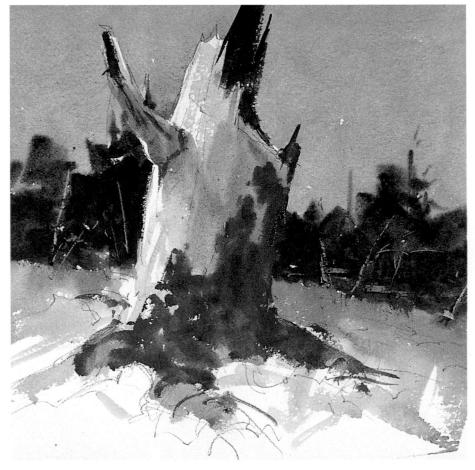

Step 3. Now the artist adds drybrush strokes to the stump, following the upward direction of the form and suggesting the roughness of the dead, weathered wood. These strokes are a mixture of cerulean blue and burnt sienna. The dead weeds in the foreground are painted roughly with a big brush-a mixture of yellow ochre, burnt sienna, and burnt umber-with one wet stroke blurring into the next. While the foreground color is still wet. it's fun to scrape into the color with the tip of a brush handle to suggest individual weeds. If you look closely, you can see some drybrush strokes suggesting the rough texture of the ground.

Step 4. The artist adds to the foreground drybrush strokes of burnt umber. More darks are added to the stump with a mixture of alizarin crimson and Hooker's green. The artist uses this mixture for the very slender strokes and additional drybrush textures on the light part of the stump. The sharp corner of a blade is used to scrape out some light lines next to the dark ones, strongly emphasizing the texture of the wood. Finally, the artist adds a few touches of cadmium red at the base of the stump, within the dark shadows at the top of the stump, and inside the cracked branch. The finished painting is actually a combination of many effects. The sky is a flat wash. The distant trees are painted wet-in-wet into the sky. Drybrush is used selectively, mainly on the stump and in the foreground.

How to Drybrush

Drybrush is a method of exploiting the texture of the paper to create rough, textured brushstrokes. The brush isn't literally dry, but just damp. Skim the damp brush over the paper, hitting the ridges and skipping over the valleys. The color tends to be deposited on those ridges, leaving the valleys bare. The harder you press, the more color you deposit, but some paper always peeks through, and the strokes have a fascinating, ragged quality that's ideal for suggesting textures such as tree trunks or masses of leaves.

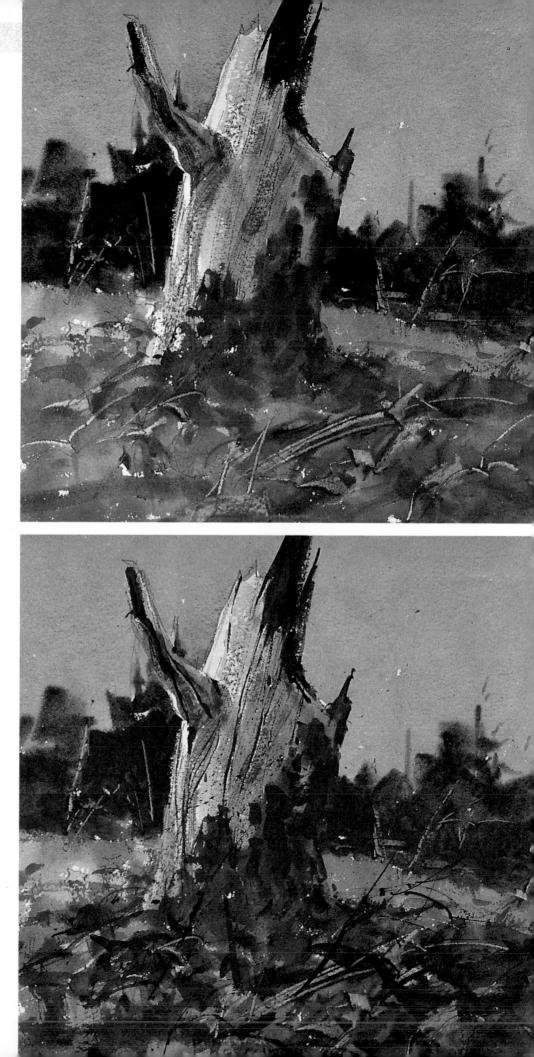

HOW TO CORRECT PAINTINGS

Step 1. When a watercolor gets off to a bad start, it's really best to scrap it and start on a fresh sheet of paper. You'll learn more that way. But the fact is that you *can* make some modest corrections if you think the painting looks promising and you want to save it if you can. Here's a typical example of a painting that's gone wrong at the very beginning. That cloud looks as heavy and colorless as lead. Even a dark cloud ought to look luminous—and this one doesn't. Can the artist lighten the cloud sufficiently to make a fresh start?

Step 2. The solution is washing out. You can fill the bathtub-or any big, flat container, such as a baking tinwith clear, cold water, and drop the paper into the water to soak for an hour or two. Some of the color will loosen and float away. You can encourage the color to loosen by brushing it very gently or massaging it with a silky natural sponge. Of course, you may not need the bathtub if you just want to lighten a small part of the painting. In that case, wet the area with plenty of clear water; brush it gently with a big bristle brush or massage it with a wet natural sponge; and blot up the loosened color with a clean paper towel. Let the wet paper dry thoroughly. If you use the bathtub method, give the sheet one last dip in clear water, let the water drip off, and then tack down the edges of the paper while it dries. This cloud did lose a fair amount of color in the bathtub. Unfortunately, so did the sky. But now the cloud is pale enough to try something new.

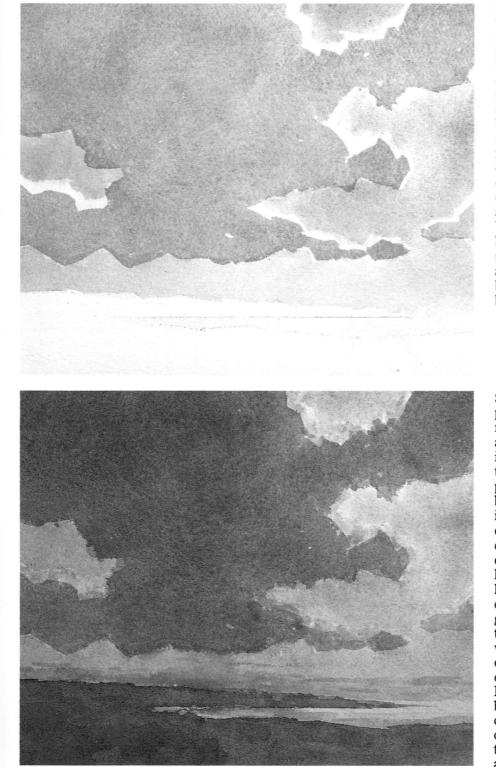

Step 3. Before trying to improve the cloud color, there's one less obvious problem that needs attention. The lighted edges of the cloud are too hard. The solution is a technique called lifting out, which is just watercolor language for scrubbing out with a bristle brush. The artist dampens a bristle brush with clear water and scrubs the very tip gently back and forth over the lighted edges of the cloud on the right-hand side of the dark shape. The brush lifts just enough color to blur the edges, which are blotted with a dry paper towel. When the clouds are dry again, a big round brush brightens that leaden shadow with a wash of yellow ochre, and then enriches the sky with a blend of cerulean and ultramarine blue.

Step 4. Yes, Step 3 is a modest improvement—but how can the artist make a really dramatic change? The answer is glazing, which means brushing transparent color over large areas to change the whole character of the painting. The artist decides to go for broke and try to transform the painting into a sunset! He brushes that quiet cloud with a glaze of alizarin crimson and ultramarine blue. With a darker version of this same mixture, he paints the shape of the shore below. A pale version of this glaze is carried over the lower sky. When the glaze is thoroughly dry, the artist touches the edges of the clouds with cadmium yellow and cadmium orange – a mixture that's carried down over the lower sky and into the water. Is the picture saved? Well, Step 4 is better than Step 1. But you can't escape a fundamental "law" of watercolor: The colors would be fresher if the artist started over from scratch and got them right *without* having to make corrections.

Permanence. A watercolor painting, properly taken care of, should last for centuries. Although the subject of framing would take a book in itself, here are some suggestions about the proper way to preserve finished paintings.

Permanent Materials. It's obvious that you can't paint a durable picture unless you use the right materials. All the colors recommended in this book are chemically stable, which means that they won't deteriorate with the passage of time and won't produce unstable chemical combinations when blended with one another. When you buy other colors, either to expand your palette or to replace one of these eleven colors, study the manufacturer's literature to make sure that you're buying a permanent color. All the good color manufacturers have charts that tell you, quite frankly, which colors are permanent and which colors aren't. For the same reason, it's important to buy the best moldmade or hand-made paper. Although few papers are now made of rags, many manufacturers still use the phrase "100% rag" to designate paper that's chemically pure-and that's what you should buy once you feel your paintings are worth saving. Lower grade papers will yellow and discolor with the passage of time.

Matting. A mat (which the British call a mount) is essential protection for a watercolor. The usual mat is a sturdy sheet of white or tinted cardboard, generally about 4" (100 mm) larger than your painting on all four sides. Into the center of this board, you cut a window that's slightly smaller than the painting. You then "sandwich" the painting between this mat and a second board, the same size as the mat. Thus, the edges and back

of the painting are protected and only the face is exposed. When you pick up the painting, you touch the "sandwich," not the painting itself.

Boards and Tape. Unfortunately, most mat (or mount) boards are not chemically pure, containing corrosive substances that will eventually migrate from the board to discolor your watercolor paper. If you really want your paintings to last for posterity, you've got to buy the chemically pure, museum-quality mat board, sometimes called conservation board. The ordinary mat board does come in lovely colors, but you can match these by painting the museum board with acrylic colors. Paint both sides to prevent warping. Too many watercolorists paste their paintings to the mat or the backing board with masking or Scotch tape. Don't! The adhesive stays sticky forever and will gradually discolor the painting. The best tape is the glue-coated cloth librarians use for repairing books. Or you can make your own tape out of strips of discarded watercolor paper and white library paste.

Framing. If you're going to hang your painting, the matted picture must be placed under a sheet of glass (or plastic) and then framed. Most watercolorists prefer a simple frame-slender strips of wood or metal in muted colors that harmonize with the picture-rather than the heavier, more ornate frames in which we often see oil paintings. If you're going to cut your own mats and make your own frames, buy a good book on picture framing, which is beyond the scope of this book. If you're going to turn the job over to a commercial framer, make sure he uses museum-quality mat board. Equally important, make sure that he doesn't work with masking or

Scotch tape – which too many framers rely on for speed and convenience.

What to Avoid. Commercial mat boards come in some dazzling colors that are likely to overwhelm your painting. Whether you make your own mats or have the job done by a framer, avoid the garish colors that call more attention to themselves than to your painting. Try to find a subdued color that "stays in its place" and allows the painting to occupy center stage. Resist the temptation to glue your finished painting down to a stiff board, even if the painting is a bit wavy. The painting should hang free inside the sandwich of mat and backing board, hinged either to the mat or the backing board by two pieces of tape along the two top corners of the picture. When you do hang the painting, keep it away from damp walls, leaky windows, leaky ceilings, and windows that will allow direct sunlight to pour onto the picture. Any paintingwhether watercolor, oil, acrylic, or pastel-will eventually lose some of its brilliance with prolonged exposure to strong sunlight.

Storing Unframed Paintings. Unframed paintings, with or without mats, should always be stored horizontally, never vertically. Standing on its end, even the heaviest watercolor paper and the stiffest mat will begin to curl. Store these just as you'd store sheets of watercolor paper: in envelopes, shallow boxes, or portfolios kept flat in a drawer or on a shelf. Take proper care of your paintings, and people will enjoy them for generations to come.

BEYOND THE BASICS

LEARNING TO MODEL FORM

Step 1. To learn how to model forms—to get a sense of threedimensional roundness—it's best to start out with some still life objects from the kitchen, such as this arrangement of an eggplant, an onion, and some radishes. Begin with a simple drawing. You needn't be too precise in drawing your lines, since you're going to erase them with kneaded rubber (or putty rubber) after the complete painting is dry.

Step 2. In this demonstration, the artist paints the background and the tabletop with big, free strokes. The background is ultramarine blue mixed with a touch of burnt sienna. The tabletop is mostly burnt umber, plus a bit of cerulean blue. The greens behind the radishes are Hooker's green and burnt sienna, painted with a small round brush. The artist scrapes out the stems with the tip of the brush handle while the color is still wet.

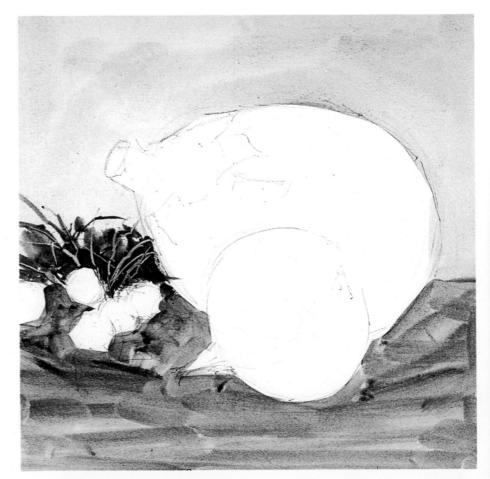

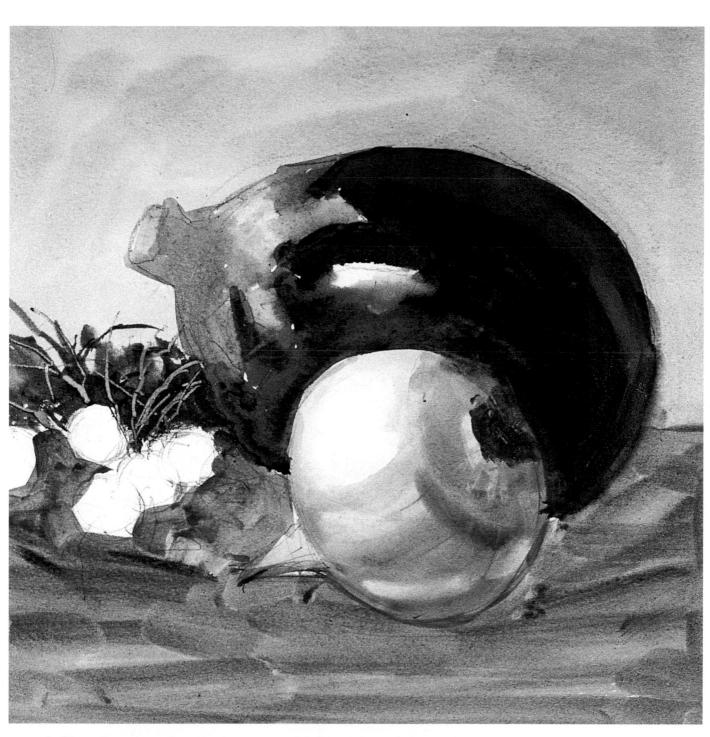

Step 3. The artist brushes in a blend of alizarin crimson, ultramarine blue, and burnt umber with curving strokes to create the rounded form of the eggplant. Some strokes are darker than others. They all blur together, except where he's left a piece of bare paper for the highlight. He paints the onion wet-in-wet with a mixture of yellow ochre, cadmium orange, and a touch of cerulean blue, with all the strokes blending together. The dark spots on the onion are burnt umber, brushed in while the underlying color is still wet. The green on the eggplant is cadmium ycllow, cerulean blue, and yellow ochre.

LEARNING TO MODEL FORM

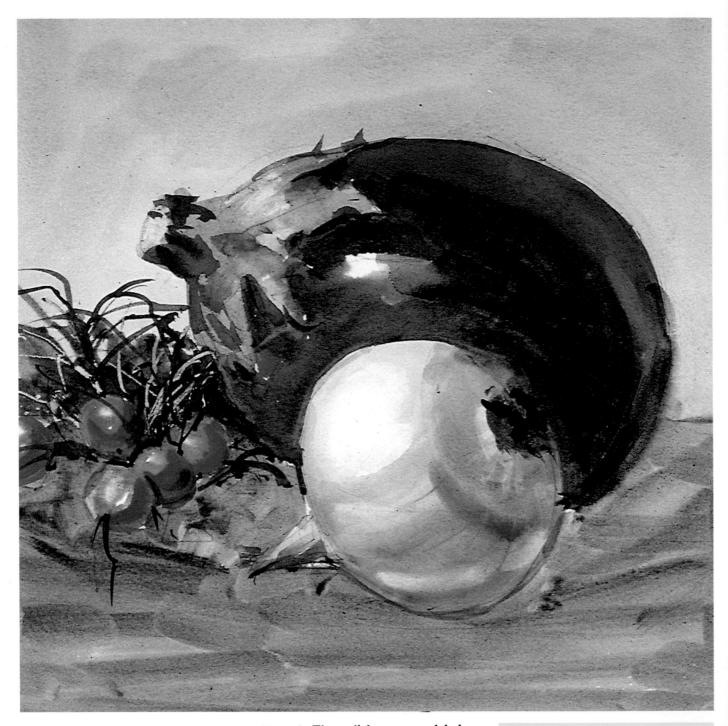

Step 4. The radishes are modeled with the short, curving strokes of a small round brush—a blend of cadmium yellow, cadmium red, and alizarin crimson for the bright tones, then Hooker's green for the dark touches. The dark greens on the tip of the eggplant are also Hooker's green, darkened with a touch of cadmium red.

Tips About Modeling Form

1. Make your brushstrokes follow the forms: curved strokes for rounded forms; straight strokes for flat planes.

2. Pay attention to the lights and shadows. Try making a sketch of the lights and shadows before you start to paint.

3. Reserve the lights. Let your lightest areas remain bare paper until the last stage of the painting. And don't cover them completely.

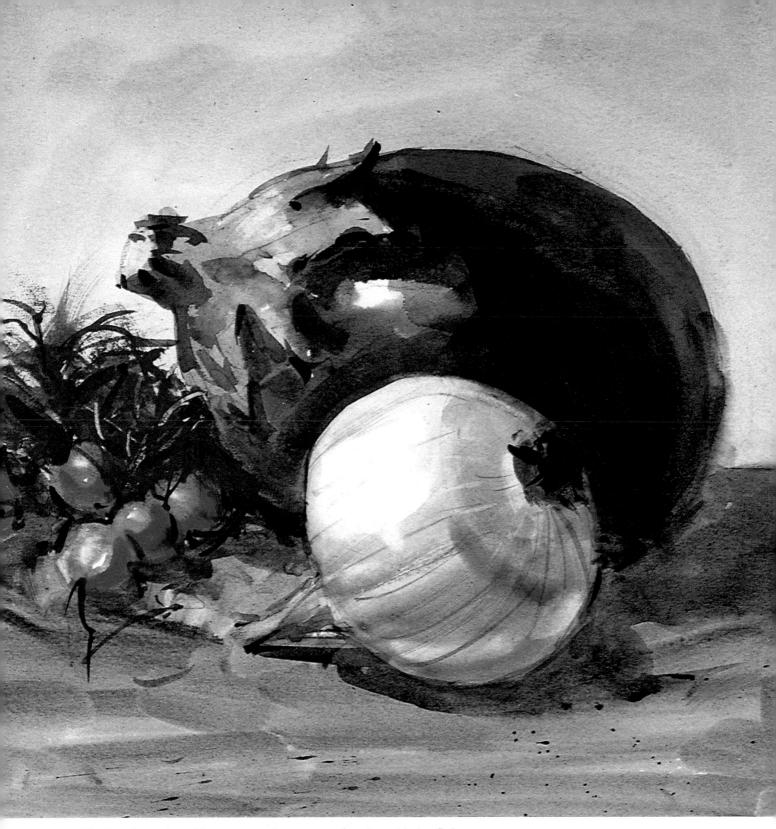

Step 5. Finally, the artist adds cast shadows beneath the eggplant, onion, and radishes with a dark mixture of burnt umber and ultramarine blue. He adds some dark touches to the green tip of the eggplant, at both ends of the onion, and behind the radishes with a mixture of Hooker's green and alizarin crimson. He also adds some lines of burnt umber to the onion and scratches out some light lines with

the corner of a sharp blade. Going back to the green mixture in Step 1, he adds some drybrush strokes behind the radishes. As you can see, the main point is to follow the forms. The brushstrokes on the vegetables are rounded, like the shapes of the vegetables themselves. And the strokes of the table are horizontal, like the surface of the table.

TRY A STILL LIFE OF FRUIT

Step 1. This casual arrangement of fruit makes an excellent subject for a still life. Croney begins it with a simple pencil drawing that indicates the rounded shapes of the fruit, the bowl, and the dividing line between the tabletop and the background wall. He paints the background with a mixture of cerulean blue, yellow ochre, and burnt sienna, with more blue in some places and more brown or yellow in others. He uses the same mixture with more yellow ochre on the underside of the bowl.

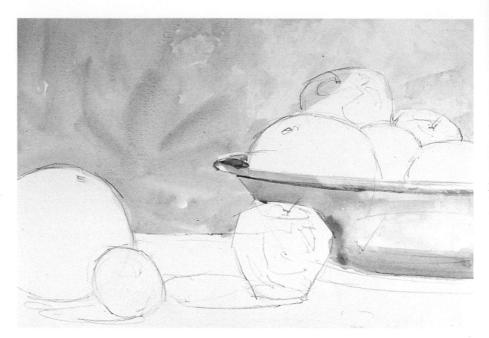

Step 2. Croney paints the light side of the grapefruit with cadmium yellow, plus some yellow ochre and a touch of cerulean blue on the shadow side. While the pale washes are still wet, he adds the dark strokes so that the dark and light strokes blur together a bit. Notice how the strokes curve to follow the rounded forms.

Let's Look at the Brushwork

The strokes follow the forms. The artist paints the fruit with curving strokes and the bowl with straighter strokes. He lets his strokes *show* to emphasize the curves of the forms.

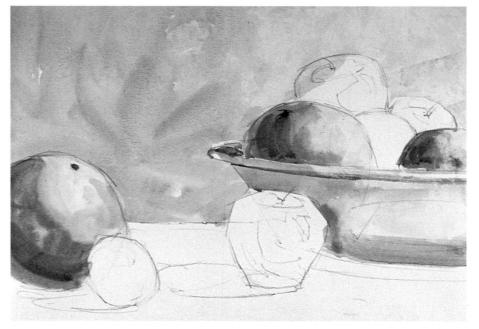

Step 3. Now he'll put an orange just behind the two grapefruits in the bowl. He starts it with a mixture of cadmium yellow and cadmium orange. Then he adds an extra dash of cadmium orange to the top of the orange while the first wash is still wet and brushes a little Hooker's green into the wet wash farther down to suggest a shadow. The plum is mainly ultramarine blue and alizarin crimson, with a hint of yellow ochre. A bit of bare paper is left for the highlight. He adds more water to the wash for the lighter side of the plum, less for the shadow side. The two washes blend together, wet-in-wet.

Step 4. Croney paints the lighter sides of the apples with cadmium red and a little cadmium yellow, adding alizarin crimson and more cadmium red to the shadow side. The darkest areas of shadow include a little Hooker's green added while the lighter strokes are still slightly wet. The green at the top of the apple is Hooker's green plus a little cadmium yellow. The paler apple at the back of the bowl is painted with the same mixtures, but with more water.

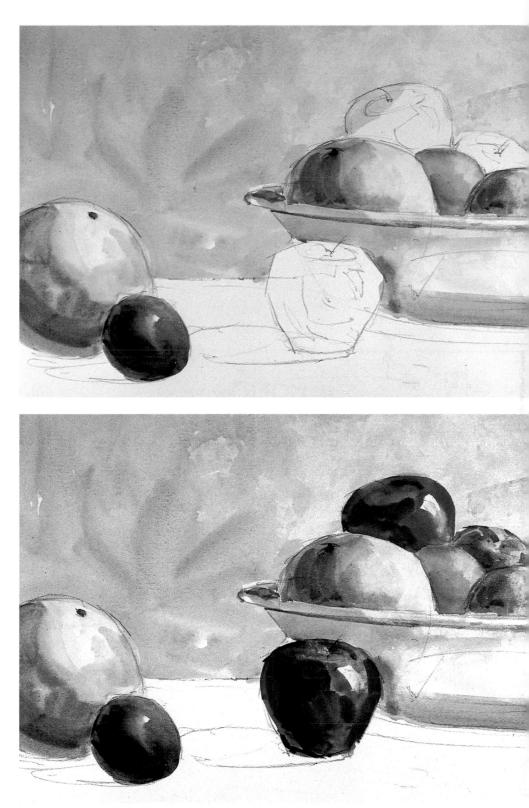

TRY A STILL LIFE OF FRUIT

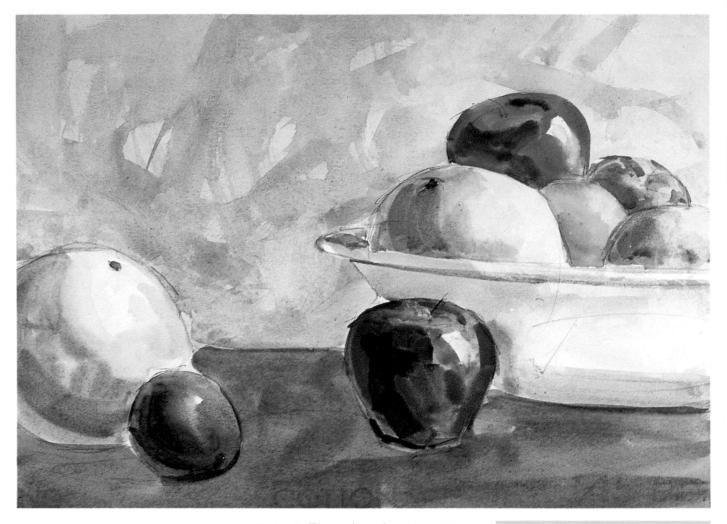

Step 5. The artist paints the table with a large flat brush carrying a fluid mixture of Hooker's green and burnt sienna. You can see that some brush-strokes contain more green and some contain more brown. He adds more strokes to the background wall with the same big brush. The free, erratic strokes carry mixtures of cerulean blue, yellow ochre, and burnt sienna, some strokes bluer and some browner.

Lights and Darks

The brush works around the highlights – reserving the lights, which remain bare paper. Dark strokes go over pale washes before the underlying color is completely dry – so the dark strokes are slightly blurred.

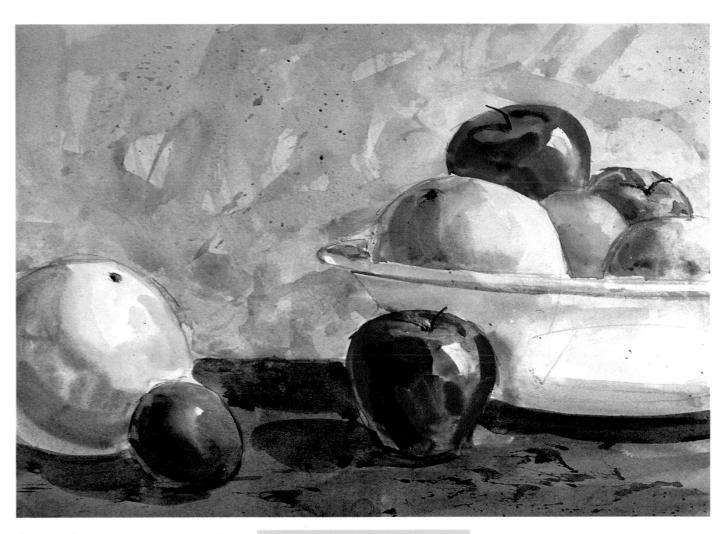

Step 6. Croney adds shadows on the table with a dark mixture of burnt umber and Hooker's green, carefully painted with a small round sable. He adds a few strokes to the tabletop to suggest the wood texture. To add more texture to the wall and the tabletop, he uses a technique called spattering. He dips the brush into wet color, which is then thrown onto the painting surface with a whipping motion of the wrist, spattering small droplets of paint. He then adds stems to the apples, using a blackish blend of Hooker's green and alizarin crimson.

Other Ways to Paint Fruit

1. Try painting the background and tabletop in flat washes.

2. Try modeling the fruit with graded washes.

3. Try adding texture to the background and the tabletop with drybrush.

4. Try scrubbing out highlights with a damp bristle brush-and blotting with a paper towel.

5. Try painting with just three tube colors: ultramarine blue, alizarin crimson, and cadmium yellow.

Step 7. The picture seems to need another dark note, so the artist adds a second plum, using the same mixtures as the plum painted in Step 3, to the bowl. Finally, he adds details with the tip of a small round brush. With the same brush he used for the drybrush textures on the table, he paints lines on the tabletop to suggest cracks. He scratches some light lines next to the dark ones with the corner

of a sharp blade. He adds dark lines to sharpen the edges of the fruit in the bowl, beneath the bowl, and beneath the fruit on the table—to make them "sit" more securely. These darks aren't black, but a mixture of Hooker's green and alizarin crimson, like the apple stems. Finally, he darkens the shadow on the side of the bowl slightly with cerulean blue, yellow ochre, and burnt sienna.

CAPTURE THE COLORS OF FLOWERS

Step 1. Perhaps the most delightful indoor subject is a vase of flowers, especially in some casual arrangement such as this one. The artist begins by painting the background with a mixture of ultramarine blue, yellow ochre, and a touch of alizarin crimson. When the background is dry, he paints in the general shapes of the flowers wet-in-wet with various mixtures of cadmium orange, cadmium red, and alizarin crimson, letting them blur into one another. With the flowers just partially dry, he quickly adds the leaves, sometimes blurring them into the edges of the flowers. The leaves are Hooker's green and burnt umber.

Step 2. The artist adds cooler flowers with a mixture of cerulean blue and alizarin crimson. The brushwork is still broad and free; the flowers and leaves are all just colored shapes. The yellow centers of the flowers are yellow ochre and cadmium yellow. With the main shapes blocked in, the artist adds less important shapes around the edges. He puts new, pale flowers at the top and bottom—yellow ochre and cerulean blue in the light areas and Hooker's green, yellow ochre, and ultramarine blue in the darker areas.

CAPTURE THE COLORS OF FLOWERS

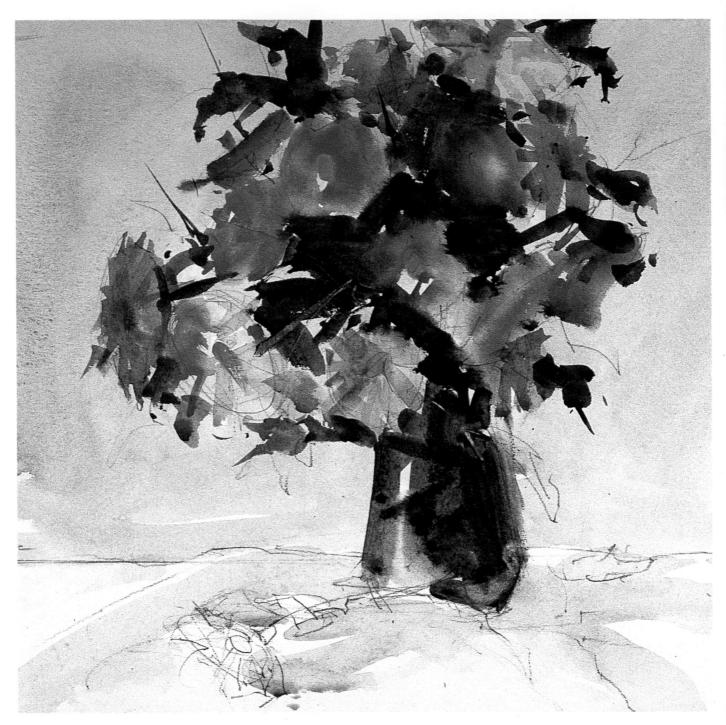

How to Paint Clear Glass

Clear glass has no color of its own, so you paint the colors of the objects *inside* the glass. Or you paint the colors reflected on the surface of the glass, which are the colors of the objects that *surround* it. If you paint everything but the glass itself—which you *can't* paint—the viewer will see glass! **Step 3.** Now it's time to begin work on the glass vase. The glass and the water within it have no color of their own, but simply reflect the color of their surroundings. Thus, the vase takes on the color of the dark stems in the water and the dark leaves above. The strokes on the vase are various mixtures of cerulean blue and burnt sienna, with a hint of Hooker's green, all painted into one another while they're still wet. The artist leaves a patch of light paper for a highlight and creates a second, softer light by blotting up some wet color with a paper towel. He suggests the folds on the tabletop with a mixture of cerulean blue and burnt sienna.

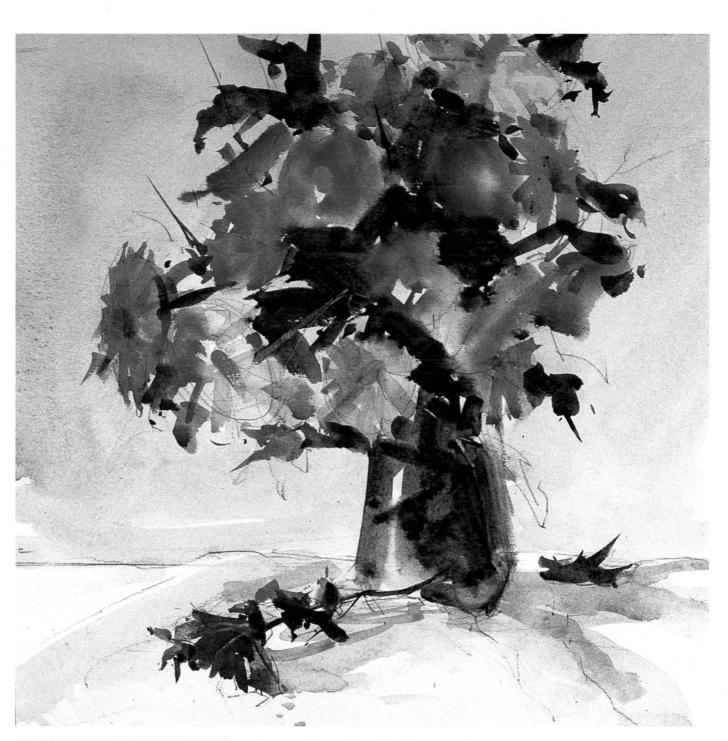

A Little Goes a Long Way

In painting the delicate, graceful forms of flowers, it's important not to be too careful. Paint them as freely and broadly as you paint trees. And don't get carried away with too much detail. A little detail goes a long way. **Step 4.** The artist adds a flower and a leaf to the tabletop. The petals are a mixture of cadmium orange, cadmium red, and alizarin crimson, painted with a small round brush. The light green is cadmium yellow, yellow ochre, and Hooker's green, while the dark green is Hooker's green and a touch of alizarin crimson. The artist adds cool shadows beneath the flower and under the leaves with cerulean blue and a little burnt sienna.

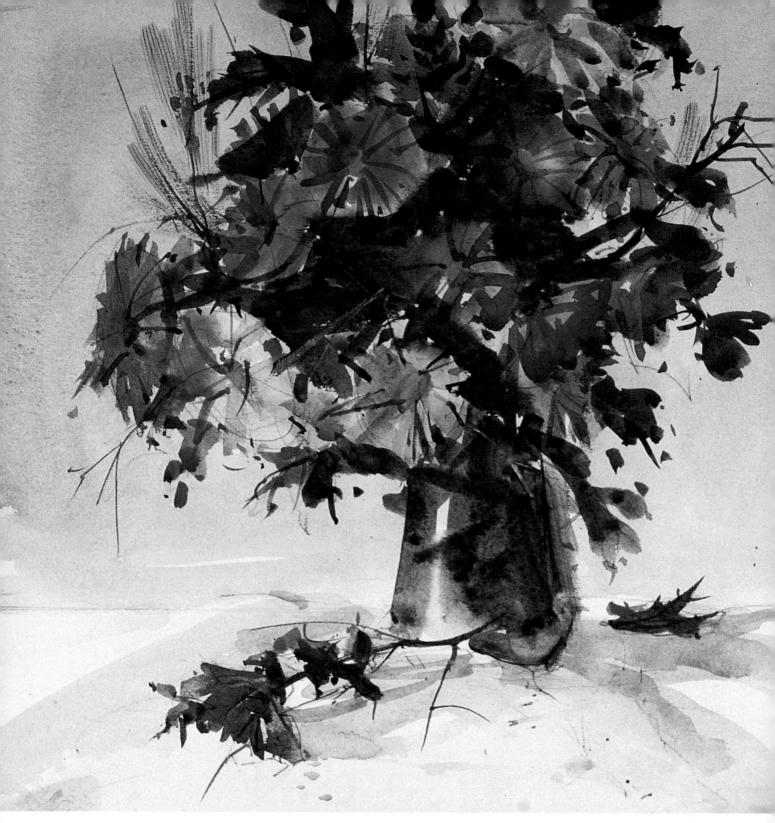

Step 5. Now come the details. Alizarin crimson and Hooker's green make a good dark tone for painting the slender lines that suggest the vase and the petals of the flowers. The artist then uses the same mixture for adding more stems and a few more leaves. You need to look carefully at the picture and add just a few more details, very selectively. The artist adds even

more twigs at the right and left sides of the bouquet and to the stem of the flower on the tabletop. He also adds a fernlike shape at the upper left. All these dark notes are mixtures of Hooker's green and burnt umber or Hooker's green and alizarin crimson. Just a bit of spatter in the immediate foreground suggests some fallen petals or bits of bark from twigs.

PAINTING FLOWERS OUTDOORS

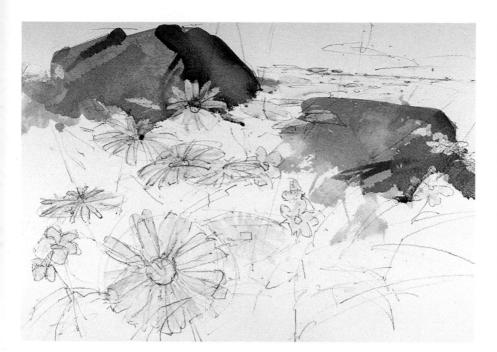

Step 1. Having painted a bouquet of flowers indoors, why not try painting flowers in their natural outdoor setting? This demonstration begins with a fairly precise drawing of the main flower shapes, plus a few simple lines for the rocks and the lighter mass of flowers in the distance. The artist uses a big round brush to paint the rocks with a mixture of alizarin crimson, ultramarine blue, and yellow ochre. He builds up the rock forms with a series of washes, each successive wash getting a bit darker. He brushes liquid masking fluid, or frisket, over the flowers to repel paint and keep the paper white. You'll see why in a minute.

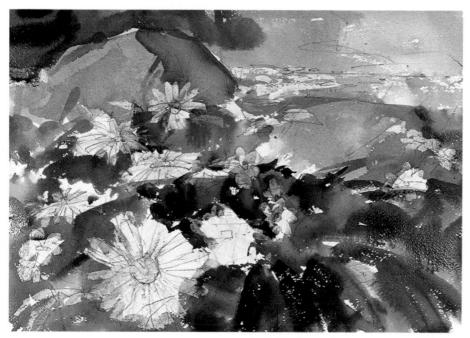

Step 2. Now the whole painting is covered with big, splashy strokes to indicate the large color areas. The lighter greens are mixtures of cadmium yellow, Hooker's green, and burnt sienna. The darker greens arc Hooker's green and burnt umber. The splashes of hot color are mixtures of cadmium orange, cadmium red, and alizarin crimson. Some color runs over the pale shapes of the flowers but doesn't soak into the paper, because these areas have been protected by the dried masking liquid.

PAINTING FLOWERS OUTDOORS

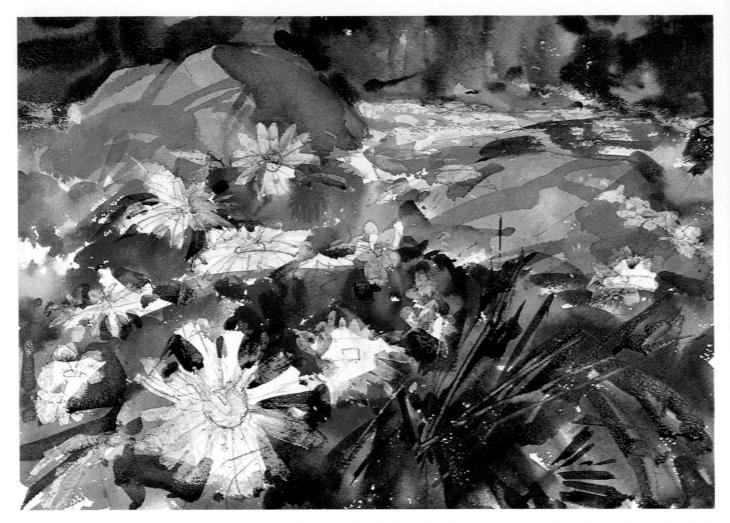

Step 3. The artist darkens the background at the top of the painting with strokes of Hooker's green blended with burnt umber and ultramarine blue. Notice how the various dark strokes overlap and blur together, wet-in-wet. He paints the shadows on the rocks with the same mixture used in Step 1. (So far, everything has been done with a big round brush.) Now the artist does more work in the foreground, where he adds slender, dark strokes with a small round brush to suggest grasses and weeds. You can see these in the lower right, where the dark strokes are a mixture of Hooker's green, burnt umber, and ultramarine blue. While the paint is still damp, the lighter lines in the lower right are scraped in with the tip of the brush handle.

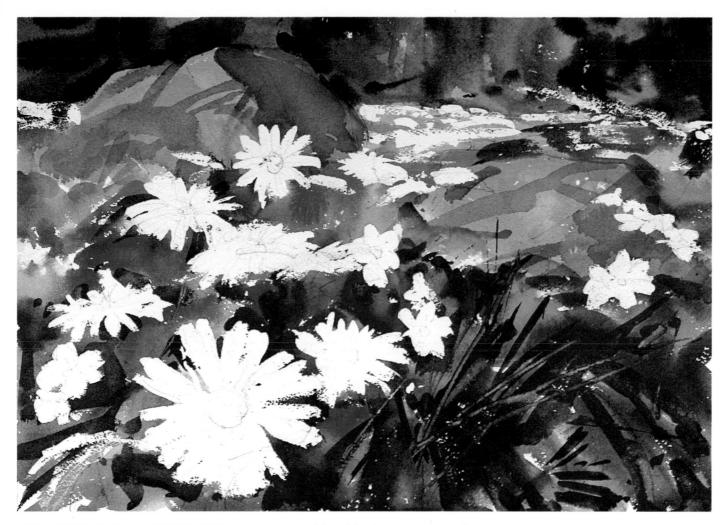

Mixing Greens

You can use green straight from the tube-modified by other colors, as you see in this demonstration-but these are some other color mixtures that make interesting greens.

1. Ultramarine blue and cadmium yellow light.

2. Ultramarine blue and yellow ochre.

3. Cerulean blue and cadmium yellow light.

4. Cerulean blue and yellow ochre.

5. Phthalocyanine blue and cadmium yellow light.

6. Phthalocyanine blue and yellow ochre.

7. Payne's gray and cadmium yellow light.

8. Payne's gray and yellow ochre.

Step 4. Now it's time to remove the dried masking liquid from the flowers in the foreground and from the mass of flowers beyond the rocks. You can peel away the frisket with your fingers; it comes off like a thin sheet of rubber. The flowers are now ready for you to paint.

PAINTING FLOWERS OUTDOORS

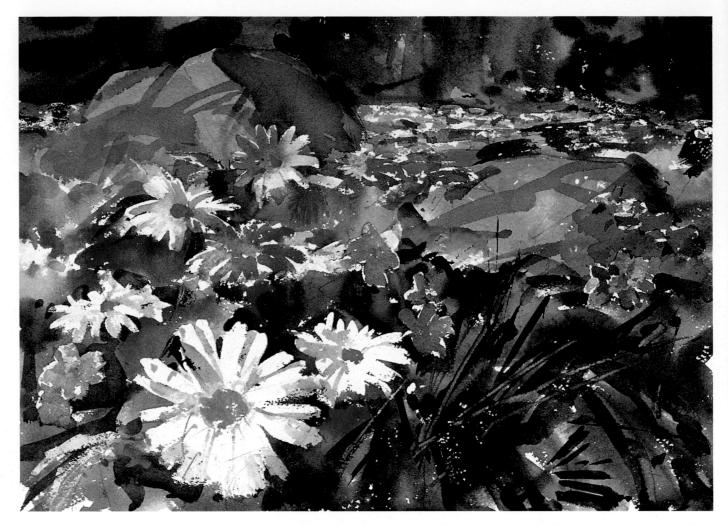

Take Another Look

If you squint at the finished painting, you'll make an interesting discovery: The painting consists mostly of dark, rather subdued washes, and there are really very few bright colors. These bright colors have so much impact precisely because they're surrounded by more somber hues. **Step 5.** The artist paints the violet flowers with a mixture of ultramarine blue and alizarin crimson. The shadows on the white flowers are a very pale mixture of yellow ochre and cerulean blue. The centers of the white flowers are yellow ochre with a touch of cadmium orange and cerulean blue. The brilliant reddish flower just left of center is cadmium red and alizarin crimson. Touches of these mixtures are added to the mass of flowers beyond the rocks.

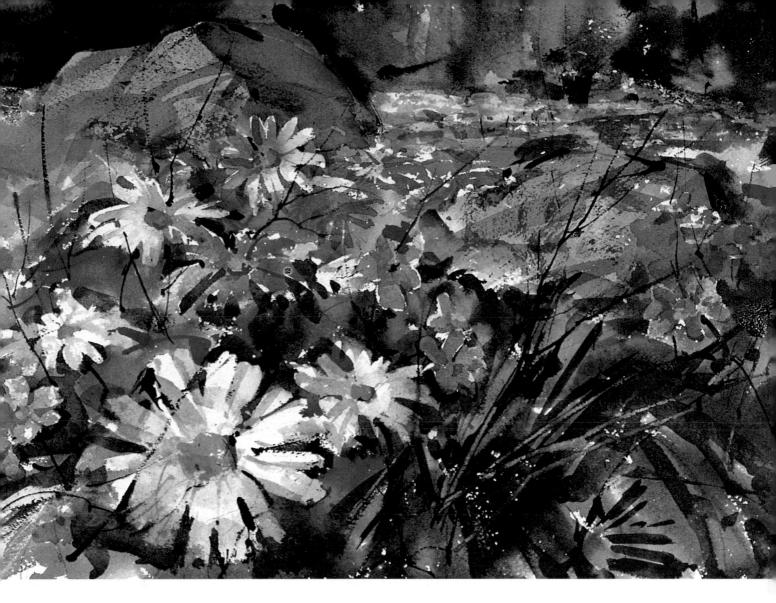

Step 6. The artist washes cool shadows over the flowers in the foreground—a mixture of ultramarine blue, burnt sienna, and yellow ochre. He softens and blurs the edges of some of the white flowers by scrubbing them with a wet bristle brush, then blotting them with a paper towel. You can see this clearly in the smaller white flower at the center of the picture. With a small round brush, the artist adds dark strokes around the nearby flowers to sharpen their shapes—the darks are a mixture of Hooker's green and alizarin crimson. He uses the same mixture to add crisp, slender strokes for blades of grass that stick up through the masses of flowers, particularly in the left side of the painting. The same dark mixture is used to add a few dark strokes to the rocks, and the brush is skimmed lightly over the rocks to add some drybrush textures. For these very slender lines, it's helpful to have a skinny brush called a rigger.

TRY AN OUTDOOR "STILL LIFE"

Step 1. Look for other outdoor "still lifes" like this tree trunk fallen across a stream. The initial pencil drawing defines the shape of the trunk very carefully, indicates a couple of large cracks in the trunk, but simply sug-gests the shapes of the surrounding weeds and the reflection of the trunk in the water. But don't follow pencil lines too carefully when you start to paint. The artist uses a big round brush, painting the background first to define the shape of the tree as precisely as possible. He paints the narrow strip of sky right down to the trunk with Payne's gray and yellow ochre. Before the sky tone dries, he brushes the mass of distant trees in with a mixture of Hooker's green, burnt umber, and Payne's gray. The color beneath the trunk is ultramarine blue and a little burnt umber.

Step 2. Work begins on the top of the trunk, leaving bare paper at the edge and then starting with a *very* pale wash of cerulean blue and burnt sienna. The shadow on the trunk is a darker version of the same mixture, with more blue in some strokes and more brown in others. While the color is still wet, the artist scratches in the white lines with the tip of the brush handle.

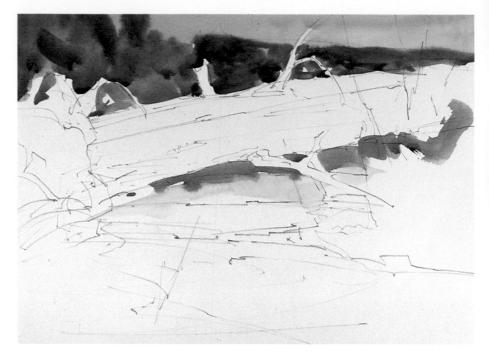

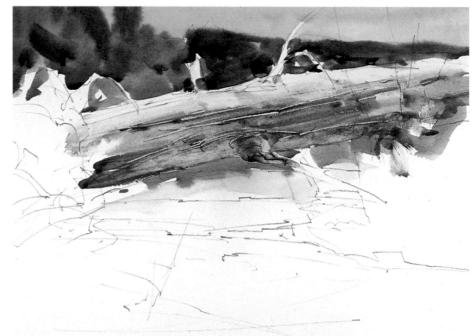

Step 3. The artist uses the big round brush again to paint the base of the tree (at your left) with a dark mixture of alizarin crimson and Hooker's green, plus some extra strokes of cadmium red that melt away into the dark. You can see more scratches made in the wet color by the brush handle. You can also try doing this with your fingernail or with the corner of a discarded plastic credit card.

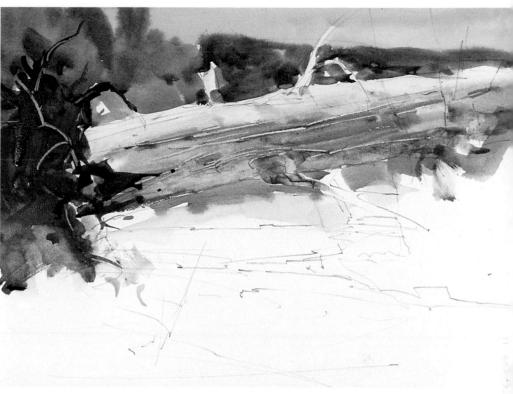

Step 4. The artist paints the masses of weeds to the right with various mixtures of Hooker's green, burnt sienna or burnt umber, Payne's gray, and sometimes a touch of cadmium yellow to brighten the green. You can see that he uses not one uniform mixture, but a number of overlapping strokes of several mixtures. He uses the same mixtures on the left and makes more light scratches into the wet color.

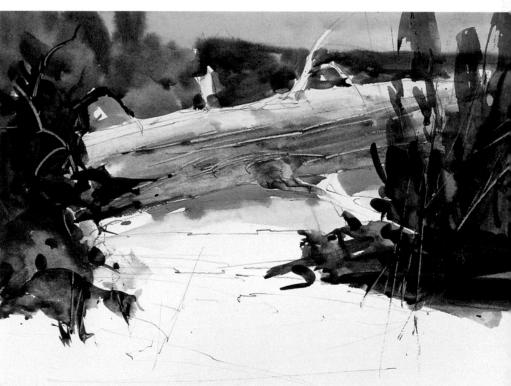

TRY AN OUTDOOR "STILL LIFE"

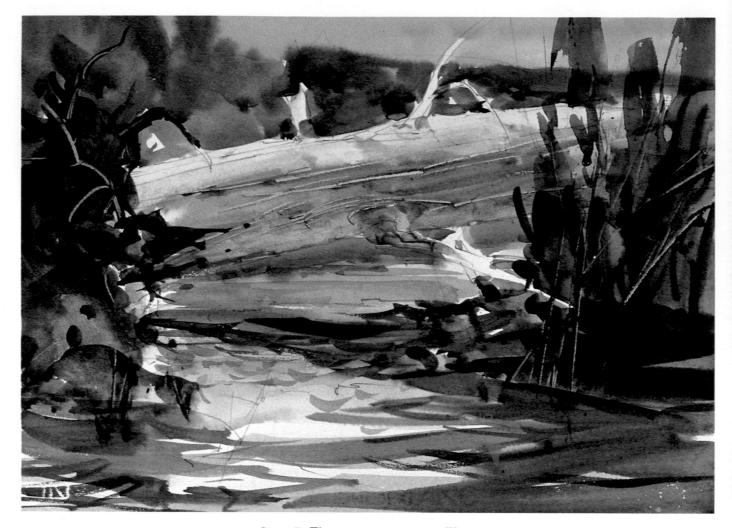

Step 5. The water comes next. First, the artist indicates the general color of the water with streaky strokes of Payne's gray and yellow ochre. Then he paints the dark reflection of the tree with a mixture of burnt sienna and cerulean blue. The other reflections in the foreground are a mixture of Hooker's green, burnt umber, and Payne's gray. He also uses this mixture for the ripples. Note that he leaves a bit of the paper bare to suggest the light on the water.

Mixing Darks

This demonstration has lots of rich darks, but they're all mixtures, not black! Here are some interesting ways to mix darks:

1. Ultramarine blue and burnt sienna – or burnt umber.

2. Phthalocyanine blue and burnt sienna—or burnt umber.

3. Hooker's green and alizarin crimson.

4. Phthalocyanine blue and cadmium red light.

5. Ultramarine blue and cadmium red light.

6. Payne's gray and burnt sienna – or burnt umber.

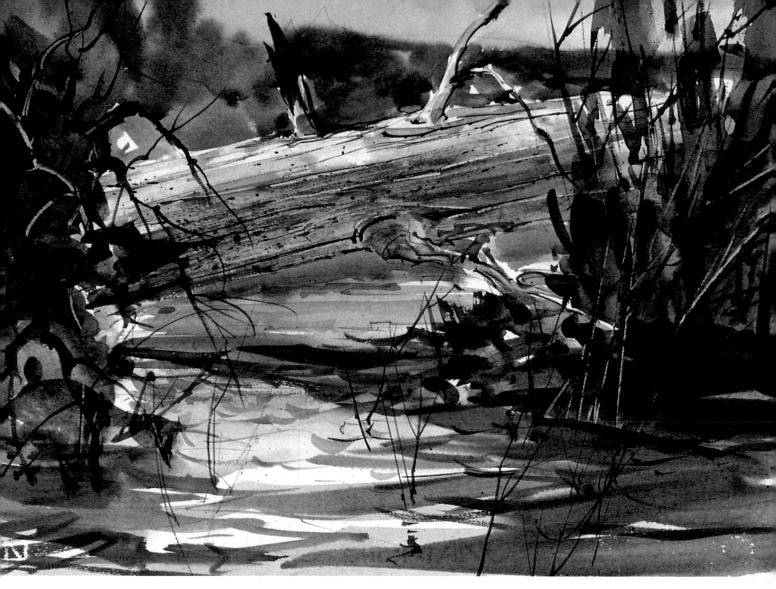

Step 6. Now a small round brush comes into play for the final textures and details. The artist runs drybrush strokes along the tree trunk, and slender lines define cracks and branches more distinctly-these darks are a mixture of alizarin crimson and Hooker's green. He adds twigs at the left, weeds at the right, and more weeds in the water, all with the tip of the brush. (This is another case where the rigger does a particularly good job for those very thin strokes.) Notice other touches, such as the spatter on the tree trunk and the warm notes of cadmium red that he adds to enliven the mass of weeds to the right.

From Drawing to Finished Painting

Compare the finished painting with the pencil drawing in Step 1 just to see where the paint follows the drawing and where it doesn't. The artist has followed the lines of the tree trunk with considerable care. But the drawing does nothing more than indicate the *location* of the masses of weeds and the dark reflection in the water, which are brushed in so freely that the lines of the drawing disappear altogether.

SHOW THE SOFT COLORS OF SPRING

Step 1. In spring, when leaves first appear on the trees, foliage is a delicate green, often with a hint of yellow and the masses of leaves aren't as thick as they will be in midsummer. This spring landscape begins with a very simple pencil drawing that just indicates the general direction of the tree trunks and the overall shapes of the leafy masses. A large round brush covers the sky with a wash of yellow ochre. Ultramarine blue is painted in while this wash is still wet.

Step 2. The artist uses the same brush to paint the distant hills with a mixture of ultramarine blue and alizarin crimson. You can see that the individual strokes vary in color: Some have more blue and some more crimson. The brushwork is rough because the hills will be partially covered by a mass of trees in the next step.

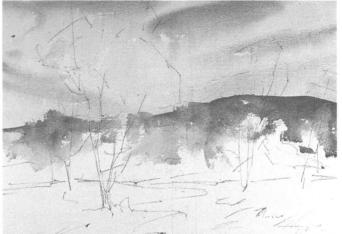

Step 3. Now the artist adds the foliage in the middle distance with a big round brush. The strokes are mixtures of cadmium yellow, Hooker's green, and cerulean blue. In many of the strokes, the yellow is allowed to dominate. And the strokes are applied over and into one another, fusing wet-in-wet. He adds the grass in the foreground with a big round brush—the strokes are again mixtures of cadmium yellow, Hooker's green, and cerulean blue. Notice that he's added a dark shadow beneath the pencil lines of the tree on the left. In contrast with the short vertical and diagonal strokes used to suggest the trees, the meadow is suggested mainly with long horizontal strokes.

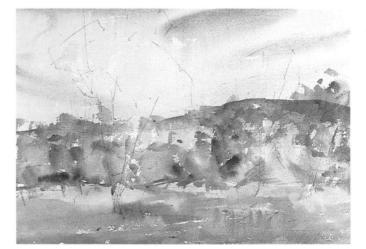

Step 4. The artist uses the small round brush to indicate some tree trunks and branches with a dark mixture of alizarin crimson and Hooker's green. Never try to render every branch and twig. Just pick out a few. This dark tone could also be a mixture of burnt sienna and ultramarine blue, if you'd like to try that instead.

Step 5. The side of the same brush is used to drybrush the first foliage with a mixture of Hooker's green and cerulean blue, with just a hint of cadmium yellow. Working with the side of the brush, rather than the tip, you can make short, ragged strokes that are broken up by the texture of the paper, suggesting masses of leaves with patches of sky breaking through. The same method is used to drybrush a shadow under the larger tree.

Mixing Color on the Paper

You can mix colors on the paper if you brush one wet color into another as the artist has done in this demonstration:

1. He painted the sky by brushing ultramarine blue over a wet wash of yellow ochre.

2. The hill strokes are various blends of ultramarine blue and alizarin crimson—sometimes redder and sometimes bluer brushed side by side so they blend together.

3. The tree strokes are various blends of cadmium yellow, Hooker's green, and cerulean blue – no two strokes exactly alike – brushed into one another so they merge, wet-in-wet.

4. He painted the grass by brushing the darker tones into the lighter—still wet—undertone.

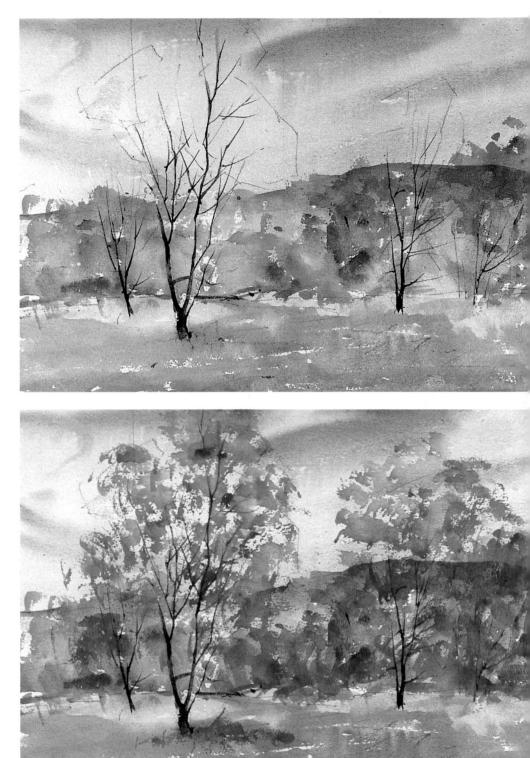

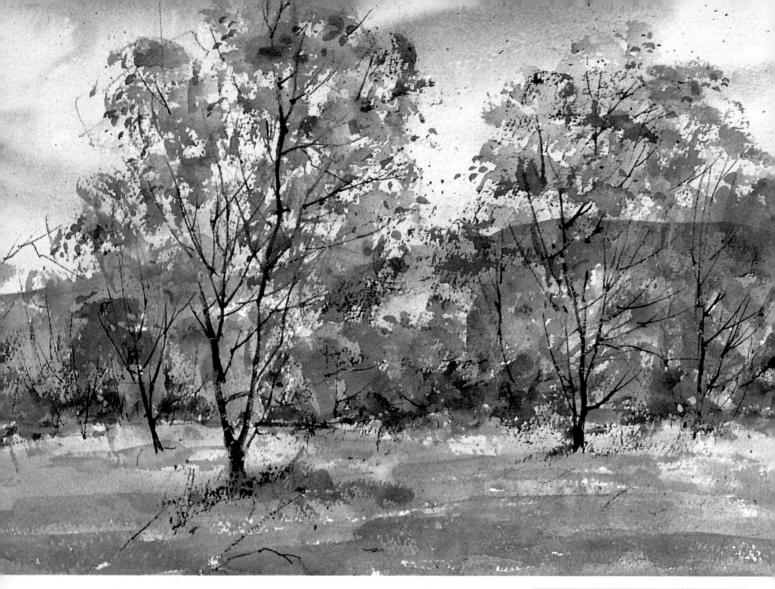

Step 6. Going back to a big round brush, the artist completes the painting mainly with drybrush strokes – mixtures of ultramarine blue, cadmium yellow, and Hooker's green. He adds some darker patches to the trees in the foreground, suggesting shadow areas on the masses of leaves. He also suggests shadows on the mass of trees in the middle distance, particularly along the lower edge and at the base of the tree on the right. Notice how he's darkened the shadow beneath the tree on the left, too. He adds darker horizontal strokes to the meadow, so there's now a gradation from dark green in the foreground to a lighter tone in the middle distance. Notice how he allows bits of paper to show through the strokes on the ground, suggesting patches of sunlight. He spatters some of the dark green mixture and a bit of cadmium yellow among the trees and uses a rigger to add some more branches.

Let's Review the Steps:

1. The artist paints the picture from top to bottom, starting with the sky.

2. He also paints the picture from background to foreground: sky, distant hills, trees in the middle distance, foreground trees.

3. The artist works from light to dark: light sky, darker hills, still darker trees in the middle distance, darkest trees in the foreground.

4. Big, broad brushwork comes first, and smallest strokes come last.

PAINTING THE RICH COLORS OF SUMMER

Step 1. In midsummer, trees are in full leaf and foliage tends to be darker and denser. Once again, this landscape begins with a very simple drawing, just suggesting the placement of the tree trunks, the leafy masses, some foreground shadows, and the shapes of the hills. The sky begins with a few strokes of a very pale yellow ochre, quickly followed by strokes of cerulean blue that fuse softly into the yellow. The strokes of the distant hills are mixtures of cerulean blue and cadmium orange.

Step 2. The artist paints the foreground with a mixture of cadmium yellow, Hooker's green, cerulean blue, and an occasional hint of cadmium orange. He uses the same mixtures for the green patches between the trees in the middle distance, but with a bit more blue and green in the strokes. The patches of color between the trees are brushed in very freely, paying little attention to their exact shapes, since a great deal of the middle distance will be covered by the bigger, darker shapes of the trees.

Step 3. With the big round brush, the artist paints the darker patches in the middle distance with a mixture of Hooker's green and cerulean blue. (You could actually use a small round brush at this point, but it's always best to use the biggest brush you can handle, since this forces you to work boldly.) The big masses of the foreground trees are brushed in with a blend of Hooker's green, cadmium yellow, and burnt sienna. The darkest strokes contain more burnt sienna. The strokes are brushed over and into one another, so they tend to fuse wet-in-wet. Along the edges of the trees, the artist uses the *side* of the brush so that the drybrush effect suggests leafy edges. He dampens his brush and uses a stroke of water to soften the transition where the leafy masses touch the ground.

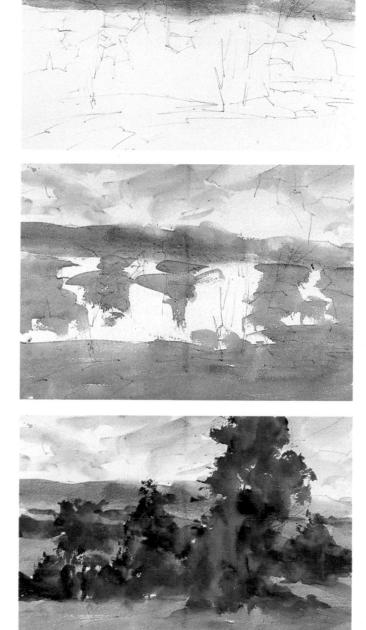

PAINTING THE RICH COLORS OF SUMMER

Step 4. The artist uses a mixture of Hooker's green and burnt umber to darken the foliage. He creates shadow areas among the leafy masses. He also suggests where the trunk of the largest tree will be and where a shadow will appear beneath it. With a small round brush, he adds a few dark flecks around the edges of the trees to suggest more leaves.

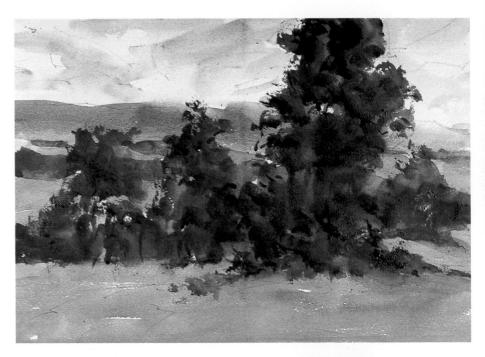

Step 5. The artist paints the tree shadows in the foreground with a mixture of Hooker's green and burnt sienna. The strokes curve slightly, suggesting the curve of the meadow. He leaves gaps for the wash from Step 2 to show through to create the sunlit patches.

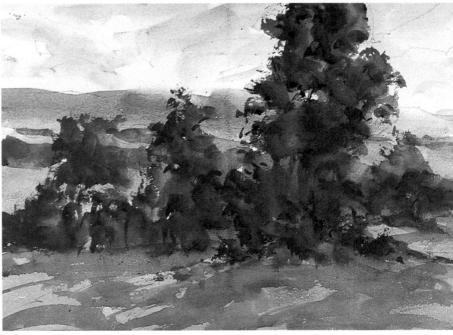

Hard and Soft Edges

Try to vary the edges of your shapes; make some edges softer than others. See how the technique was used here:

1. The edge of the distant hill starts out hard at the left, but is softened by a touch of clear water toward the center.

2. The sky shapes are sometimes soft—where two wet strokes meet—and sometimes hard.

3. The artist softens the edges of the trees at various points by touches of drybrush.

4. A damp brush softened the lower edges of the trees where they meet the meadow.

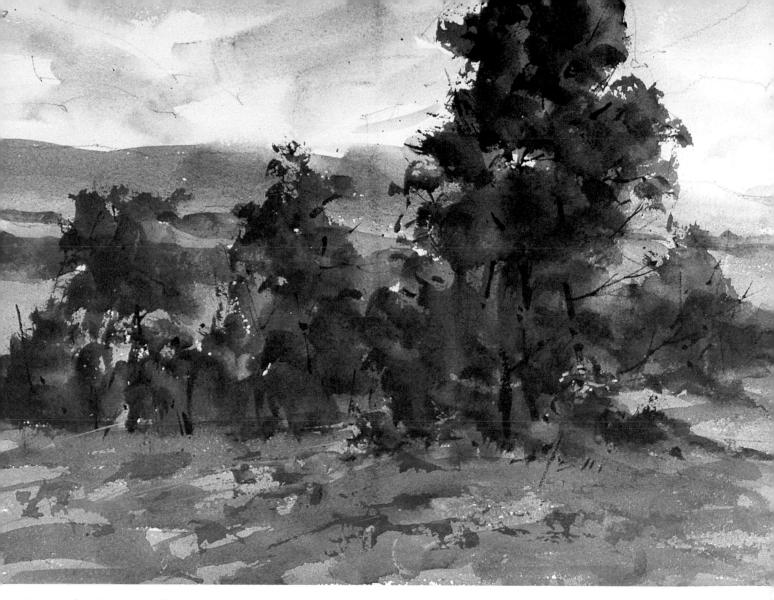

Step 6. As always, details are saved for the very end. The artist uses a small round brush to indicate trunks and branches among the trees. He adds more dark strokes to the foreground while reinforcing the shadow under the largest tree with some dark strokes, too. He adds tiny flecks of cadmium yellow to the grass and around the base of the largest tree. They're very unobtrusive, but they do make the painting look just a bit sunnier. This painting is a particularly good example of how few strokes you need to paint a convincing landscape. The trees consist almost entirely of large masses of color with just a few touches of a small brush to suggest trunk and branches. By the way, did you notice that the pencil lines in the sky haven't been erased? You can leave them there if you like, or you can take them out with a kneaded (putty rubber) eraser. But wait until the painting is absolutely dry, or even this very soft eraser will abrade the surface.

MAKE AUTUMN COLORS VIVID

Step 1. The hot colors of autumn trees look even richer if they're placed against a very subdued back-ground, such as a gray or overcast sky. So this autumn scene begins with a sky of Payne's gray, warmed with a bit of yellow ochre. The artist brushes the sky tone right over the pencil drawing, which will later disappear under masses of color. The distant hills are cerulean blue and a bit of cadmium red. A big sky like this can be painted quickly with a large flat brush *or* with a large round brush.

Step 2. The artist paints the mass of foliage in the middle distance with short strokes of a big round brush. The strokes are mixtures of cadmium orange, Hooker's green, and burnt sienna. The darker strokes contain more burnt sienna, and the hotter colors contain more cadmium orange.

Tips for Painting Autumn Colors

1. Don't paint everything bright orange, red, and yellow.

2. Look for more subtle colors amid all the brilliant hues – browns, mauves, olives – or *invent* them!

3. Create a cool setting for all those hot colors: a blue or gray sky, green trees in the distance, blue or violet hills.

4. Punctuate the hot colors with cool notes for variety: some evergreens or just some greenish tones among the foliage, as you see here.

5. Place your brightest colors at the center of interest – not throughout the picture.

Step 3. Now the artist loosely paints the colorful masses of foliage with the short strokes of a big round brush. He uses various mixtures of cadmium yellow, yellow ochre, cadmium orange, Hooker's green, and burnt umber – never more than two or three colors in any mixture. The wet strokes tend to blur into each other. And he uses the side of the brush to create a drybrush effect that suggests leaves. He leaves gaps between the strokes to let patches of sky break through.

Step 4. The artist adds the darks of the tree trunks and the rocks at the left with a small round brush, carrying a blend of alizarin crimson, Hooker's green, and just a touch of cadmium red. Observe how the trunks of the larger trees to the left are painted with short strokes, so that the trunks are often concealed by the masses of leaves. The color on the rocks is rather thick—not too much water so the strokes have a drybrush feeling that suggests the rough texture of the rocks.

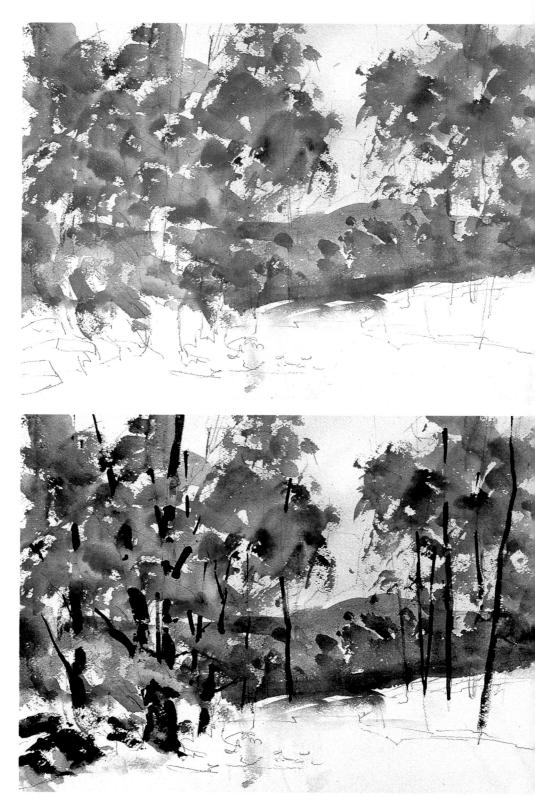

MAKE AUTUMN COLORS VIVID

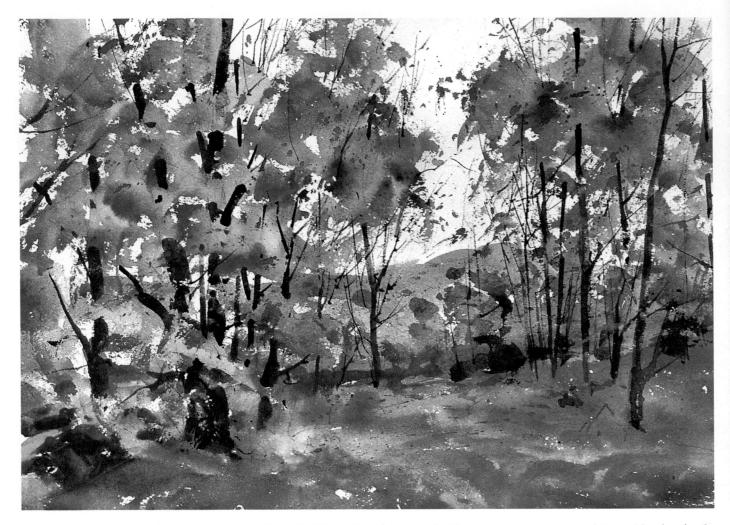

Step 5. The artist picks up his big round brush again to paint the foreground with various mixtures of cadmium orange, cadmium red, alizarin crimson, and Hooker's green—never more than two or three colors to a given mixture. The darks suggesting shadows on the ground contain more Hooker's green. The strokes blend into one another, wet-in-wet, and curve slightly to suggest the contour of the ground. To suggest individual leaves—some of them blowing in the autumn wind—the artist spatters a mixture of cadmium orange, cadmium red, and Hooker's green over the upper part of the picture with a small round brush. He adds more trunks and branches with the tip of a small brush and a mixture of alizarin crimson, cadmium red, and Hooker's green, which makes a very rich dark. The tiniest branches can be done with a rigger.

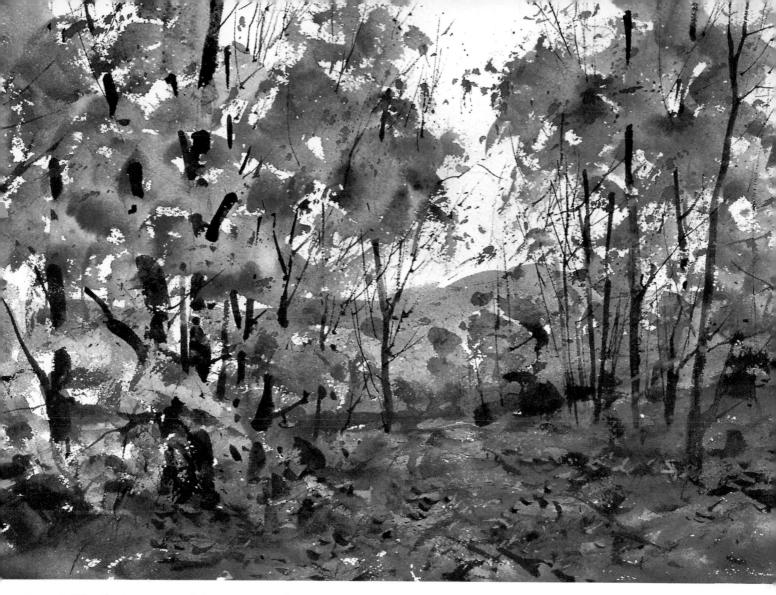

Step 6. The lively texture of the fallen leaves on the ground is suggested by drybrush strokes, made with the side of a small round brush and a mixture of alizarin crimson and Hooker's green. The artist adds more touches of this mixture with the tip of his small brush. While the paint on the ground is still damp, he scratches some lighter areas in with the tip of the brush handle or a slender, blunt knife. If you look carefully at the ground area, all you'll see is a mass of rough brushwork and a few tiny

strokes made with the tip of the brush. You don't really see any fallen leaves, but the brushwork makes you *think* you see them. Detail is suggested, never painted methodically. And look carefully at those hot autumn colors. They're not nearly as red and orange as you might think. If the whole painting were just red and orange, you'd find it terribly monotonous. You need that gray sky and those cool hints of green for relief. Besides, they make the warm colors look warmer by contrast.

INTERPRETING WINTER'S SUBTLE COLORS

Step 1. The pale tones of a snowy landscape often contrast dramatically with the dark, overcast skies of winter. The preliminary pencil drawing quickly indicates the shape of the main tree, the location of a few other trees, the shadows in the foreground, and the placement of the horizon. The dramatic cloud shapes aren't drawn in pencil, but just painted wet-in-wet. The sky begins with a pale wash of burnt sienna over the entire sky area. While this is still wet, the darker tones are brushed in-a mixture of ultramarine blue, burnt umber, and Payne's gray.

Step 2. When the sky tone is dry, the artist paints the strip of landscape along the horizon with a mixture of cerulean blue and burnt umber, using a small round brush. At the center of the horizon, you can see how he's used a brush filled just with water to soften the dark edge to create a more atmospheric feeling.

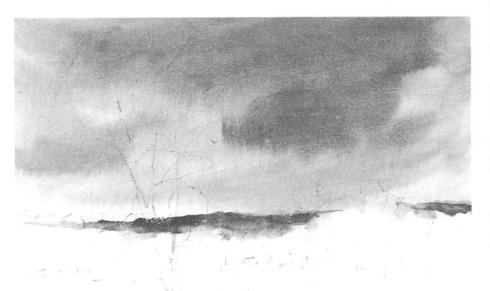

Step 3. With a blend of Hooker's green, burnt umber, and Payne's gray, the artist paints the trees in the middle distance with a small round brush. The color is a bit thick – not too much water – so the paint isn't too fluid and goes on with a slightly drybrush feeling. While the color is still wet, the tip of the brush handle scratches in some lighter lines for tree trunks. Along the lower edge of this color area, the artist uses the side of the brush to create an irregular drybrush texture.

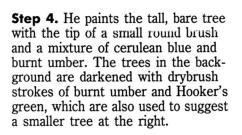

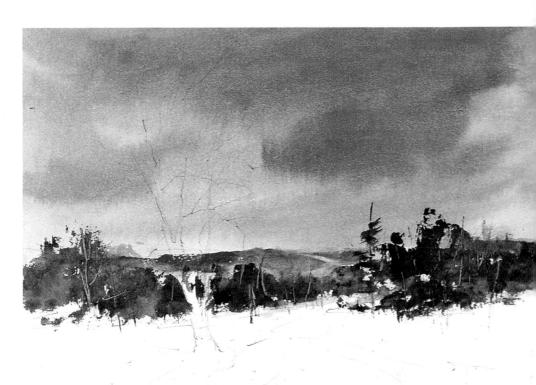

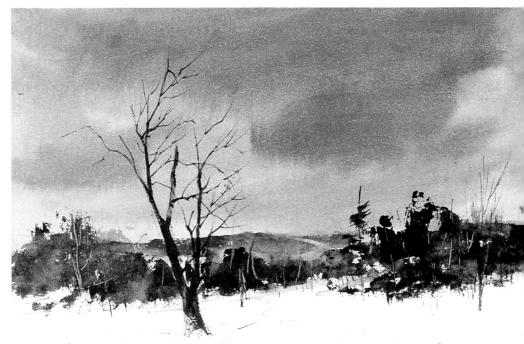

INTERPRETING WINTER'S SUBTLE COLORS

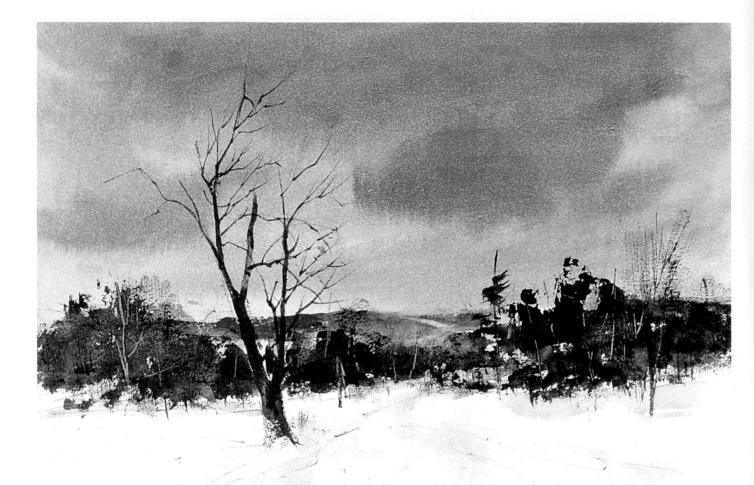

Step 5. The artist creates variations in the color of the snow with a large round brush and very pale mixtures of cerulean blue and burnt sienna. While these strokes are still wet, he softens some of them with clear water. Thus, some of the strokes have sharp, distinct edges, while others have soft edges. This mixture is also used to indicate some pale shadows under the distant trees. Here and there, these strokes are lightened with a quick touch of the paper towel.

Vary the Brushwork in Your Paintings

1. The artist paints the sky wet-inwet: light strokes first; dark strokes over the light strokes.

2. He paints the distant hills with irregular strokes of varied density, one stroke blending into another.

3. He paints the mass of trees in the middle ground with dark, thick color, producing a drybrush feeling at the edges.

4. He paints the big tree at the center of interest with fluid color and crisp, rhythmic strokes.

5. He paints the foliage of the smaller tree at the right with dry-brush strokes.

6. He paints the snow with fluid color, sometimes lightened with strokes of clear water or a touch of a paper towel.

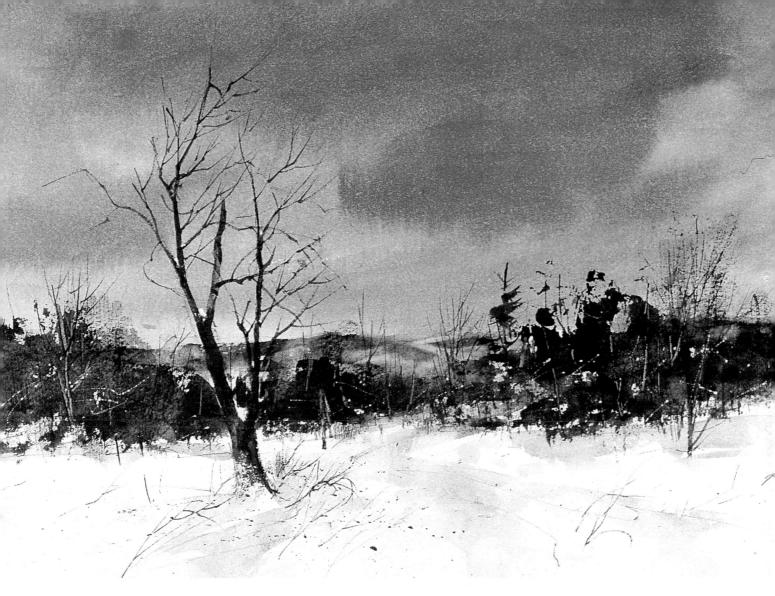

Step 6. The artist adds the finishing touches with the tip of a small round brush. More branches appear at the tops of the trees along the horizon and on the big tree just left of center. He uses a wet bristle brush to scrub out some color on the distant hills, suggesting that light is falling on them. He then blots up the wet color with a paper towel. He uses the corner of a sharp blade to scratch out a few whites on the main tree trunk, suggesting snow caught among the branches. The point of the smallest brush (or a rigger) can be used to suggest the slender lines of the dead weeds that break through the snow

in the foreground. To indicate a few fallen leaves, blown by the wind, the artist uses a small round brush to spatter some dark specks across the foreground. These darks are all mixtures of burnt sienna and cerulean blue. This winter landscape is a good example of how much color you can suggest with subdued tones. The grayish sky is actually full of warm and cool color. The snow isn't a dead white, but also contains very delicate warm and cool notes. And the dark notes contain no black at all-they're actually mixtures of much brighter colors. Thus, even the darkest strokes have a hint of color.

SOME TECHNICAL TRICKS

Scratching Wet Color. When your color is just past the sopping-wet stage-still moist, but beginning to settle into the paper-you can make a light line by pushing the color aside with some blunt tool such as the corner of a plastic credit card, the rounded blade of a butter knife, or the tip of your brush handle (if it's not too sharp). Don't dig in and actually scratch the paper. The trick is to press the blunt tool against the paper and push aside the wet color the way you'd scrape butter off a slice of bread. That's how the artist made the pale lines of the weedy foreground in this landscape. Then he added the dark strokes to suggest light and shadow on the weeds.

Scraping Dry Color. Once your color is bone dry, you can try another way to make lighter passages. The foam in this turbulent stream was produced by scraping away dry color with a razor blade. The blade skimmed lightly over the paper, just hitting the high points of the "tooth," thus creating light flecks that look like churning foam. The artist didn't scrape down to the bare paper, but left just enough color to surround the pale flecks. The lightstruck branch—jutting up from the fallen trunk-was also scratched out of the dry color with a razor blade. For the foam, the artist used the whole edge of the blade to shave away the paper surface; but for the branch, he used the sharp corner of the blade.

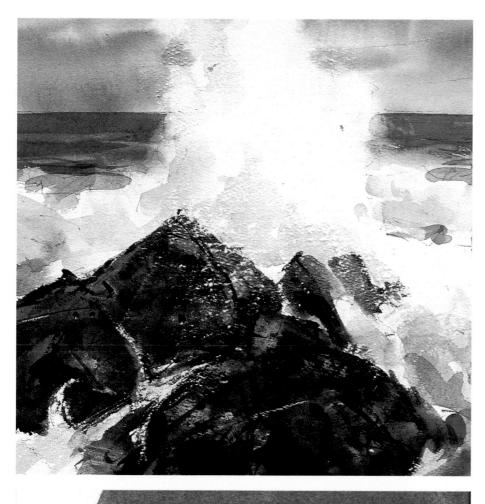

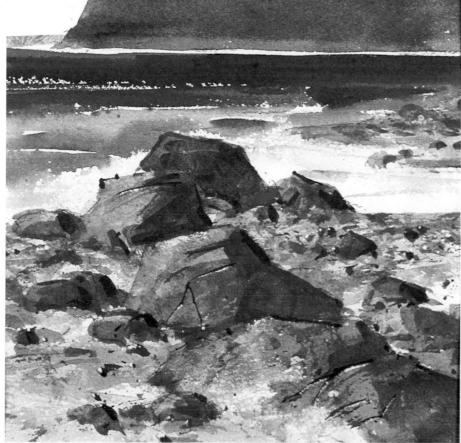

Scraping and Scratching. Here's an even more dramatic example of scraping and scratching. Once the rocks were absolutely dry-you mustn't do this if there's even a hint of moisture in the paper-a knife blade traveled lightly over the darks of the rocks and over the lighter tones of the foam. As the blade shaved away the surface of the paper, flecks of bare white emerged to suggest flying foam and the texture of the rock formation. Then the sharp tip of the blade scraped away some ragged white lines to suggest foam trickling between the rocks, plus cracks in the rocks themselves. You can also try this technique with sandpaper or an emery board. But don't paint over the abraded area, or it will turn dark and murky. Save the scraping and scratching operation for the very end.

Combining Scratching with

Brushwork. The cracks in these rocks are an interesting combination of knife and brushwork. The brush drew dark lines to suggest the dark shadows within the cracks. These strokes were allowed to dry. Then the tip of a knife blade (or the corner of a razor blade) scratched white lines beside the brushstrokes to suggest light hitting the edges of the cracks. These scratching and scraping techniques are useful because it's so difficult to make a light line surrounded by darker color. Because watercolor is transparent, you can't paint the dark area first and then paint the light line over it. You have to paint the dark color around the light line – or you can paint the dark area and make the light line with a sharp tool, as you see here.

ANALYZING LIGHTING

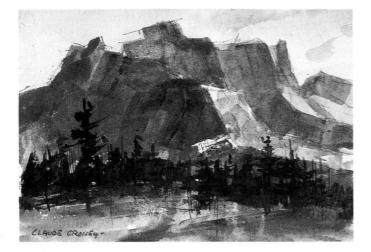

Identifying Light Direction. The direction of light determines the shapes of the light and shadow planes, so it's important to identify the light direction when you paint any outdoor subject. In this sketch for the mountain demonstration you saw earlier, the artist clearly determines that the light is coming from the right, creating planes of bright sunlight on the right sides of the cliffs and planes of deep shadow on the left sides.

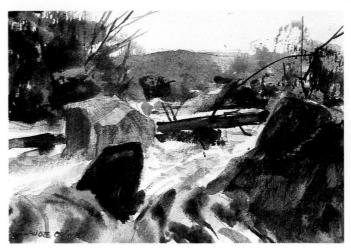

More Complex Lighting. This sketch (for the stream demonstration) analyzes a more complex effect. The light falls from *above*, striking the horizontal top planes of the pale rock and the fallen tree, but leaving the side planes in shadow. However, the light is also *behind* the foreground rocks, so we see their shadowy side planes, with only the slightest hint of light on their tops.

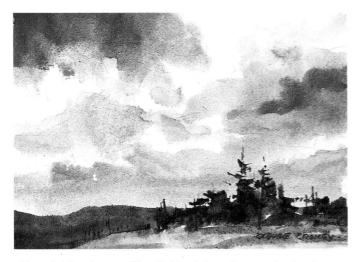

Cloud Shadows. The light of the sky can be broken up by the clouds that pass over the sun and cast shadows on the land below. This sky has clear breaks between the clouds, through which the sun illuminates the bright patches of the landscape. But the clouds throw their shadows on the darker land masses at the horizon. You can use such lights and shadows creatively to dramatize your landscapes.

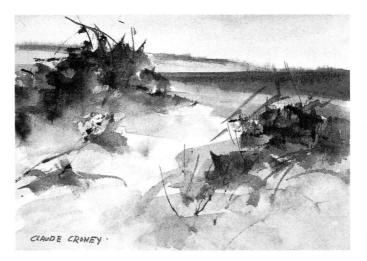

Lights and Shadows on Soft Forms. It may be a bit harder to see the lights and shadows—and to analyze the light direction—when you're painting softer forms such as dunes or snowbanks. In this sketch, the artist sees the light coming from the distance, *behind* the dunes, which are mainly in shadow. But the light breaks through the gap between the dunes, illuminating the valley between the two higher shapes.

UNDERSTANDING AERIAL PERSPECTIVE

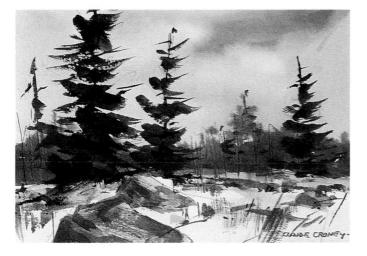

Dark Foreground, Pale Distance. When you paint landscapes and coastal subjects, pay particular attention to aerial perspective, which is the phenomenon that you see here. Notice that the nearby evergreens are darker and more sharply defined than the more distant shapes, which are paler and less detailed—as well as smaller.

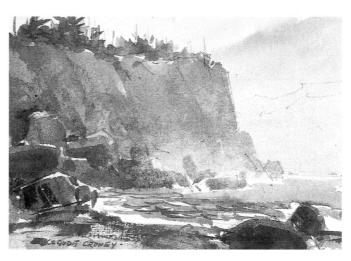

Atmosphere Creates Distance. In this sketch for another demonstration, the artist has studied the effect of aerial perspective on the main shape in his picture. As the headland moves away into the distance, it seems to melt into the atmosphere, growing paler and less distinct. In contrast, the nearby rocks are darker and have stronger contrasts of light and shadow. Remember that contrast also diminishes with distance.

Brighter Foreground, Subdued Background. This study for the meadow demonstration shows how the colors in the foreground are brighter than the colors in the distance—another important factor in aerial perspective. Typically, the foreground also contains greater detail. You can exaggerate these effects to focus the viewer's attention on your center of interest.

Selective Focus. Still another effect of aerial perspective is what photographers call *selective focus*. In this color sketch for the snow demonstration, the artist notes that the forms in the foreground—the trees, the edges of the rocks, most edges of the frozen stream—are sharply defined. However, the trees at the horizon are blurry and indistinct. You can emphasize selective focus by painting distant objects wet-in-wet, as the artist does here.

IMPROVING YOUR COMPOSITION

Place Focal Point Off-Center. The center of interest in this landscape – the silhouette of the dark tree – is *not* placed at the midpoint of the composition, but about one-third in from the right-hand side. A dead-center placement is a bore. That's why so many great landscapes have the focal point just a bit off-center. And if you're in doubt, try dividing your picture into thirds and placing your focal point one-third in from the right *or* the left.

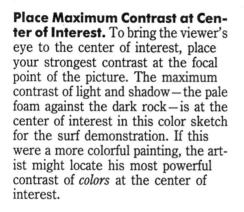

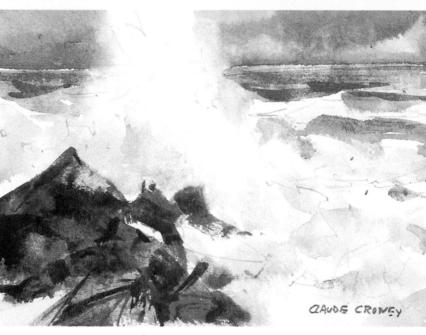

Place Maximum Detail at Center

of Interest. Another way to carry the viewer's eye to the focal point of the picture is to concentrate the greatest amount of detail at the center of interest. This sketch—for the dune demonstration—places all the complex brushwork of the beach grass at the tops of the dunes. Some strokes suggest beach grass in the foreground, but they're scattered and don't compete. Note that the tops of the dunes are also the point of greatest *dark-and-light* contrast.

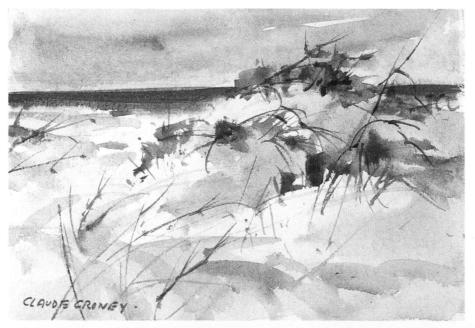

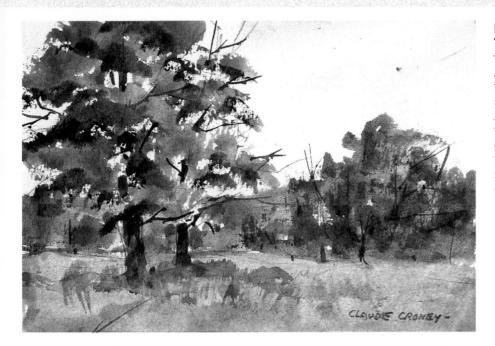

Place Horizon Line Below Center.

The horizon line of this landscape is well below the center of the picture. And the big tree is off-center, too. So the artist avoids a composition that's symmetrical in any possible way. Asymmetrical compositions are always more interesting than symmetrical ones. Try to visualize how dull this composition would be if the horizon line and the big tree were both dead center, creating a bull's eye.

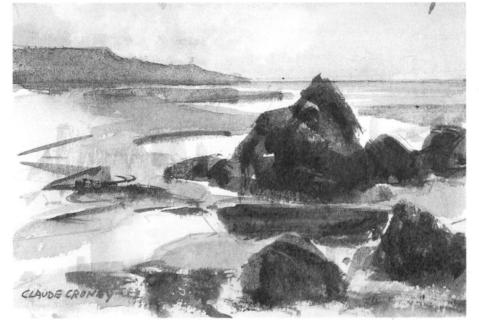

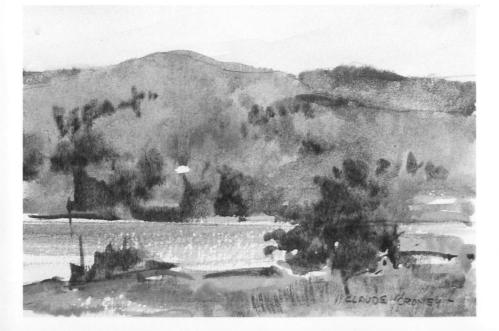

Place Horizon Line Above

Center. In this seascape – a sketch for the rocky shore demonstration you saw earlier – the horizon line is *above* the center line, which can be just as effective as a low horizon. Once again, the maximum contrast is at the center of interest, where the dark rocks meet the bright water behind them. And notice how the design of the tide pools is a kind of path that leads the eye to the focal point. As you paint, look for motifs that create a pathway for the eye.

Divide Picture Into Uneven

Shapes. Like so many landscapes and seascapes, this composition divides naturally into horizontal bands that represent sky, distant landscape, water, and nearby landscape. But the essential point is that no two bands are exactly the same thickness from top to bottom. The sky is a shallower band than the hills. The water is an even thinner band than the sky or the hills. And the foreground land is the thinnest band of all. This landscape would be deadly if all four bands were the same, but instead, the artist divides his picture into uneven shapes.

HOW THE THREE-VALUE SYSTEM WORKS

Value Analysis of Mountain

Demonstration. When you plan a landscape or a seascape, it's helpful to visualize the picture in three distinct values-three different degrees of lightness and darkness, plus a fourth for the sky. Decide which is the darkest tone, which is the middletone, and which is the lightest area. In this value sketch of the mountain demonstration, the trees are certainly the dark; the foreground and the shadows on the mountains are both the same middletone: and the flash of sunlight on the mountainside is the light. The sky is about midway between the light and the middletone.

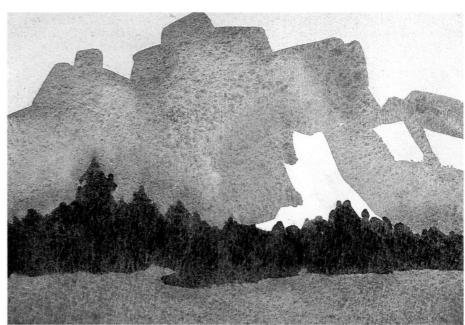

Value Analysis of Summer

Demonstration. Now the darkest value is the mass of shadowy trees; the middletone appears in the immediate foreground and again in the distant landscape; and the light appears in a shallow, sunlit band just behind the trees. The irregular tone of the sky is lighter than the middletone but darker than the light. These sketches are made with just two colors, by the way: ultramarine blue and burnt sienna. This combination of one cool color and one warm color is ideal for value studies—and especially for quick sketches on location.

Value Analysis of Tidepools

Demonstration. This sketch reveals a particularly elegant pictorial design in which the rocks and their reflections are the dark; the sand and the distant headland merge into a middletone; and the reflective tidepools are the light. The sky is somewhere between the light and the middletone. No matter how colorful the final painting will be, it's always helpful to start out with a value sketch.

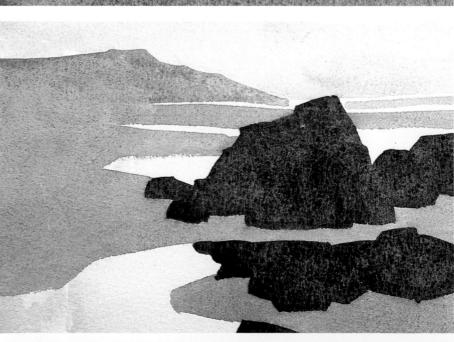

LANDSCAPE SUBJECTS

67

SELECTING LANDSCAPE SUBJECTS

Be Decisive. Beginning landscape painters often spend hours wandering about, trying to discover the "perfect' landscape subject. By the time they find it-if they ever do-they're exhausted, and the painting day is half over. Given just so much time and energy, you'll produce a far better painting if you invest that time and energy in painting the first reasonably promising subject, even if it's not "perfect." In reality, nature almost never gives you a perfect picture, anyhow. The professional painter knows this and always settles for an "imperfect" subject, which he transforms into a picture by moving around the trees, leaving out the smaller clouds, and adding some rocks that aren't even in the picture. So don't waste more than ten or fifteen minutes looking for your subject. As soon as you see something that *might* make a good painting, go to work.

Find Your Focal Point. Often. the simplest way to select a subject is to find some particular landscape element that appeals to you. It may just be an old tree, a few jagged rocks, a winding stream, or a hill against the sky. This motif isn't a picture in itself, but simply your center of interest, around which you build a picture. Once you've got your focal point or your center of interest, then you can orchestrate your picture around it. It's like writing a play around some famous performer. Now that you've got your star, you're ready to bring in the supporting cast. That old tree is probably surrounded by other trees, plus some grass, weeds, or rocks. You can now assemble a certain number of these around your center of interest to create a satisfying picture. In the same way, the dramatic shape of that hill against the sky isn't a picture in itself, but becomes the focal point of

a picture when you include some surrounding hills, some trees in the foreground, and some sky above. Selecting the center of interest is just the *beginning*—but it's a good way to get started.

Contrast or Conflict. Another way to discover a subject is not to look for a single motif such as a tree or a hill, but to find some contrast or conflict within the landscape. You may just be intrigued by the contrast of dark trees against the white snow of a winter landscape: the clumsy, blocky forms of a rock formation amid the slender. graceful forms of weeds and wildflowers in a meadow; the long, low lines of the plains contrasting with the round, billowing forms of the clouds above. Of course, having found your subject, you still have to decide on your center of interest, so your painting has some focal point. Which are the biggest trees, rocks, or clouds, or the ones with the most interesting shapes? If you can't find a center of interest ready-made, you'll have to create one by making it bigger or by exaggerating its odd shape.

Watch the Light. From dawn to dusk, the sun keeps moving, which means that the direction of the light keeps changing. At one moment, a subject may seem hopelessly dull. But an hour later, the light is coming from a slightly different direction, and that subject is transformed. At noon, those trees, rocks, or hills may not impress you at all because the sun is high in the sky, producing a bright, even light, with very few dramatic shadows. But in the late afternoon, with the sun low in the sky, creating strong shadows and interesting silhouettes, those dull trees, rocks, or hills may take on unexpected drama. Conversely, the delicate colors of those wildflowers may

look brightest at midday and lose their fascination in late afternoon. So the key to finding a subject may be watching for the right time of day and the right light effect.

Keep It Simple. Knowing what to leave out (or take out) is just as important as deciding what to put into a painting. Nature offers you an infinite amount of detail, and it's tempting to try to load it all into the picture. But you can't include everything. It makes the job of painting much harder and bewilders the viewer. Besides, watercolor doesn't lend itself to rendering a great deal of precise detail. Watercolor is a broad medium, and it's best for painting simple forms with broad strokes. So don't try to paint every tree trunk, branch, twig, and leaf in the forest. Pick out a few trunks and a few branches; try to paint the leaves as large masses of color. Don't try to paint every cloud in the sky, like a vast flock of sheep, but focus on a few large shapes, even if it means merging several small clouds into a big oneand simply leaving out a lot of others. Pick out a few large rocks for your center of interest, then include some smaller ones to make the big ones look bigger by contrast.

Using a Viewfinder. Many landscape painters use a very simple tool to help them decide what to paint. Take a piece of cardboard just a bit smaller than the page you're now reading. In the center of the cardboard, cut a "window" the same proportion as a half sheet of watercolor paper—about 4" x 6" (100 mm x 150 mm). Hold this viewfinder at a convenient distance from your eye—not too close—and you'll quickly isolate all sorts of pictures within the landscape, for more pictures than you could paint in a day.

Plan Your Mixtures. Before you start to mix any color you see in your subject, think carefully about the simplest color mixture that will do the job. Don't just dart your brush at several mounds of color on your palette and keep adding a bit of this, a bit of that, until it comes out more-or-less right. The more colors you add, the muddier the mixture is likely to be. Nor will you be able to duplicate that mixture later on if you need more color. Ideally, no mixture should contain more than three colors. Occasionally, when those three colors are almost what you want, but need some very subtle modification, you can add a touch of some fourth color. But two or three colors should do for most mixtures.

Greens. Certainly one of the most pervasive colors in landscape painting is green. Of course, there's no one green, but rather an infinite number of greens. The tender yellow-greens of trees in the springtime are vastly different from the deeper, richer greens of trees in midsummer. Evergreens are often a smoky bluish green or a dark green that's almost black. You have two blues on your palette, ultramarine and cerulean, and two yellows, cadmium and ochre. You can create a surprising variety of greens just by mixing various blues and vellows. You can also modify the one green on your palette (Hooker's green) by adding blue or yellow or both. You'll find that Payne's gray will also act something like a blue when mixed with yellow. And the range of these mixtures can be greatly extended by adding a touch of one of your browns: burnt umber or burnt sienna. If you look closely, you'll see many brownish greens in nature. Even a faint touch of red-cadmium or alizarin crimson-will add a fascinating hint of darkness if you don't

add too much. The important thing is *not* to rely totally on Hooker's green, but to regard it as one possible component in various green mixtures.

Browns. In landscapes, browns are just as common as greens-and just as varied. You do have two browns on your palette, burnt umber and burnt sienna, but these are just the beginning. Try modifying them with a bit of blue or green to produce a variety of gravish browns or greenish browns. A touch of yellow ochre will add a subtle hint of warmth, while a touch of cadmium yellow is like adding strong sunshine. Cadmium red or cadmium orange will turn your two browns coppery. But you don't even have to start with brown to produce brown. Any combination of blue, red, and yellow will give you an interesting brown. And these blue-red-yellow mixtures will change radically, depending upon the proportion of each color in the mixture. Two other ways to create browns are to mix one of your blues with orange or one of your reds with green. As you can see, brown is far from dull. It's one of the most diversified families of colors.

Painting Trees. Too many beginners paint every tree as a bright green mass of leaves and a chocolate brown trunk. It's important to look closely at the leaves and decide what shade of green you really see. Some trees, like willows, tend to have smoky, gravish green foliage. Certain spruces are almost blue. In the tropics, many trees contain a great deal of yellow within the green. Tree trunks are just as diverse. Few trunks are really brown. The bark is often a brownish gray or gravish brown. And many tree trunks are unexpected colors, such as yellow, blue, brownish-violet, or even dusty red. When they're soaking wet after the rain, tree trunks often look black.

Painting Rocks and Soil. Just as it's easy to fall into the trap of thinking that all trees look alike, it's dangerous to assume that all rocks are gray and all soil is brown. Look closely and you'll see that rocks can be yellow, blue, green, even pink, red, or orange. And when a rock *does* turn out to be gray, that gray often has a hint of blue, green, or some unexpected color. Soil, of course, is made of the same substance as rock, so the colors of soil are just as varied. Sand is probably the hardest ground color to paint. Don't just assume that it's always yellow; look closely and you'll see that it's often gray or brown-or even blue after the rain, when the wetness reflects the color of the sky.

Color Schemes. Just as it's important to plan your color mixtures, you've got to plan the overall color scheme of a landscape. Try to concentrate your brightest colors at the center of interest, rather than spreading bright colors over the entire picture. If your focal point is a flaming autumn tree, adjust the surrounding trees so they're a bit browner and less vivid. Decide whether your painting is going to be dominated by warm color (brown, red, orange, yellow) or cool color (blue or green). If it's mainly cool color—such as a panorama of green hills, green trees, and blue sky-try to find a few warm notes for variety. A few brownish or yellowish trees will keep that green landscape from looking like a colossal salad. If warm tones dominate - as they often do in an autumn landscape or a painting of the desert-try to introduce a few cool notes, such as some evergreens or cacti. And remember that bright colors really sing out when subdued colors are nearby.

MIXING COLORS FOR LANDSCAPES

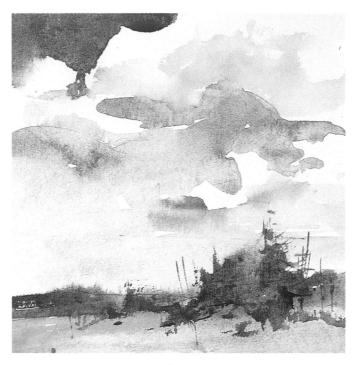

Sunny Sky. On a sunny day, the sky is usually bluest at the top, paler and warmer at the horizon. Here, the deeper blues are a mixture of ultramarine blue and cerulean blue.

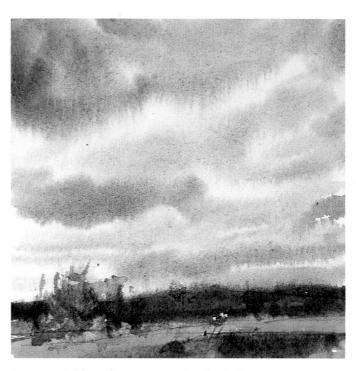

Overcast Sky. An overcast sky isn't always steely gray but often has a warm tone because the sun is trying to force its way through the clouds. These clouds, painted on wet paper, are a mixture of Payne's gray, yellow ochre, and burnt umber.

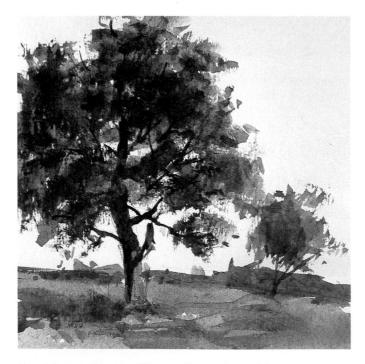

Deciduous Trees. The sunlit patches of leaves are a mixture of Hooker's green, burnt sienna, and burnt umber, dominated by the green. The shadow areas are the same mixture, with more burnt sienna and burnt umber.

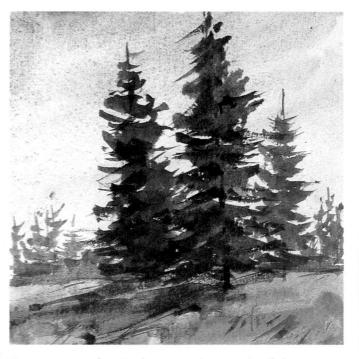

Evergreens. On the foreground trees, the lighter areas are Hooker's green, cadmium yellow, and burnt sienna, while the darker areas are Hooker's green, burnt umber, and ultramarine blue. The distant trees are a pale mixture of Hooker's green, burnt sienna, and ultramarine blue.

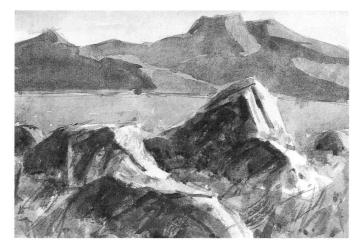

Rocks. Rocks contain many subtle colors. The shadow sides of these rocks are built up with multiple strokes in various combinations of yellow ochre, burnt sienna, burnt umber, and cerulean blue. The lighted sides are bare paper with touches of yellow ochre, burnt sienna, and cerulean blue. The distant mountains, which are really paler, cooler versions of the nearby rocks, are painted with burnt sienna and cerulean blue.

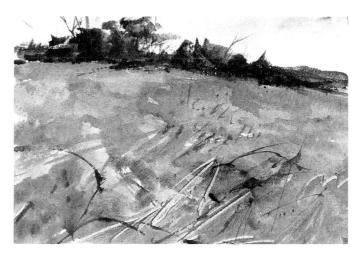

Meadow. A meadow can be a rich tapestry of cool greens and warm yellows, oranges, and browns. This field was painted with various mixtures of cerulean blue, Hooker's green, cadmium yellow, yellow ochre, and burnt sienna. Hooker's green and the yellows dominate the distance, while the foreground contains both yellows and much more burnt sienna.

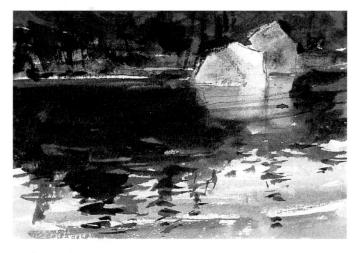

Reflections. Water reflects the colors of the foliage along the shore, the rocks, and the sky. The greens along the shore and in the water are Hooker's green, burnt sienna, and ultramarine blue. The rocks are yellow ochre, burnt sienna, and ultramarine blue, with the same combination in their reflections, slightly cooled by Hooker's green.

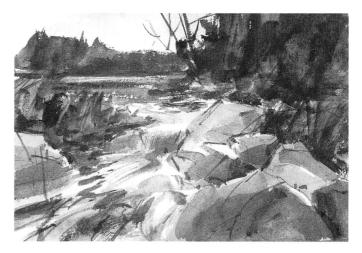

Stream. Although moving water may be interrupted by a broken pattern of lights and shadows, it's still a reflecting surface. Here, the sky is cerulean blue and a touch of yellow ochre, reflected in the cool areas of the stream. The distant trees along the horizon are Hooker's green, ultramarine blue, and burnt sienna, reflected in the water at the upper left.

CONSTRUCTING THE SHAPES OF TREES

Step 1. The pencil drawing clearly defines the individual masses of foliage and the tree trunks to the left and indicates the general shapes of the trees along the horizon. The sky begins as a pale wash of yellow ochre, into which pale strokes of cerulean blue are painted. The distant hills, which you can see clearly to the left, are painted with cerulean blue and cadmium red. While this tone is still wet, the trees are brushed in with Hooker's green and burnt sienna, blurring into the color of the hills.

Step 2. The artist covers the field with a light wash of yellow ochre and Hooker's green, followed by darker strokes of this mixture, some containing a hint of burnt sienna and others containing just a bit of ultramarine blue. Some of these darker strokes go on while the underlying wash is still wet. Others are applied after the surface is dry.

Learning About Trees

Trees are almost everywhere, so if you're going to paint landscapes, keep a sketchbook of trees and fill it with studies of trees.

1. Make line drawings—sometimes called contour drawings that record the distinctive shapes of the trunks, branches, and foliage masses of different types of trees.

2. Make small watercolor sketches that record the colors of the trunks and foliage of different trees.

3. Make these color studies at different times of year to record the color changes that take place in spring, summer, fall, and winter.

4. With charcoal, Conté, or a soft pencil, record the distinctive patterns of lights and shadows within the leafy masses of different trees.

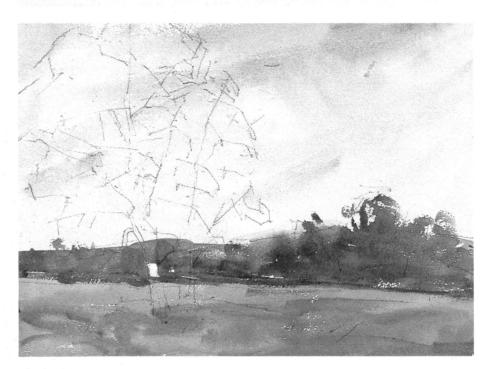

Step 3. The lighter, brighter areas of the foliage are brushed in with broad, short, curving strokes—in various combinations of cadmium yellow, yellow ochre, Hooker's green, and ultramarine blue. While these lighter strokes are still wet, the artist brushes the darks over and into them, so the darks and lights tend to blur together. The darks are Hooker's green, ultramarine blue, and burnt sienna.

Look at the Brushwork

1. The artist paints the row of trees at the horizon with short, scrubby strokes that suggest the ragged shapes of the foliage.

2. Notice the touch of drybrush in the treetops at the left of the horizon.

3. He paints the field with horizontal strokes that follow the flat shape of the ground and also suggest the shadows beneath the trees.

4. He paints the leafy masses with short, quick dabs that leave a hint of drybrush as he pulls the brush away from the paper at an angle.

5. This drybrush effect is enhanced by painting with the *side* of the brush.

Step 4. So far, everything has been done with big brushes. Now, a small round brush comes into play. The artist paints the trunks with a dark mixture of Hooker's green and alizarin crimson. He uses the very tip of the brush to paint the branches with the same mixture. At times, the brush skims very lightly over the surface of the paper so that the strokes have a drybrush feeling.

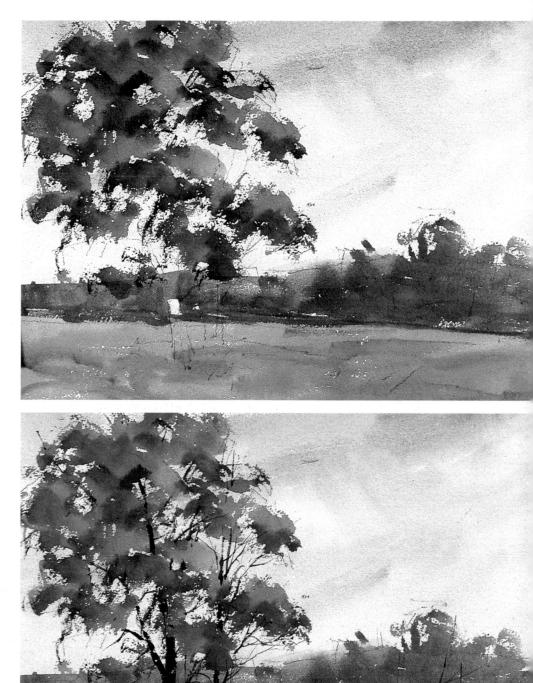

CONSTRUCTING THE SHAPES OF TREES

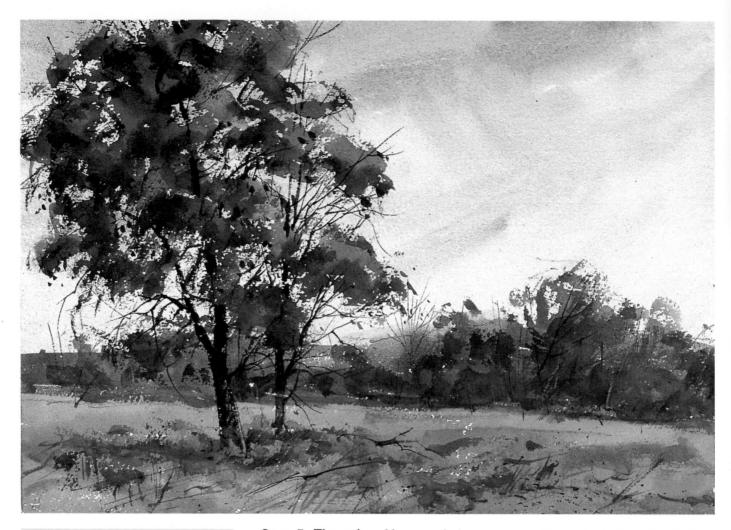

Do's and Don't's for Painting Trees

1. Don't paint individual leaves. Do paint masses of foliage, visualizing them as big, simple shapes.

2. Don't forget the shadows within the foliage. Do look for the lights and shadows on the leafy masses, just as you look for them when you paint rocks.

3. Don't paint the foliage as one solid mass. Do leave some holes for the sky to shine through.

4. Don't paint the trunk as a straight cylinder, like a telephone pole. Do look for the curves—and notice how the trunk widens as it nears the ground.

5. Don't paint every tree with the same green out of the tube. Do learn to mix lots of different greens.

Step 5. The artist adds more dark notes to the tree with a mixture of Hooker's green and burnt umber. He uses the small brush again-often holding it so the side of the brush leaves irregular patches of color on the paper. He uses the same mixture and the same kind of strokes to darken the distant mass of trees, which now have a more distinct feeling of light and shadow. You can see where he's suggested a few dark trunks among the distant trees-and he's scraped out a few light trunks with the tip of the brush handle. He saves the foreground for the very end. A large brush is freely stroked across the field, sometimes depositing wet strokes and sometimes creating drybrush textures. These darks are mixtures of burnt sienna and Hooker's green. He uses a small brush to build

up small, rough strokes directly beneath the trees, suggesting shadows on the grass. He adds more branches with the very tip of the small brush, carrying a mixture of alizarin crimson and Hooker's green. A sharp blade scrapes away some flecks of light on the thicker tree trunk. The alizarin crimson and Hooker's green mixture is also used for the slender strokes that pick out individual weeds at the lower edge of the painting. Finally, the artist dips a small round brush in the alizarin crimson-Hooker's green mixture and flicks it at the foreground, spattering droplets that you can see most distinctly in the lower right section. The foreground contains just enough texture and detail to suggest an intricate tangle of weeds and grasses—but not so much detail that it becomes distracting.

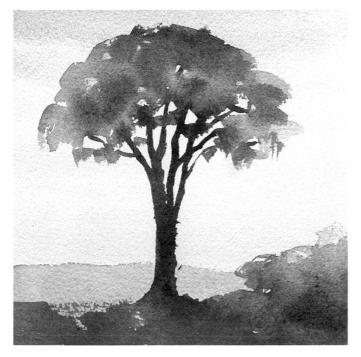

Tree Forms

Elm. A single domelike mass of leaves is typical of the elm. The branches grow upward and then turn slightly outward—but they never grow sideways like oak branches.

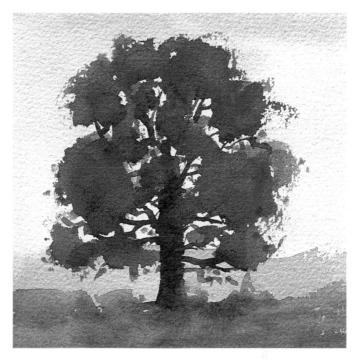

Oak. An oak has a broad, rounded shape, with big gaps between the bunches of leaves. You can see lots of sky and lots of branches in these gaps. The branches grow outward to the side.

Willow. The thick trunk and branches of the willow contrast with the very delicate, lacy leaves that trail downward like frothy, falling water.

Apple. The apple tree is low, with a thick trunk and branches that often seem twisted and erratic. The tree may tilt to one side. The foliage forms irregular bunches that look lacy around the edges. There are big gaps of sky between the clusters of leaves.

CAPTURE THE FORMS OF EVERGREENS

Step 1. The pencil drawing defines the main masses of the trees, but not too precisely—so there's plenty of freedom for impulsive brushwork later on. The sky begins with a very wet wash of yellow ochre, applied with a big flat brush, followed by broad strokes of Payne's gray and ultramarine blue while the underlying wash is still wet. Just before the sky loses its shine, the distant trees are painted into the wetness with Hooker's green, Payne's gray, and cerulean blue, applied with a small brush.

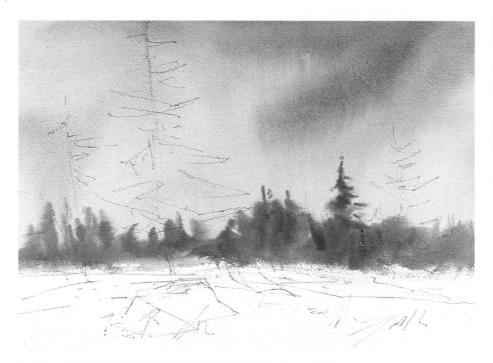

Step 2. When the sky and the distant trees are dry, the artist brushes in two more trees with a darker mixture of Hooker's green, Payne's gray, and cerulean blue, applied with a small round brush. These tree strokes have a special character that reflects the way the brush is handled. The wet brush is pressed down hard at the center of the tree and then pulled quickly away to the side. Thus, the stroke is thick and dark at one end, but then tapers down to a thinner, more irregular shape as the brush moves outward.

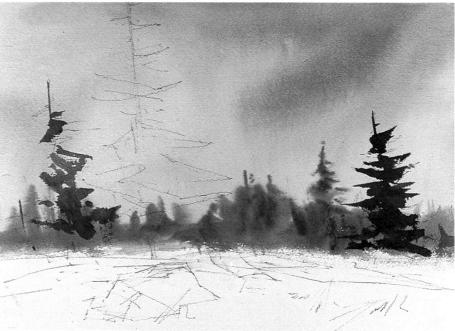

Step 3. The artist now paints the largest tree with a big round brush, using the same kind of strokes as in Step 2. He paints lighter foliage with Hooker's green, ultramarine blue, and burnt umber, and then allows it to dry. The darks are painted with the same mixture but contain more ultramarine blue. While the color is still damp, the artist uses a blunt knife to scrape away some pale lines for the trunk.

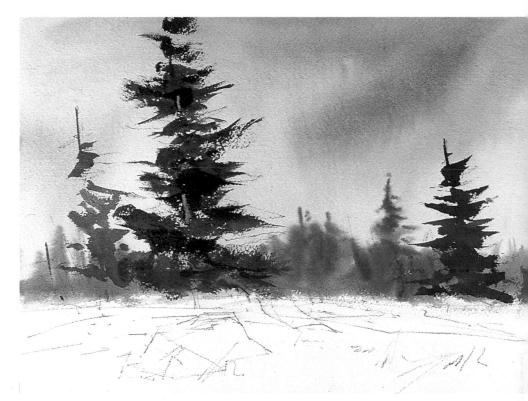

Step 4. The artist paints both the light and shadow planes of the rocks with Payne's gray and yellow ochre—with less water for the shadows. To suggest a few tones on the snow, he quickly glides a small brush over the paper with pale strokes of ultramarine blue and burnt umber. Notice how he allows flecks of paper to show through

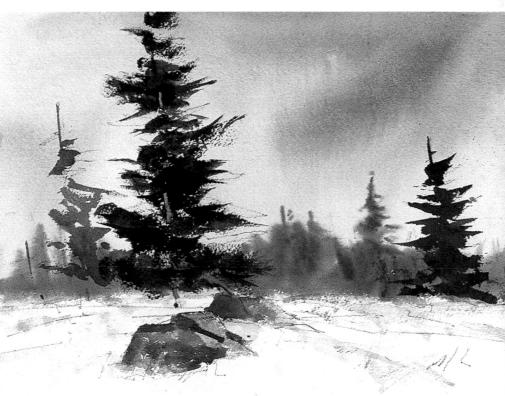

CAPTURE THE FORMS OF EVERGREENS

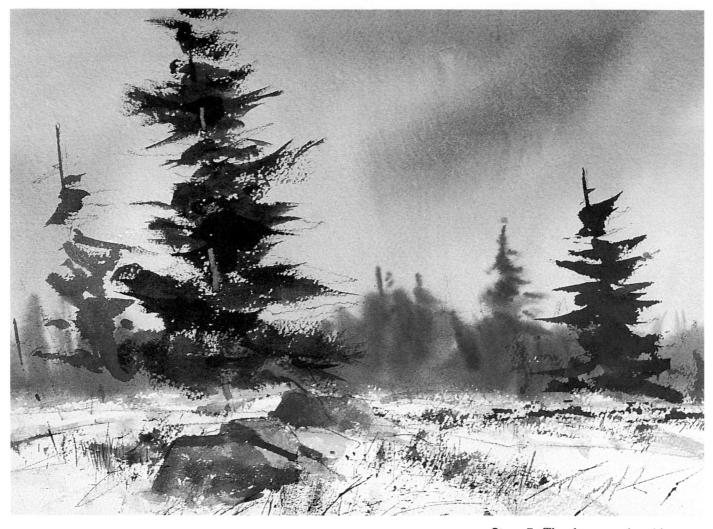

Step 5. The dry grass breaking through the snow adds some warm notes to enliven a picture that is generally cool. The artist uses the tip of a small round brush to add drybrush strokes of cadmium orange, burnt sienna, and burnt umber. The same color appears in the very slender strokes that suggest a few weeds – and is spattered across the foreground. These very thin strokes are a good opportunity to use the rigger.

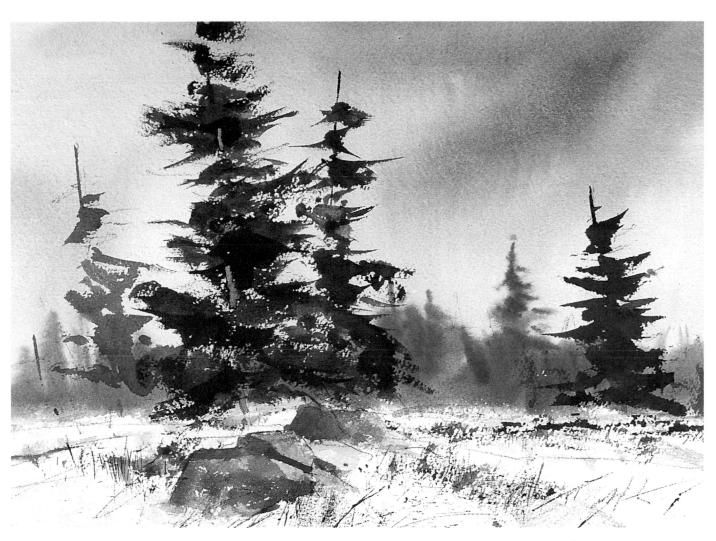

Tips About Wet-in-Wet Painting

The artist paints the sky and the distant trees wet-in-wet. Here are some tips for controlling the "wet paper method," as it's sometimes called:

1. Work with color that looks a bit *too dark;* the color will get a lot lighter as it spreads on the wet surface.

2. Keep your drawing board flat, not tilted. Pick up the board and tilt it to direct the flow of the color.

3. When you want a very soft shape such as the clouds, paint it on very wet paper, when the water is still shiny.

4. When you want a more precise form with soft edges, such as the distant trees, paint it when the wet paper starts to lose its shine but remains quite damp.

5. Stop painting as soon as the paper starts to dry out, or you'll wreck your work with ugly blotches. **Step 6.** The picture needs an additional tree to add weight at the center of interest. The artist does this with a dark mixture of Hooker's green, ultramarine blue, and burnt umber — using the press-and-pull strokes that worked so well for the other trees.

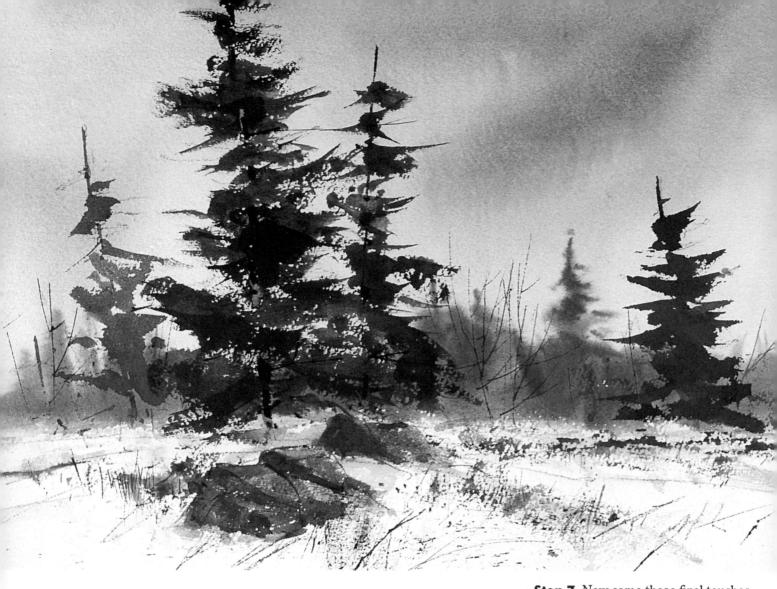

Step 7. Now come those final touches that seem invisible at first glance but do make a great difference when you look closely. The artist loads a small round brush with a dark mixture of alizarin crimson and Hooker's green. He uses the very tip to add darks, such as the trunks of the central trees, the cracks and additional touches of shadow on the rocks, and the skeletons of more trees along the horizon. He adds a pale mixture of ultramarine blue and burnt umber just under the central tree to suggest a shadow that anchors the tree more firmly to the ground. Compare the finished trees and rocks with those in Step 6 and you'll see how much the picture gains by these slight touches. the shadows of the rocks, suggesting a rough texture.

SUGGESTING THE DETAIL OF A MEADOW

Step 1. A meadow contains so much tangled detail that it's really impossible to do a very precise pencil drawing. So all you can do is indicate a few masses of light and dark, plus a few big weeds or branches and the shapes along the horizon. The artist paints the slender band of sky with overlapping strokes of yellow ochre and ultramarine blue, using a large round brush. When the sky is dry, he paints the darker tone of the distant hill with a small round brush, loaded with cerulean blue and cadmium red. He softens and blurs the lower edge of this band of color with a stroke of clear water, applied while the color is still wet.

Step 2. When the hill is dry, he brushes the shapes of the distant trees over it with a small brush and a mixture of Hooker's green, burnt sienna, and cerulean blue. The strokes are quick, short, and sometimes applied with the side of the brush, giving a rough, irregular charcharacter to the trees. Once again, he softens and blurs some of the lower edges with a brushload of clear water.

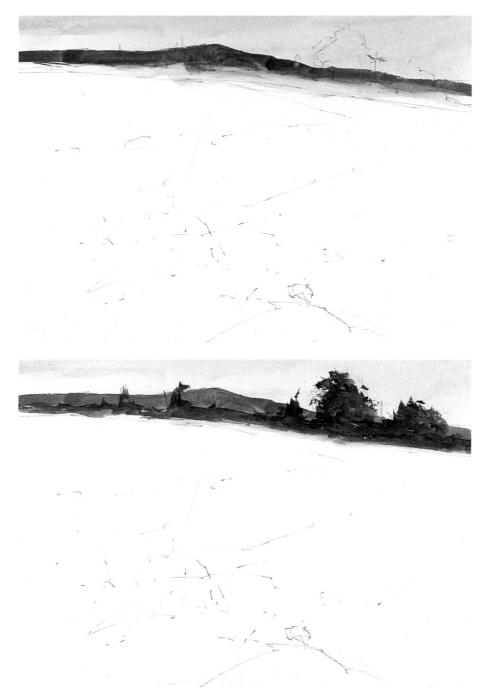

SUGGESTING THE DETAIL OF A MEADOW

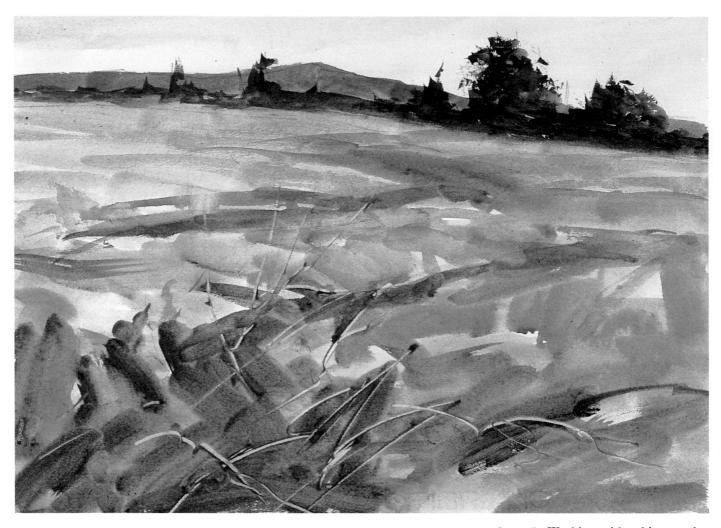

Give Your Meadows Shape

A meadow isn't a flat tabletop; it has a *shape*. Try to analyze the shape of the meadow before you start to paint. Look for curves, bulges, angles, changes of direction. Look at the meadow in this demonstration: It tilts one way in the foreground and then tilts another way in the distance. Step 3. Working with a big round brush once again, the artist paints the entire meadow with casual, sweeping strokes that follow the curve of the landscape. The strokes are various mixtures of cadmium yellow, yellow ochre, Hooker's green, burnt sienna, and burnt umber-never more than three colors mixed for any one stroke. He adds the lighter tones first and allows them to dry; then he adds darker strokes in the foreground and allows them to blur into one another. Weeds are suggested by scratches of the brush handle or a fingernail-right into the wet color.

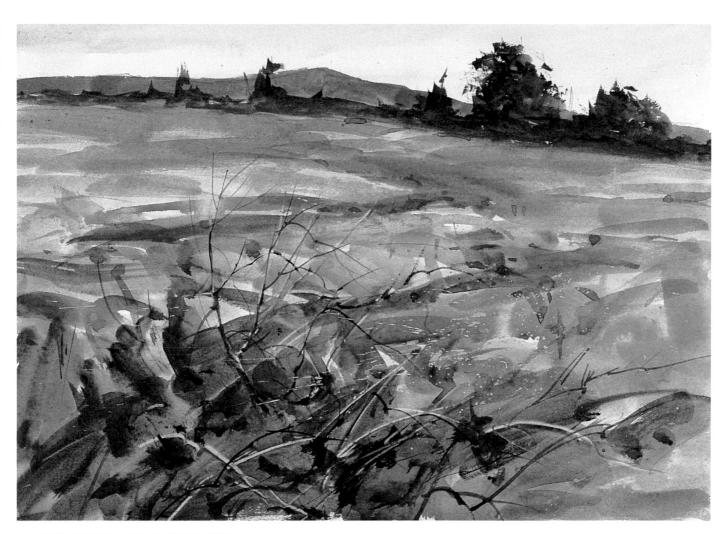

Placing Details

Don't paint every weed, flower, and blade of grass. Paint just a few details. The viewer will imagine the rest. Concentrate most of your details in the foreground, with less in the middle ground, and very little (or none at all) in the distance. This is one of the most important lessons of landscape painting: If you have a certain amount of detail in the foreground, the viewer will imagine that the whole picture contains a lot more detail than he or she actually sees. **Step 4.** The color of the meadow needs to be stronger, so the artist uses the same mixtures to build up the darks of the foreground. He also uses them to darken the distant meadow, particularly in the upper left section. Do you remember how the dark bases of the trees in the upper right section were blurred with clear water? Now these trees seem to emerge softly from the meadow, growing out of their own shadows on the grass. The time has come to add some detail. He picks up a dark mixture of alizarin crimson and Hooker's green with a small round brush. He lets the tip of the brush skate rapidly over the surface of the paper, suggesting twigs and blades of grass intertwined with the pale scratches made in Step 3. These details are concentrated in the foreground, not scattered over the entire field. He spatters a mixture of cadmium yellow and burnt umber among the twigs to suggest wildflowers.

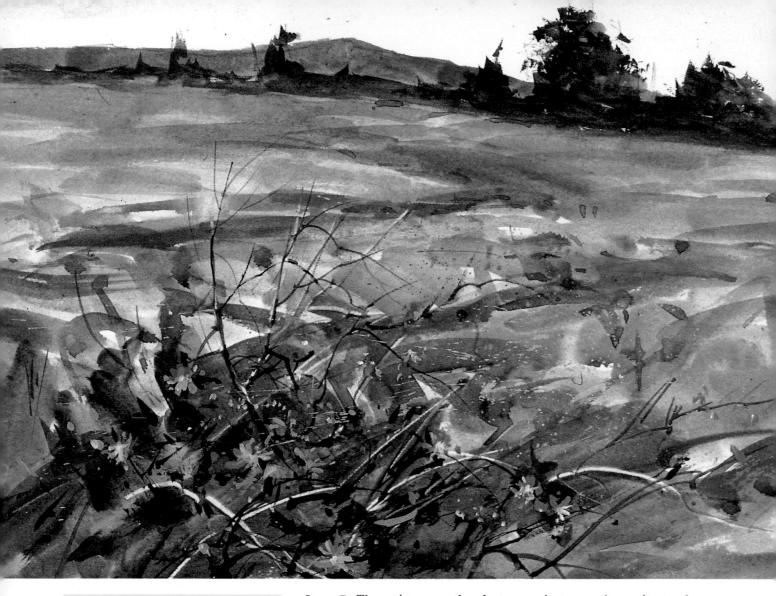

Add a Little Color

Look for the variety of color in meadows: greens (not just one single green), yellows, browns, pinks, violets. You can even invent some if you like! **Step 5.** The artist saves the cluster of wildflowers for the final stage, and he'll use a technique we haven't seen before in these demonstrations. Because watercolor is transparent, you can't really paint pale flowers over a dark background. So this is one of those rare times when you really need some *opaque* color. You'll need a tube of white acrylic color or white watercolor (Chinese white, as it's called). Mix a touch of this opaque white with your regular watercolors to give them just enough opacity to show up against the dark background. (It's best to do this on some surface other than your regular palette.) These flowers are mixtures of cadmium yellow, cadmium red, and alizarin crimson, with just a little opaque white. The paler strokes and the centers of the flowers obviously contain more white than the darker strokes. Only a few flowers are painted in detail. But more flowers are suggested by mere specks of color applied with the very tip of the brush.

PAINT MAJESTIC MOUNTAINS

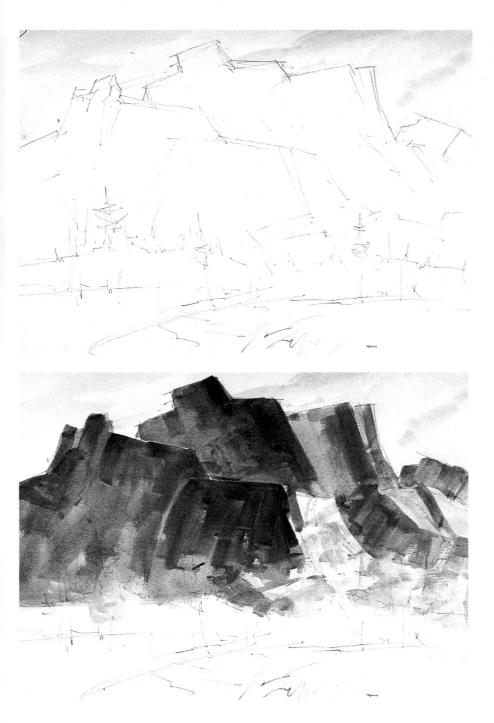

Step 1. The mountains have squarish, blocky shapes, perfect for painting with a big flat brush. So the pencil drawing defines these shapes very clearly. The pencil lines also indicate the spiky shapes of the trees at the base of the mountains. The artist first paints the sky with a very pale wash of yellow ochre and cerulean blue. When this is dry, he paints slightly darker strokes of this mixture, plus cadmium yellow, over the pale background.

Step 2. The underlying pale tone of the mountains is blocked in with the broad strokes of a big flat brush, loaded with mixtures of yellow ochre, burnt sienna, and ultramarine blue. When this underlying tone is dry, the artist uses the same brush to add darker strokes to the same mixture, containing more ultramarine blue and burnt sienna. He allows these strokes to dry and then lays still darker strokes over them so than there's a gradual buildup of strokes from light to dark.

PAINT MAJESTIC MOUNTAINS

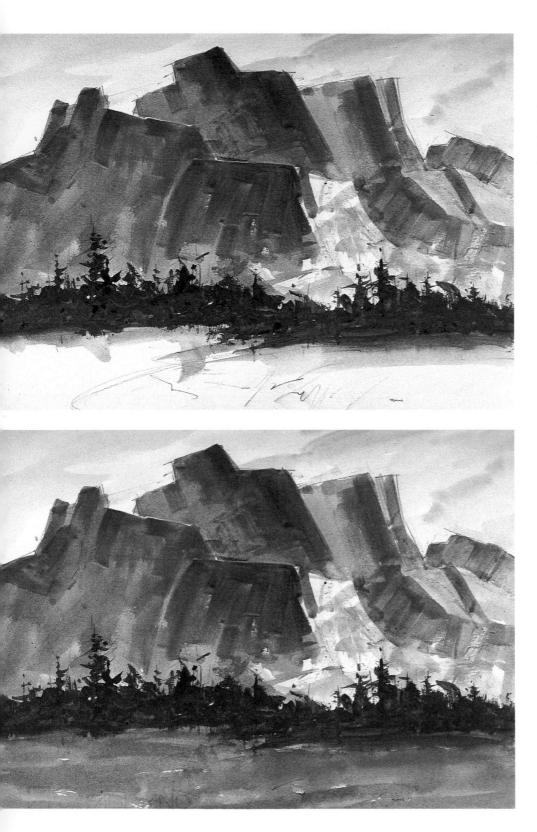

Step 3. A small round brush works with quick, short, choppy strokes to paint the irregular line of trees at the base of the mountain. These strokes are a mixture of Hooker's green and burnt umber; there's no attempt to follow the original pencil drawing too precisely. Before this color dries, the lower edges of the trees are blurred by a stroke of pure water.

Take Another Look at the Brushwork

The artist paints the sides of the mountains with straight, angular strokes of a flat brush to emphasize the blockiness of the shapes. He tilts the mountain strokes to express the angles of the cliffs. Not one tree trunk is absolutely vertical!

Step 4. The artist paints the grass in the foreground with horizontal strokes of mixtures of Hooker's green, burnt sienna, and cadmium orange. He brushes the strokes in very quickly and keeps the surface very wet, so one stroke fuses with another. Notice how the brushstrokes follow the forms in the painting. The mountains are straight, diagonal or nearvertical strokes. He paints the foreground with horizontal strokes, and combines short horizontal and vertical strokes to paint the trees.

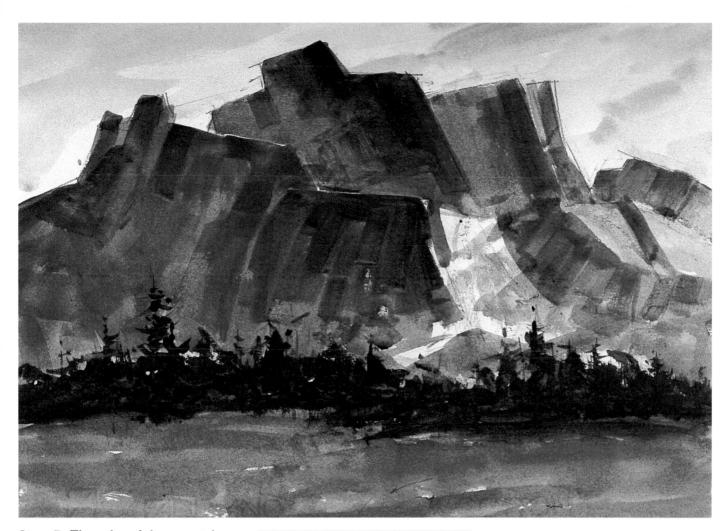

Step 5. The color of the mountains needs to be integrated more effectively with the rest of the picture; thus the artist brushes a cooler tone of cerulean blue and burnt sienna over them, darkening the bases of the mountains where they meet the row of trees. Now most of the mountains are clearly in shadow, dramatizing the sunstruck patch just to the right of center.

The Right Brush for the Job

The artist paints the evergreens with a *small* round brush that's pressed against the paper and then pulled sideways to express the jagged shapes of the evergreen foliage. The tip of a *small* round brush paints the wispy detail of the foreground to suggest weeds bending in the breeze. A *big* round brush paints the sky with diagonal strokes that suggest windblown clouds.

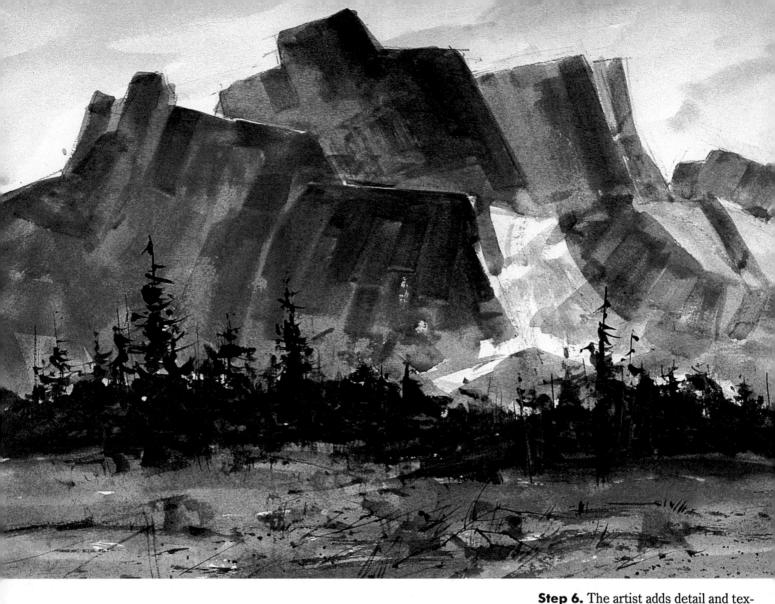

ture to the foreground with a small round brush. He adds quick, slender strokes with a mixture of burnt sienna and Hooker's green. He spatters the same mixture across the foreground. You now have the feeling that there are weeds and tufts of grass in the meadow. The final operation is to build up the row of trees so they seem closer, loftier, and more distinct. The artist applies a dark mixture of Hooker's green and burnt umber with the tip of a small brush, working in short vertical and horizontal strokes. These are the press-and-pull strokes used to paint the evergreens in an earlier demonstration. Some strokes are darker and some are lighter, creating the impression of lights and shadows among the trees. Because you now see the trees more clearly, they're closer to the foreground; by contrast, the mountains seem more distant. The picture gains a much deeper sense of space.

MODELING HILLS WITH DRYBRUSH

Step 1. The pencil drawing traces the shapes of the hilltops very carefully; defines the curves within the hills and the lines of the shore; but simply suggests the trees, leaving room for free brushwork later on. The sky begins with a pale wash of yellow ochre, followed by strokes of Payne's gray, wet-in-wet. The distant hills are painted with Hooker's green, cerulean blue, and Payne's gray.

Step 2. The artist covers the big shape of the hills with a wash of Hooker's green, yellow ochre, and ultramarine blue. While the underlying color is still damp, he adds darker strokes to suggest trees. These strokes are a mixture of Hooker's green, burnt sienna, and ultramarine blue, blurring slightly with the damp undertone. When the entire area is dry, more trees are suggested with this dark mixture.

Let's Review Our Steps:

1. The artist paints the sky and distant hills first.

2. Next he paints the nearer hills, with some indication of detail-but not too much.

3. He starts the water in the middle ground and the land in the fore-ground.

4. He indicates the first foreground details—the tree and bushes—with more to come.

5. He adds a bit more detail to the hills, the water, and the land in the foreground.

6. The artist works from top to bottom, from far to near, from broad shapes to precise details.

MODELING HILLS WITH DRYBRUSH

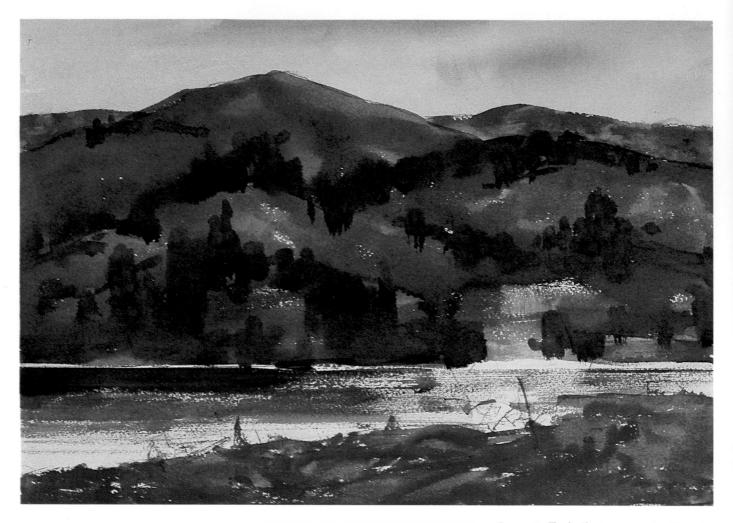

Paint and Drybrush

Paint consistency makes an important difference in drybrush work. The artist paints the river with *fluid* color, diluted with plenty of water, so the drybrush strokes carry smoothly over the paper. He paints the dark tree with *thicker* color, diluted with just a touch of water, so the brush really drags over the paper and makes a more ragged stroke.

Step 3. To indicate the reflections in the water, the artist loads a small flat brush with Hooker's green, burnt umber, and ultramarine blue; it's then drawn across the paper with steady horizontal strokes. At the left, the color is heavy and fluid. At the right, the brush is merely damp, producing a drybrush effect that suggests light shining on the water. The light patches are bare paper. The artist paints the foreground with mixtures of cadmium yellow, Hooker's green, and cadmium orange. He applies the strokes quickly, overlapping one another and flowing together. Here and there, you see touches of almost pure cadmium orange, which add some necessary warm notes to a cool picture.

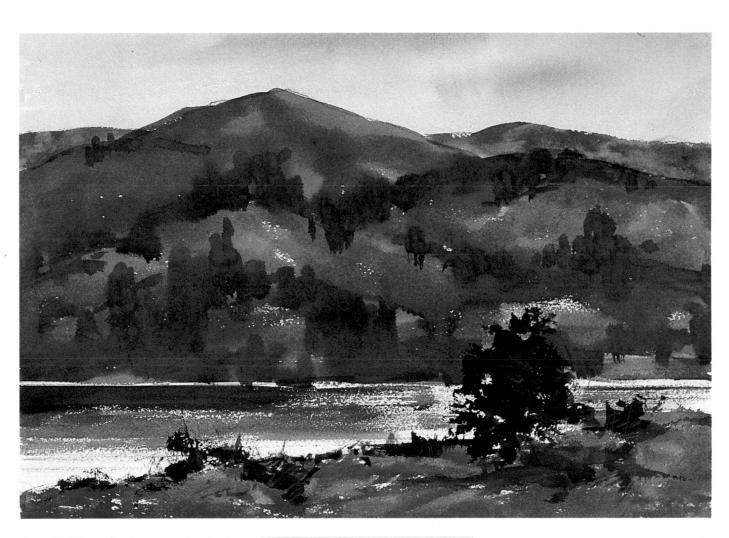

Step 4. When the foreground color is dry, the artist brushes in the tree and bushes with a mixture of Hooker's green, burnt umber, and burnt sienna. The color is quite thick, containing just enough water to make it fluid, and he uses the side of a small round brush to create ragged, irregular strokes. A slightly paler version of this mixture—with more water—becomes the shadow under the tree.

Paper and Drybrush

Drybrushing is even more effective on rough paper. The prominent tooth of the paper breaks up the drybrush stroke into distinct fragments of light and dark—as you see in the water.

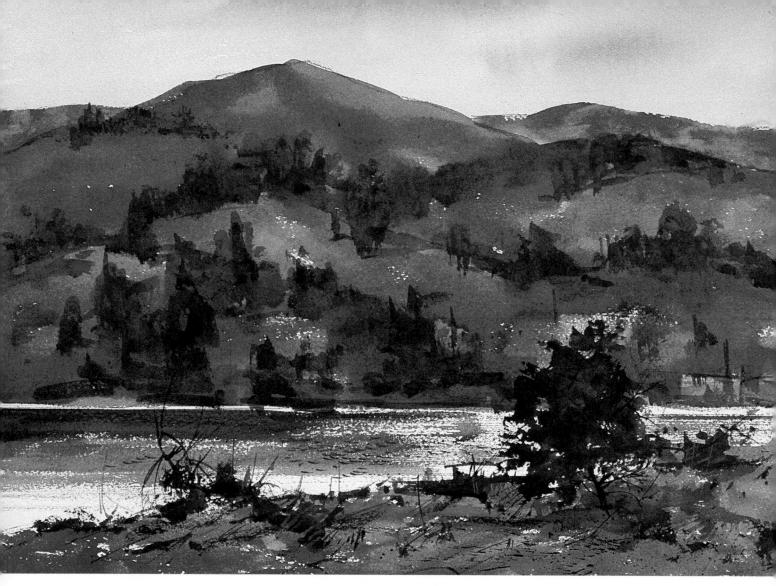

Change of Pace

For a change of pace, try drybrush with a bristle brush—the kind used for oil painting.

Step 5. The artist adds strokes of burnt umber and Hooker's green to make the dark trees on the distant hill slightly more distinct. Some of these strokes are broad and chunky. suggesting the overall shape of a tree. Other strokes are vertical and slender, suggesting tree trunks. If you look closely, you're not really sure that you see any specific trees, but these additional dark strokes suggest enough to give you the feeling that the trees are really there. This same mixture is used to darken the reflection in the left side of the water. Now the artist adds those last vital details

to the grass and trees in the foreground. He picks up a mixture of alizarin crimson, Hooker's green, and burnt sienna with a small round brush. With the tip of the brush, he adds a trunk and some branches to the large tree, some tangled branches to the bush in the lower left, and some slender lines to suggest twigs and weeds. You can also see additional drybrush work in the dark reflection under the hill at the left. The ripples don't cover the entire strip of water; there are just enough ripples to give you the feeling that the water is moving.

MAKE A LAKE SPARKLE WITH LIGHT

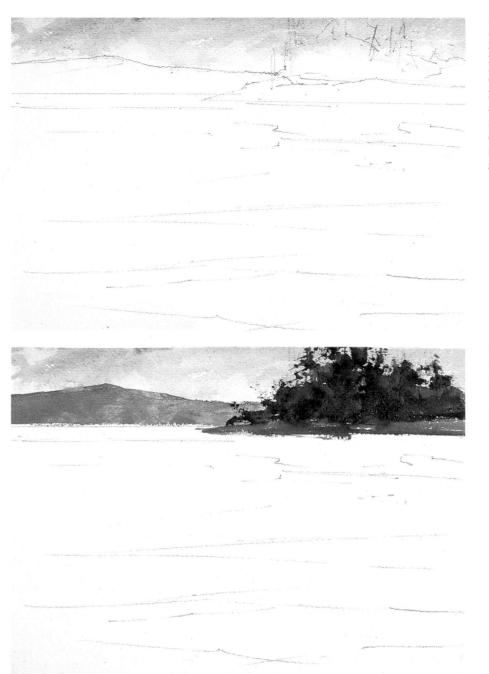

Step 1. Your pencil drawing can't possibly indicate every wave and ripple in the surface of the lake, so simply draw a few lines to separate the dark areas from the light ones. Add a few pencil lines to define the shapes along the shoreline. Here, the artist starts the sky with a wash of yellow ochre. Once that has dried, he adds strokes of cerulean blue, modified by a hint of yellow ochre.

Step 2. He paints the distant hills with a wash of yellow ochre, Payne's gray, and cerulean blue. While the wash is still wet, he blots it with a paper towel, which lightens the tone and fades it out on the right-hand side. This makes the distant shore seem farther away and gives the painting a more atmospheric quality. Now he paints the tree-covered island with a mixture of Hooker's green and burnt umber. The color mixture doesn't contain too much water, and the brush is only damp rather than wet, which will give a ragged drybrush character to the strokes. The strokes are short and rough, some darker and some lighter, some containing more Hooker's green and others containing more burnt umber.

MAKE A LAKE SPARKLE WITH LIGHT

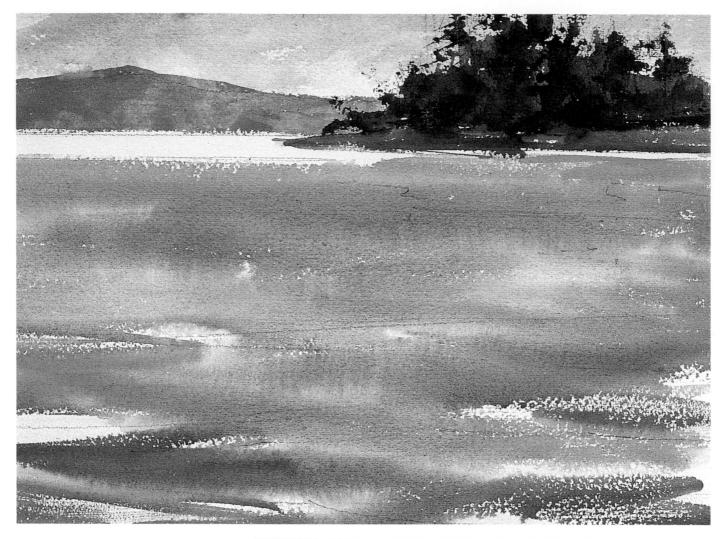

Combine Wet and Dry Techniques

The water is an interesting combination of wet-in-wet and drybrush. The artist brushes the darks of the water into the wet undertone. While the area is still very wet, he tilts his drawing board so the dark color runs downward a bit, creating the vertical streaks you see in the foreground. But not all of the foreground is painted wet-in-wet. In the right and left lower corners, the brush skims over the paper to create a drybrush effect that will suggest shimmering light in the final stage. **Step 3.** The artist paints the water with a very wet wash applied with a big round brush. A pale wash of yellow ochre and cerulean blue goes onto the paper first, followed by darker mixtures of yellow ochre, cerulean blue, ultramarine blue, and Hooker's green, which quickly spread and blur. In the foreground, he uses gradually less fluid color and doesn't wet the brush nearly as much, until the strokes at the very bottom of the picture are drybrush. The paint really looks wet—just like the water.

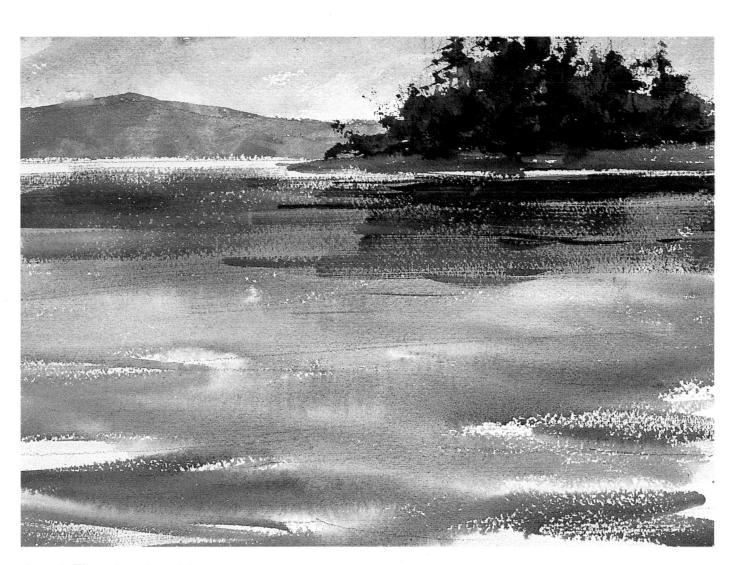

Step 4. When the colors of the water are dry, the artist goes to work on the dark reflections under the island with a small brush. These dark, horizontal drybrush strokes are a mixture of ultramarine blue, Hooker's green, and burnt umber. He draws a few ripples and horizontal lines into the water with the tip of the brush. The dark patch in the upper left section is the same mixture. See how the drybrush strokes in this section create the feeling that light is flashing on the ripples.

MAKE A LAKE SPARKLE WITH LIGHT

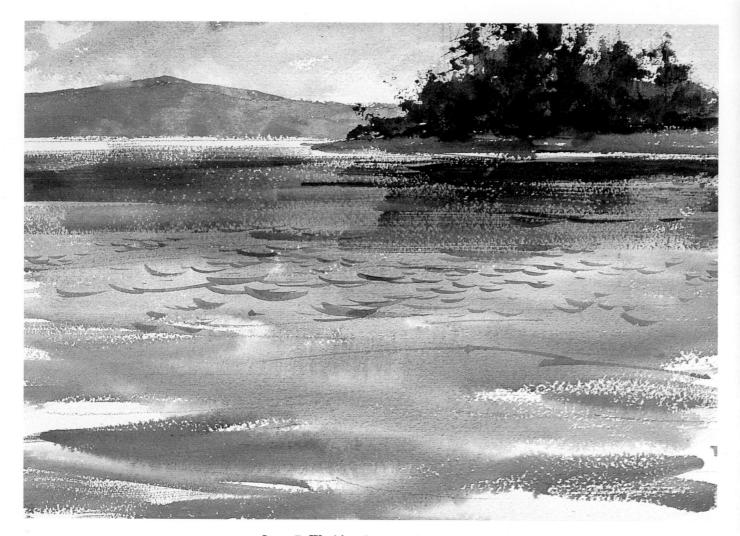

Step 5. Working downward, the artist uses a small round brush to add short, choppy, slightly curved strokes to suggest ripples. The strokes vary in length and thickness; thus they're never monotonous. The mixture is Hooker's green and ultramarine blue.

Paint Dark Over Light

The whole idea is to work from top to bottom, and from distance to middle distance to foreground. The artist starts at the top, painting the sky in two stages, dark over light. Working downward, he paints the distant hills and the island. The nearer the shape, the darker it's painted. Even the water in the foreground is painted dark over light.

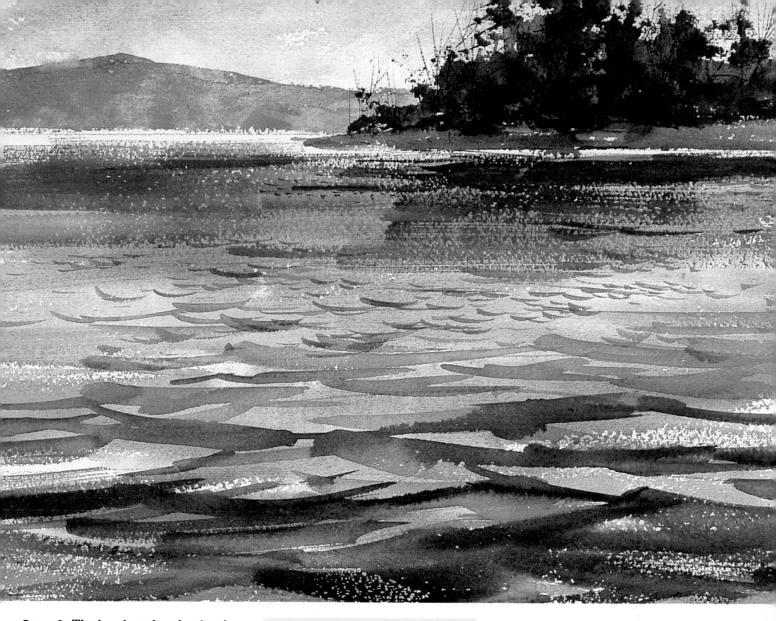

Step 6. The brushstrokes for the ripples grow longer, thicker, and darker as they approach the immediate foreground. Burnt umber darkens the blend of Hooker's green and ultramarine blue. The smaller strokes are done with a small round brush. Now the bigger strokes are executed by a large brush. Specks of white paper continue to peek through like sparkles of light on the water. Finally, a few branches and other details are added to the island with a mixture of burnt umber and Hooker's green.

Do Details Last

Details are added *selectively* to the water in the middle distance in the final stage of the painting. The details of the foreground water are brushed in and a few last details are added to the island.

CONVEY THE MOVEMENT OF A STREAM

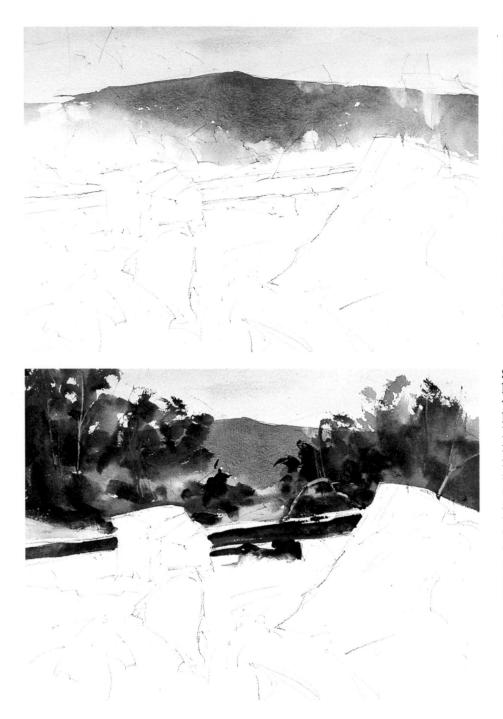

Step 1. This painting contains so many elements that the composition is fairly complex and needs a careful pencil drawing to determine where everything goes. Thus, pencil lines locate the rocks, the fallen tree trunks, and the curving patterns of the water. The sky is a wash of yellow ochre, followed by strokes of cerulean blue, applied while the underlying color is still wet. The mountain along the horizon is a wash of ultramarine blue, alizarin crimson, and vellow ochre. As you can see, the wash isn't absolutely smooth. At some points, there's more alizarin crimson, while there are other places where you can see more yellow ochre or more ultramarine blue. The lower edge of the wash is lightened and slightly blurred by strokes of clear water.

Step 2. Over the dried wash of the hills, the artist paints the trees with various combinations of cadmium yellow, yellow ochre, burnt umber, and Hooker's green. The lighter strokes, mainly yellow and green mixtures, go in first. Then, while the underlying strokes are still wet, the darker strokes go over them. Thus, the light and dark strokes tend to fuse. While the darks are still wet, some light trunks and branches are scraped out with a blunt knife. The dark tree trunk is painted with a blend of Hooker's green and alizarin crimson, and a bright patch of cadmium red is added while the dark tone is still wet.

Step 3. The artist paints the sunny rock with fluid strokes of pure yellow ochre, blotted with a paper towel on the lighter side. He paints the darker rocks with ultramarine blue, burnt umber, and cerulean blue. Pale strokes come first, and then he paints in the dark ones while the underlying color is still wet. The lower edges of the rocks are blurred with clear water so that the solid forms seem to melt away into the running stream.

Step 4. The artist adds shadows of burnt sienna and cerulean blue to the sunlit rock. Then he deepens the shadows on the other rocks with ultramarine blue and burnt umber. This same mixture is used to add shadows to the distant trees with short, scrubby strokes. And the artist adds some branches with the tip of a small brush. You can also see some spatters of this mixture on the rock in the lower right.

Tips for Painting Rocks

1. Think geometry! Are the rocks cubical, spherical, cylindrical, pyramidal?

2. Make a preliminary drawing of the rocks to define their geometry and to record the lights and shadows.

3. Divide the rocky shapes into distinct planes of light and shadow. Even spherical rocks have lights and shadows!

4. Analyze the color. Rocks aren't always gray or brown. In this demonstration, the most important rock is yellow.

5. Remember that rocks can be *any* color: green, blue, violet, red, orange.

6. Simplify! Don't paint every crack in the rock. A few cracks will do.

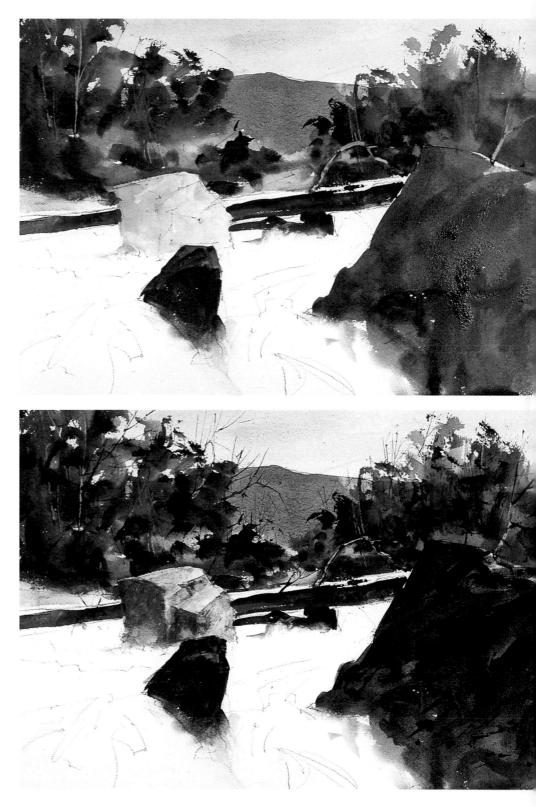

CONVEY THE MOVEMENT OF A STREAM

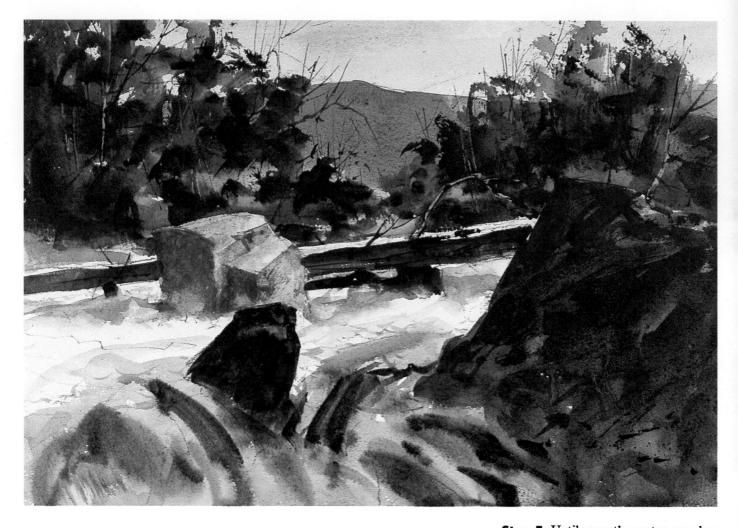

Step 5. Until now, the water area has been left as bare paper. Now the artist covers the immediate foreground with a very pale wash of yellow ochre, Hooker's green, and cerulean blue. While this area is still wet, the artist goes back in with dark strokes of Hooker's green and burnt umber that fuse with the underlying color, wetin-wet. A paler version of this same mixture indicates the shadow under the fallen tree trunk. The central strip of water is still bare white paper.

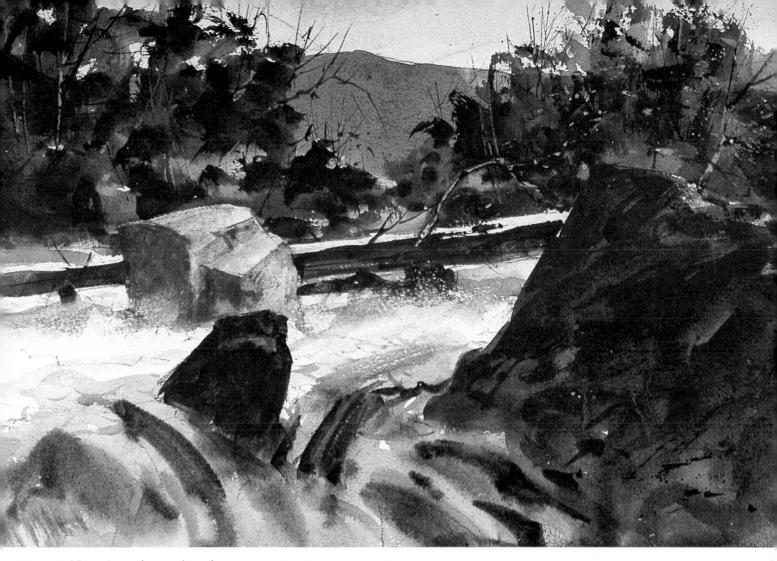

Step 6. Now the artist strokes the *edge* of a sharp knife or razor blade — not the tip—across the area beneath the fallen trunk. The blade catches the high points of the paper and scrapes away just enough color to reveal tiny flecks of bare paper that look amazingly like foam. He also uses the knife to scrape away a patch of light in the shadow side of the sunlit rock,

so the shadow seems to contain some light reflected from the surface of the water. To enliven the trees to the right—and suggest some leaves caught in sunlight—he spatters droplets of cadmium yellow with a small round brush. Some small, pale strokes that suggest a few ripples in the water—a mixture of burnt umber, ultramarine blue, and a lot of water.

SHAPING SNOW AND ICE

Step 1. A snow-covered field – which is, after all, simply water in another form-is just as difficult to draw as a lake. The best you can do is to draw the curves of the snowdrifts, the banks of the icy stream, the line of the horizon, and the shapes of the tree trunks. The sky begins as a pale wash of ultramarine blue and burnt sienna, followed by darker strokes of ultramarine blue and burnt umber, applied while the underlying color is still wet. While the sky is still damp, the artist quickly puts in the distant trees with short strokes of burnt umber and Hooker's green.

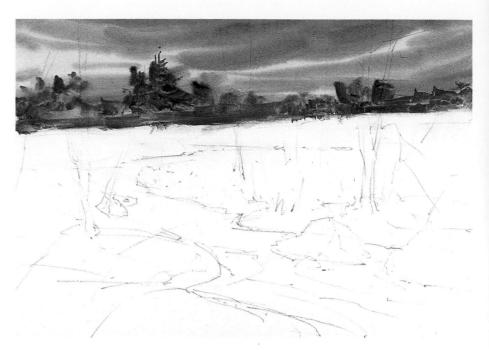

Step 2. With a very pale mixture of cerulean blue and burnt sienna the artist brushes in the shadows on the snowbanks and the patches of color on the snow. The shadows are darker in the foreground area. Bare paper is left for the lightest areas.

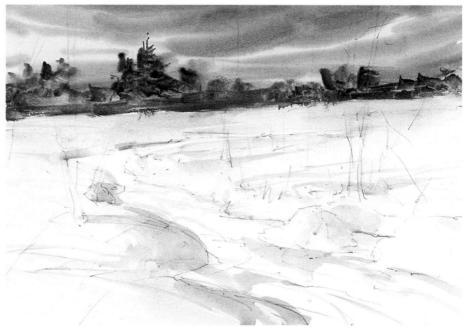

Step 3. The artist adds the thickest, darkest tree trunks with very fluid strokes, a blend of alizarin crimson and Hooker's green. Look closely at the trunks-particularly the ones on your right-and you'll see that the mixture is sometimes dominated by the green and sometimes by the red. The artist adds more trees with the tip of a small round brush, carrying a mixture of Hooker's green and burnt umber. In the sky, you can see a light spatter of cadmium red, alizarin crimson, and Hooker's green, flicked on with the same brush. These dark droplets give you the idea that some dead leaves are still hanging from the slender branches. The distant trees are darkened with strokes of Hooker's green and burnt umber.

Step 4. The artist now paints the icy water, which reflects the dark tones of the sky and the surrounding trees, with curving strokes that wind from the foreground through the middle distance and back toward the horizon. The pale strokes come first; they're mixtures of Hooker's green and burnt umber. Then come the darker strokes, which are Hooker's green and alizarin crimson or cerulean blue and burnt umber.

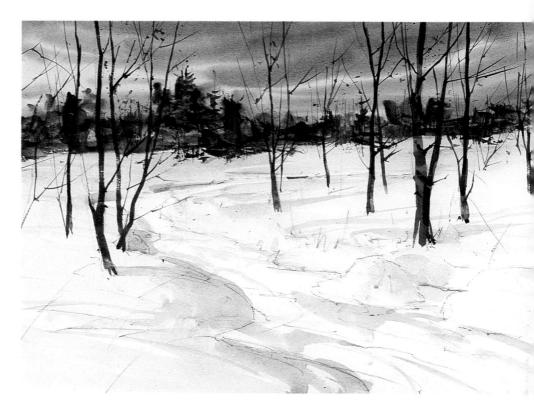

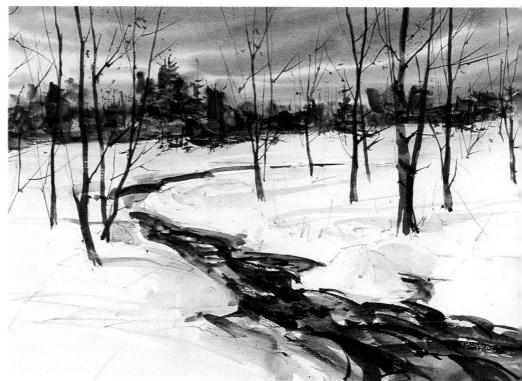

SHAPING SNOW AND ICE

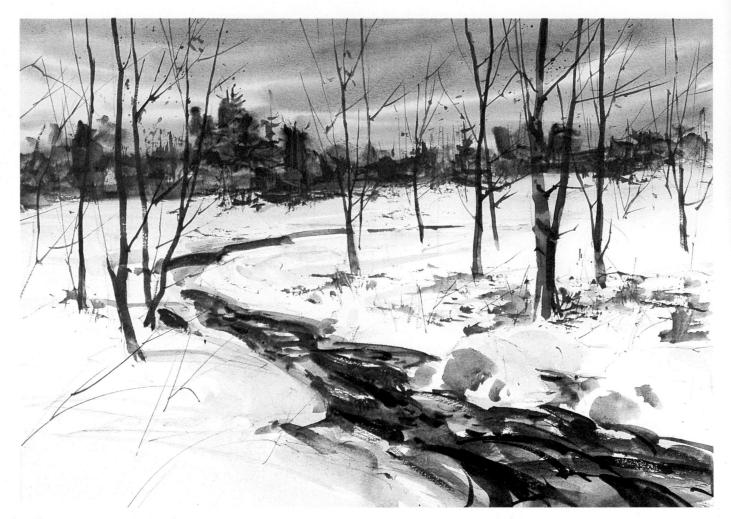

Step 5. The artist adds warmer touches along the banks, suggesting rocks. These are mixtures of burnt umber and cerulean blue. He adds touches of burnt sienna and cerulean blue among the tree trunks to suggest patches of dried weeds. The same mixtures are used for the thin strokes that render the stalks sticking up through the snow.

How to Paint Lines

A round brush can make many different kinds of lines, depending upon which part of the brush you use—and how you hold it:

1. If you work with just the tip, you can make rhythmic, slender lines.

2. If you press down a bit harder, more of the brush will spread out onto the paper, and you can produce thicker lines. **3.** In this demonstration, the thick strokes of the trunks and the heavier branches are made by pressing down firmly, so the whole body of the brush contacts the paper.

4. For the thinner trunks and branches, the brush isn't pressed down quite so hard.

5. For the slender branches, twigs, and dead weeds, only the *tip* of the brush touches the paper.

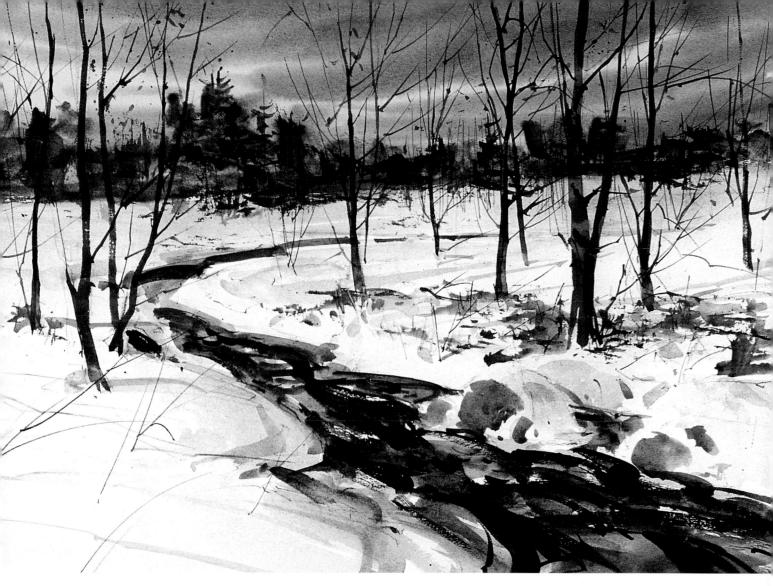

Step 6. In this final stage, the curves of the snowbanks-to the left of the frozen stream-are accentuated with curving strokes of cerulean blue and burnt sienna. This same mixture is used to add more touches of shadow beneath the trees on the right side of the stream. A few more touches of warm color-cadmium orange-enrich the dry grass among the trees. The artist adds more darks and more branches to the tree trunks with a mixture of alizarin crimson and Hooker's green. This snowy landscape shows how brushstrokes can mold the forms of the land. You've already seen how the direction of the strokes follows the frozen stream from the foreground into the distance. And you've noticed how the curving strokes in the foreground establish the rounded shapes of the snowbanks. But look carefully at the delicate streaks of shadow cast by the trees. These inconspicuous lines remind you that the snow isn't always flat, but sometimes has a slightly diagonal pitch, which you can see in the middle of the picture, and sometimes has a distinct roll, which you can see in the lower left section. These shadows function as contour lines, leading the eye over the curves and angles of the landscape.

ADD CLOUDS FOR INTERESTING SKIES

Step 1. It's usually best to begin a sunny sky by painting in the blue patches between the clouds. The big blue shape in the upper left section comes first-a mixture of ultramarine blue, cerulean blue, and a little yellow ochre, touched with clear water to blur a few edges. The artist brushes the right side of the sky with clear water. Then he carries more strokes of the same mixture from left to right above the horizon, which blur as they strike the wet paper. He also paints the strip of blue at the horizon on wet paper, which produces very soft edges.

Step 2. After the blue areas are dry, the artist brushes in the shadow sides of the clouds with a pale wash of Payne's gray and yellow ochre. Once again, he uses a brush carrying clear water to blur the edges of some of these strokes, so that the shadows seem to melt away into the lighted areas of the clouds. When the shadows of the clouds are dry, more edges seem to need softening. He loads a small bristle brush with water and uses it to scrub away color at various places where the edges of the clouds meet the edges of the blue sky. Then he adds more strokes of Payne's gray and yellow ochre to suggest darker clouds along the horizon.

Step 3. When the sky tones are completely dry, the artist paints the distant hills with mixtures of ultramarine blue, cerulean blue, and burnt umber—with more burnt umber in the darker patches. Notice how he uses strokes of clear water to soften some of the edges of the hills where they blend into the unpainted patch of foreground at the right.

Tips for Painting Clouds

1. Cloud shapes change faster than you can paint them when you're working on location—so make quick pencil sketches and work from the sketches.

2. Clouds are *not* just vague puffs of smoke. They're three-dimensional objects with planes of light and shadow-like rocks!

3. Record the shapes of the light and shadow planes in your sketches. Don't start to paint until you have a clear idea of these shapes.

4. Simplify! Don't include every cloud. Two or three are usually enough.

5. Observe the edges of the clouds. Some are soft and wispy; others are more precise.

6. Clouds aren't just gray and white. The lights and the shadows are full of color. Look for those colors!

Step 4. The artist allows the hills to dry and then paints the trees with Hooker's green and burnt sienna, warmed here and there with a bit of cadmium red or cadmium orange. He paints the lower masses of the trees with broad strokes, while the upper trunks and branches are mere touches of the tip of the brush.

ADD CLOUDS FOR INTERESTING SKIES

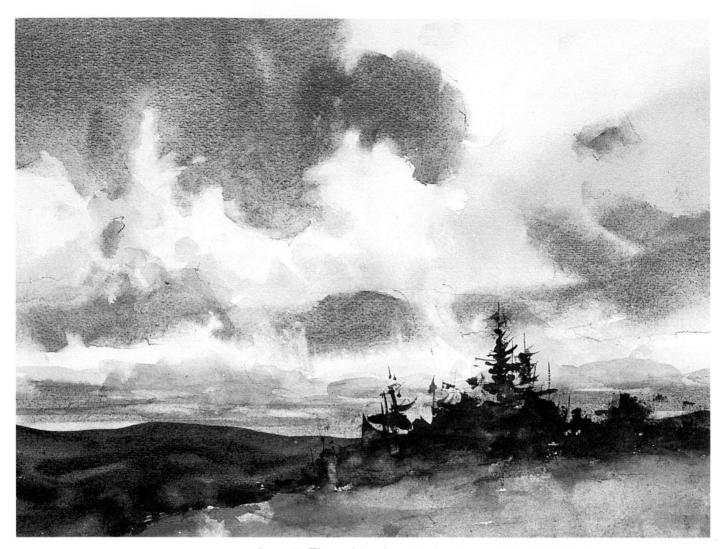

Step 5. The artist paints the land in the foreground wet-in-wet with dark and light strokes of Hooker's green, cadmium orange, and cadmium yellow. You can see where areas contain more orange and where they contain more green. He adds a good deal of water to the wash in the lower righthand section to suggest sunlight falling on the grass.

To Paint a Cloudy Sky

1. Paint the blue patches first, softening some edges with strokes of clear water.

2. Where you want very soft edges, moisten that area and *then* paint the blue sky.

3. Let the blue patches dry thoroughly.

4. Paint the shadow areas of the clouds, leaving bare paper for the lighted areas.

5. Soften some edges with clear water to make the shadow planes melt into the lighted planes.

6. Let the shadows dry thoroughly.

7. To soften more edges—or lighten any area that seems too dark—scrub with a wet bristle brush and pick up the loose color with a paper towel or cleansing tissue.

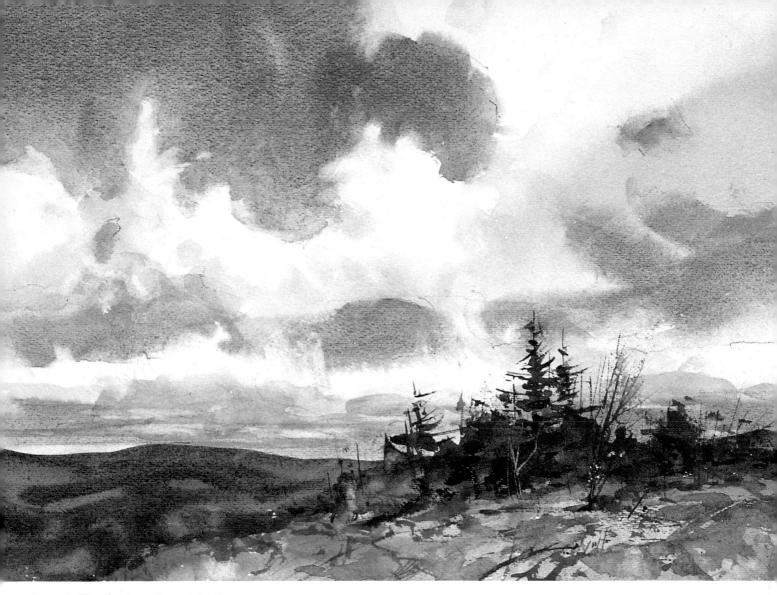

Step 6. The final touches of detail are concentrated entirely in the trees and grass in the immediate foreground. The artist uses a dark blend of Hooker's green and burnt umber to add more detail to the trees - more trunks and branches and touches of shadow. You can see where he uses a sharp blade to scratch out a light trunk beneath the tallest tree. He casually drags the side of a small brush, loaded with Hooker's green and burnt sienna, across the grass to create darker patches. Then the tip of the brush picks up a darker mixture of Hooker's green and burnt sienna to trace some warm, ragged lines over the landscape. You don't actually see grasses, weeds, or twigs, but these strokes make you believe that you see them.

COOL COLORS MAKE SUNSETS GLOW

Step 1. Like most skies, a sunset is difficult to draw in pencil. Therefore, it's best to draw just the shapes of the landscape: the large tree to the right, the smaller trees along the horizon, and the lines of the stream. The artist uses a large flat brush to wet the entire sky with clear water. He paints the sky with the drawing board tilted slightly upward at the back so that the colors tend to run down. Then he brushes mixtures of yellow ochre, cadmium orange, burnt sienna, and cerulean blue onto the surface in long, slow strokes. The lights and darks and the warm and cool tones mingle, wet-in-wet.

Step 2. When the sky is dry, the artist paints the background trees with mixtures of cadmium orange, burnt sienna, and Hooker's green. He paints the warmer strokes first, which are dominated by burnt sienna. The darks contain more Hooker's green, and he paints them over the wet tones of the brighter colors. He makes the ragged strokes against the sky by jabbing the brush against the paper, then pulling away.

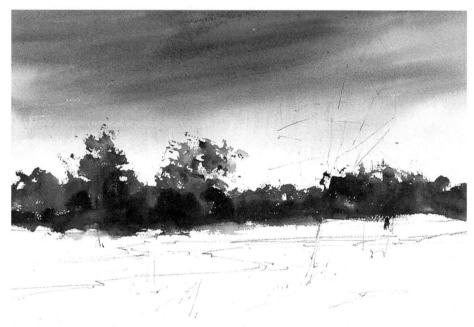

Step 3. The artist paints the shapes of the land on either side of the stream with mixtures of burnt sienna, Hooker's green, and cerulean blue. The immediate foreground contains more Hooker's green.

Working Outdoors

The sky will change faster than you can paint it—so make sketches and paint from them. The colors change so quickly that only a super pro can paint them on location. So write color notes on your sketches. Don't copy color slides! Color film does *not* record colors accurately. The camera *does* lie.

COOL COLORS MAKE SUNSETS GLOW

Cool, Not Hot

The whole secret in painting a sunset is *not* to overdo the hot colors. Sunsets aren't all hot color. They contain lots of cool colors: blue, violet, even green. Emphasize those cool colors. They'll make your warm colors look brighter by contrast. Concentrate your bright colors at the focal point of the picture—and surround them with subdued colors. **Step 4.** Now the artist paints the water with a pale mixture of burnt sienna and cerulean blue. Notice that the strokes in the water are *vertical*, leaving gaps of bare paper, creating a sense of reflected darks and lights. The tone of the water is carried down over the shore to darken the left foreground.

Step 5. So far, the landscape is covered with generally warm tones—too warm to make a satisfying picture. The painting needs some strong, cool notes. The artist paints the dark trees to the right with short, rough strokes in a mixture of Hooker's green and burnt umber. He makes the very ragged strokes against the sky by pressing the brush against the paper, pulling slightly to one side, and then pulling away. The lower tree is simply a dark, liquid mass that spreads at the bottom to suggest that it's sitting on its own shadow.

Step 6. The artist carries the same mixture of burnt umber and Hooker's green across the foreground with rough, irregular strokes, often made with the side of the brush. He allows the underlying tones to break through here and there. He adds darker touches with the tip of the brush. Along the lower edge, to the right, you can see where he's spattered droplets of dark color into the wet wash. He adds more of these darks to the distant trees with drybrush strokes. Then he carries still darker

strokes of the Hooker's green and burnt umber mixture across the foreground with the tip of a small round brush. He adds more branches to the large tree, to the trees in the distance, and along the near shore. To suggest the glare of the sun going down behind the trees at the midpoint of the distant shore, he uses a wet bristle brush to scrub out and soften the edges of the trees. When the color is loosened by the wet bristle brush, he uses a paper towel to blot the area.

SECTION FOUR SEASCAPE SUBJECTS

How Much to Include. Standing on the beach or climbing a cliff overlooking the sea, you almost always see more than you can paint in a single picture. The panorama can go for miles, and you can't possibly include everything. You have to isolate some manageable segment of what you see. Two or three waves and a few rocks can make a simple, effective composition-and will capture the drama of the sea far more effectively than a panoramic picture with row upon row of distant waves. A single headland with a bit of curving beach in the foreground, a few rocks, and a hint of the distant shore-all these are enough to suggest the grandeur of the coastline. In short, try to construct a seascape painting out of just a few simple shapes.

What to Leave Out. You always see more than you paint, so deciding what to leave out is just as important as deciding what to put in. Even when you've finally settled on a simple arrangement of headland, beach, rocks, and a suggestion of distant shore, your painting will probably need further simplification. What if the beach is covered not only with rocks, but with seaweed, driftwood, and other debris? You can't paint them all, so you've got to leave out most of the smaller rocks and merge the remaining ones into a few simple shapes. A few scraps of seaweed are enough, and you may want to redistribute that seaweed so it traces a ragged line across the beach toward the headland, giving the eye a path to follow to your center of interest. It's best to take out the driftwood altogether: that fascinating. twisted shape is a distraction, and it's better to save it for another picture. Be ruthless about leaving out any element that distracts the eye.

Redesigning the Subject. No matter how long you walk the beach, you won't find an ideal subject for a painting, with every rock, cliff, wave, and tidepool in just the right place. You must be prepared to rearrange what nature gives you and organize a picture. If the line of the beach looks too straight, you're free to redesign it into a graceful curve. Are the waves breaking too far up the beach? You can move them closer. Are the rocks too scattered and too far from the water? You can certainly relocate them and regroup them. Are the clouds too small and too high in the sky? Nothing prevents you from making them bigger and moving them down toward the horizon. It's not nature's job to give you a picture. Nature simply gives you the components, and it's your job to put them together.

Time of Day. In painting coastal subjects, when you paint can be just as important as what you paint. Experienced seascape painters like to get going early in the morning, when the sun is still fairly low in the sky, creating strong patterns of light and shadow. That's when the shapes of rocks, cliffs, waves, and surf look most dramatic. In the middle of the day, when the sun is directly overhead, the light is spread evenly over everything, shadows are less interesting, and even the most exciting subject often looks dull. Then things start to look interesting again in the latter part of the afternoon, when the sun is lower in the sky, very much like early morning. Late afternoon can be particularly dramatic as the sun drops toward the horizon. Now the shapes of rocks, headlands, and crashing surf are *between* you and the sun, which throws them into dark, bold silhouettes. So get going early, take a long lunch break, and then go back to work.

Changing Conditions. Nature never sits still, never strikes a pose for you. The waves keep moving; the wind blows the clouds across the sky: and the light changes from hour to hour. How can you "freeze" all the chaos and movement long enough to paint a picture? The best solution is always to make a small pencil sketch before you start to paint. The waves may keep moving and changing their shapes, but you *decide* on the shape you want and establish that shape in your pencil sketch. Halfway through the painting, those clouds may have shifted position, but they're in the right place in your pencil sketch. Having invested ten or fifteen minutes in the pencil sketch, you now have a firm idea of your picture, even if conditions change radically. You still paint from nature, of course, but you refer to the pencil sketch whenever you're in doubt. For example, let's say that the wind has reshaped your clouds. You look at the shapes in your original sketch, then look back at the changing shapes in the sky, and remold them to fit the sketch.

A Note of Caution. When you're climbing out on the rocks to find the right vantage point, remember the tide! Keep an eye on the rising water and get back to the beach in plenty of time. Don't get stranded.

Cool Colors. Seascapes tend to be dominated by cool colors, which means blues, greens, and grays. Within this cool color range, it's possible to achieve great variety if you know how to modify the two blues on your palette, mix interesting greens without simply relying on your tube of Hooker's green, and mix the colorful grays that are so typical of coastal subjects.

Blues. The two blues on your palette-ultramarine and cerulean-can be transformed into many shades of blue simply by adding faint touches of other colors. Just a speck of brownburnt umber or burnt sienna-will push either of these blues a bit closer to gray. Hooker's green will obviously turn them both to greenish blue. A trace of alizarin crimson will produce purplish blues, but avoid the more powerful cadmium red light, which will demolish both blues-although you *will* get some interesting coppery darks. All these different blues will give you a rich variety of colors to use in painting skies and water.

Greens. In coastal subjects, greens most often turn up when you paint water, which means waves, tidepools, and the inland water of the salt marsh. First try modifying the one green on your palette, Hooker's green, with the two blues to produce bluish greens. A touch of cadmium yellow light will turn Hooker's green – or one of those blue-green mixtures-into the brilliant transparent green that you often see when the sun shines through a wave. A trace of warm color, such as alizarin crimson or one of your browns, will darken one of those bluegreen mixtures to give you the heavier tone that you often see where the distant sea meets the sky. It's even more important to learn how to create greens by blending your blues and yellows – or Payne's gray with one of your yellows. And each of these blueyellow or gray-yellow mixtures can be further modified with a warm touch, such as one of your browns or reds.

Grays. Beginning painters often have the mistaken idea that gray is the dullest of all colors - not really a color at all. But if you look closely at nature, you'll see that grays are everywhere and are as varied as any other color. Gray isn't merely a pale version of black; it can turn out to be an extremely subdued version of any color on your palette. You should certainly learn to mix the lovely variety of grays you can get by blending blues and browns, varying the proportions of the mixture to produce cool grays (dominated by blue) and warm grays (dominated by brown). Starting with these basic blue-brown combinations, you can add a touch of any other color on your palette. Yellow ochre will add a slightly golden tone; but you've got to be more cautious about adding cadmium yellow light, because a little goes a long way and may destroy the gray altogether. A suggestion of alizarin crimson can push a gray mixture toward violet, but be careful about adding cadmium red.

Painting Water. In painting coastal subjects, the colors of water are most difficult to capture. It's important to remember that water is a reflecting surface, which means that it picks up a lot of its color from the sky. A bright blue sky—even punctuated by some clouds—generally means that you'll see plenty of bright blue in the water, too. Conversely, a gray sky means that you'll see a lot of gray in the water. Don't just make up your mind that water is "always blue" and paint bright blue waves even when the sky

is overcast. Look closely at moving water and you'll see that it's never one uniform tone, but contains a variety of colors. The horizontal surfaces, facing up toward the sky, are most likely to reflect the sky color. A vertical surface, such as the face of the wave rolling toward you, may be brilliant green because the sunlight is shining through it. The broken wave that spills along the beach may combine reflected color, picked up from the sky, with some sandy tones.

Painting Surf. Resist the temptation to paint surf as if it's a mass of snow white whipped cream. Remember that surf is simply water in another form, so it still reflects the colors of its surroundings. In bright sunlight, that "white" surf may have a slightly golden tone. On an overcast day, the surf is likely to be a delicate gray. And don't forget that surf has a shadow side, just as a cloud does. That shadow isn't necessarily gray, but might be gold, green, blue, or even violet—you've got to look carefully to make sure.

Color Schemes. Surrounded by so much cool color-blue, green, grayyou have to plan your color schemes so that your pictures don't become monotonous. Look for opportunities to introduce some subtle, warm notes. On a sunny day, the whites of the clouds frequently contain a hint of gold or pink. A blue sky often grows slightly warmer toward the horizon, where you're also likely to see a hint of gold or pink. There are apt to be touches of yellow sunlight on waves and surf. Those "gray" rocks often contain browns, yellows, oranges, and violets. Although sand is rarely as yellow as you think, it is generally tan or a subdued brownish gray, with hints of gold in bright sunlight.

MIXING COLORS FOR SEASCAPES

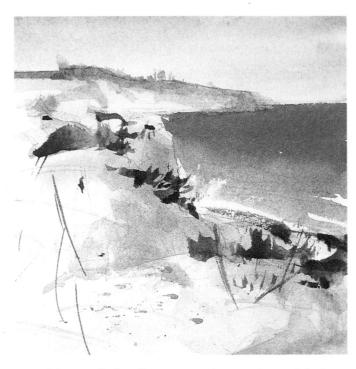

Sand in Sunlight. On a sunny day, sand certainly has a golden tone—but it's *not* as yellow as you think. This beach is painted with subdued yellow ochre—not the more brilliant cadmium yellow—with a hint of burnt sienna and some cerulean blue in the shadows.

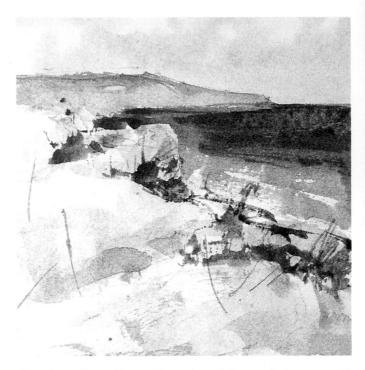

Sand on Gray Day. The color of the sand changes radically on an overcast day. The golden tone turns grayish, with just a hint of warm color. The beach is painted with yellow ochre and burnt sienna once again, but with a lot of Payne's gray instead of cerulean blue.

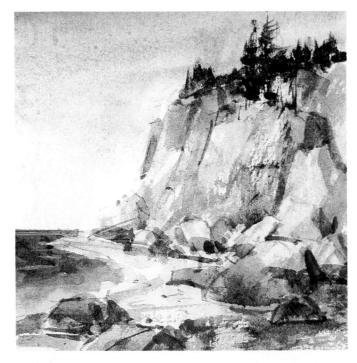

Headland in Sunlight. In sunlight, these rocks are painted with a mixture of yellow ochre and burnt sienna, plus some alizarin crimson in the brighter patches and some cerulean blue in the shadows. The shadowy rocks in the foreground are the same mixture, with more cerulean blue.

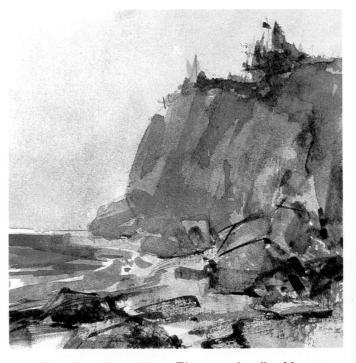

Headland on Gray Day. The same headland becomes a totally different color when the weather turns gray. The rocky shapes are painted with a mixture of yellow ochre, burnt sienna, and Payne's gray—with a bit more burnt sienna and Payne's gray in the shadow areas.

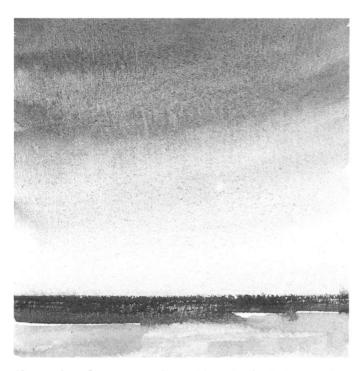

Clear Sky. On a sunny day, a blue sky is darkest and bluest at its highest point, growing paler and warmer as it approaches the horizon. This sky is painted with a lot of ultramarine blue at the very top, gradually mingling with strokes of cerulcan blue, which mingle, in turn, with yellow ochre above the horizon.

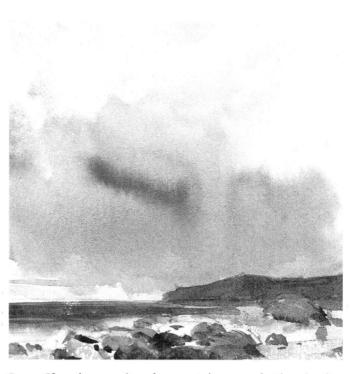

Gray Sky. A gray sky often contains gaps in the clouds, through which you can glimpse the warm tones of the sun. This overcast sky begins with a pale wash of yellow ochre, followed by large strokes of Payne's gray, put in while the underlying color is still wet.

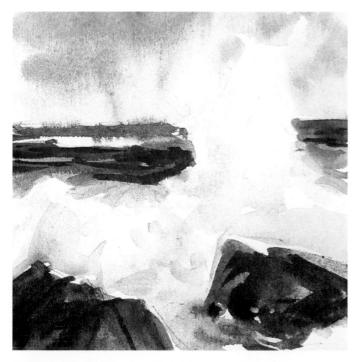

Surf in Sunlight. On a bright, sunny day, the surf and the wet, shiny rocks have a distinctly warm tone. The warm shadows on the foam are burnt sienna and cerulean blue.

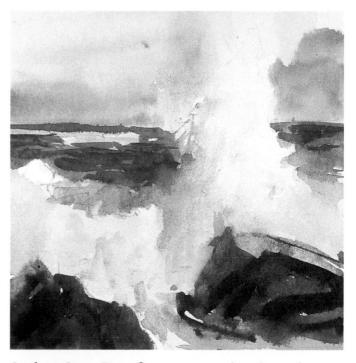

Surf on Gray Day. On an overcast day, the surf turns cooler, and the wet rocks are a more subdued tone. Now the dark tones in the foam are a pale mixture of burnt sienna and cerulean blue—with more blue.

PAINTING THE TRANSPARENCY OF WAVES

Step 1. The preliminary pencil drawing defines the shape of the foam of the breaking wave, then traces the tops of the distant waves and the shape of the shoreline. The sky is covered with a pale wash of yellow ochre, applied with a large round brush, followed by strokes of cerulean blue. The two colors merge softly, but each retains its identity.

Step 2. The artist uses a large round brush to paint the water in thick, curving strokes, leaving strips of bare paper to suggest the foamy tops of the waves. He leaves a strip of white along the horizon to look like light shining on the water. The strokes are mixtures of yellow ochre, cerulean blue, Payne's gray, and ultramarine blue – never more than two or three colors to a mixture. He paints the distant headland with a flat wash of yellow ochre, cerulean blue, and Payne's gray.

Step 3. The shape of the foam is more clearly defined by surrounding strokes of ultramarine blue, Hooker's green, and burnt umber. Before these colors are carried under the forward edges of the foam, the bare paper is brushed with clear water, so the strokes at the bottom of the wave have soft edges.

Tips for Painting Waves

1. Waves, like clouds, change so quickly that you can't paint them as they move. Make on-the-spot sketches and work from them.

2. If you're painting on location, work from the sketches *and* from nature. Transfer the sketch to the watercolor paper and then look at the waves for color and detail.

3. Remember that the color of water always reflects the sky's color.

4. A blue sky usually produces blue or blue-green water.

5. A gray or overcast sky usually produces gray or gray-green water.

6. The brightest color in the wave appears where the sun shines *through* the water.

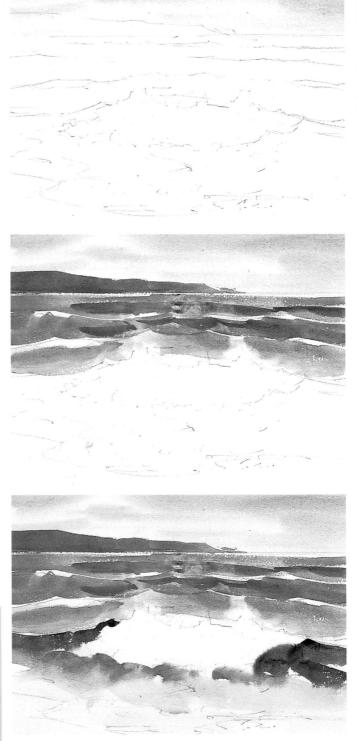

Step 4. The artist darkens the sea with more curving strokes of ultramarine blue, Hooker's green, and burnt umber. He concentrates the darkest strokes behind and around the foam, which now stands out as a strong, light shape.

Keep a Sketchbook of Waves

If you're really serious about painting seascapes, fill a sketchbook with wave studies:

1. Make rapid pencil drawings of the shapes of different kinds of waves.

2. Make careful diagrams of the patterns formed by the trickles of foam that move down the faces of the waves.

3. Paint small watercolor studies of the colors of waves at different times of day-and in various kinds of weather.

4. With charcoal, Conté, or a soft pencil, make drawings of rocks, paying particular attention to the shapes of the foam that run over and through the rocks.

5. Get some gray or tan paper and make studies of foam with white chalk.

Step 5. When the colors of the surrounding waves are dry, the artist brushes in the shadows on the foam with a pale wash of cerulean blue and burnt sienna, broken and softened by strokes of clear water that preserve the whiteness of the paper at the top of the foamy shape. Above and behind the breaking foam, he paints the green top of the wave with cadmium yellow, Hooker's green, and cerulean blue — the strokes curving downward to follow the movement of the wave.

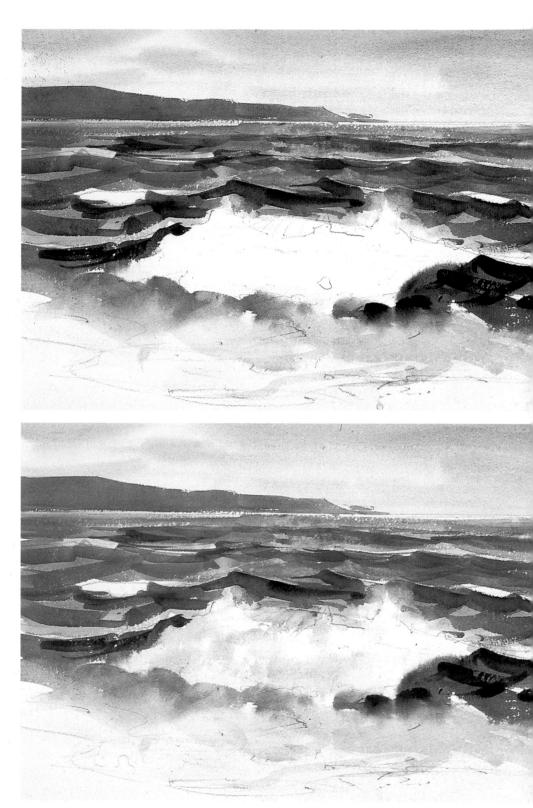

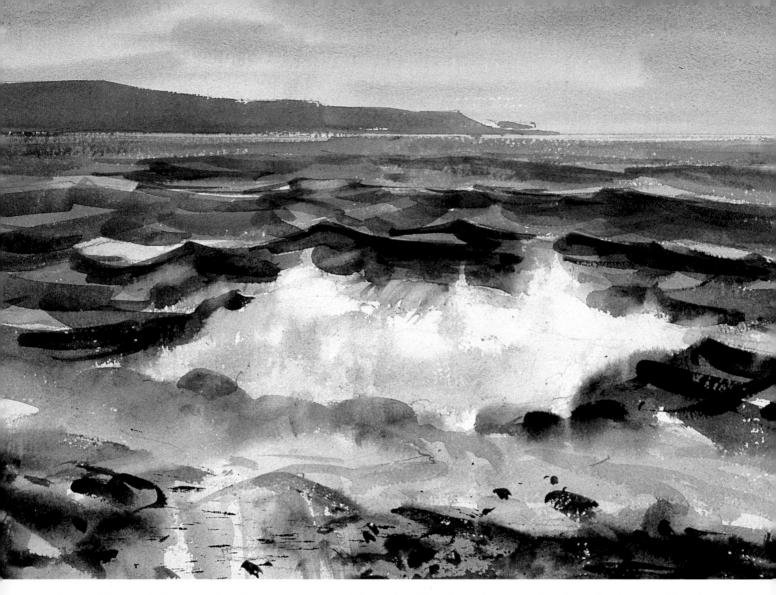

Learning About Waves

As you draw more and more waves, you'll begin to identify the different wave forms:

1. Swells are the rising and falling waves—far from shore—that look like low mountain ranges, ranked one behind the other.

2. Whitecaps appear when the wind whips the tops of the swells and produces foam.

3. Cresting waves rise and begin to pitch forward as they approach the shore-just starting to break into foam.

4. Breaking waves appear close to the shore. The wave rolls over on itself, and the forward edge explodes into foam.

5. Don't fill your painting with breaking waves. Save those dramatic wave shapes and explosions of foam for the focal point of the picture.

Step 6. The strip of beach at the lower edge of the painting is brushed in with mixtures of burnt sienna and cerulean blue in the light areas, burnt umber and ultramarine blue in the darks. The wet strokes blur into one another. Notice the pale patch just left of center, broken by vertical strokes, which looks like a reflection on the wet sand. Some of the white patches on the distant sea are a little too insistent, so they're toned down with very pale washes of yellow ochre and cerulean blue, applied with a small round brush. It's important to darken these patches so they don't distract attention from the larger white shape of the breaking wave. Just above the dark shape of the beach at the right you can see how the artist used pale strokes of ultramarine blue, Hooker's green, and burnt umber to strengthen the water spilling across the beach in the foreground. Then with the tip of a small round brush he adds dark strokes and flecks that look like rocks and bits of seaweed on the beach. Notice how a few very thin strokes carry across the pale patch of sand – just left of center – which now lies flat and looks really shiny.

EXPRESSING THE POWER OF SURF

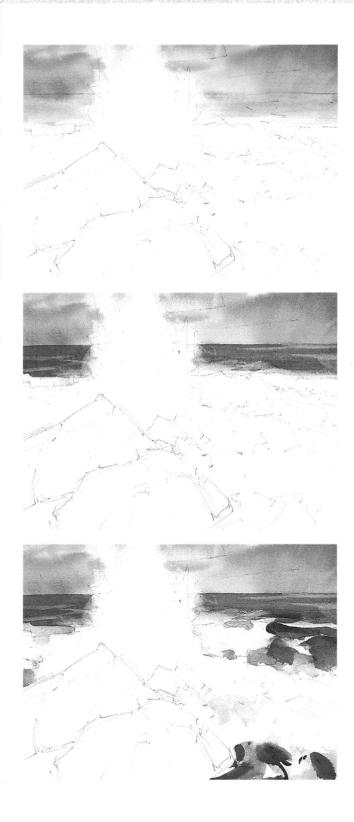

Step 1. The shapes of the rocks are carefully drawn in pencil, as are the shapes of the waves to the right. The artist has clearly established the horizon line, but he's casually drawn the burst of foam since this will have soft, wet edges. He brushes the upper third of the paper with clear water, followed by strokes of yellow ochre and Payne's gray; these are carried up to the edge of the foam, where they melt softly away, leaving bare paper.

Step 2. When the sky and distant sea are dry, the artist darkens the water with a wash of Payne's gray and yellow ochre. This, in turn, is allowed to dry. Then, he carries darker strokes of the same mixture over the underlying color, leaving lighter strip between them.

Step 3. The artist adds some pale shadows to the foamy shapes surrounding the big burst in the center. These are mixtures of yellow ochre, Payne's gray, and ultramarine blue, painted with a large round brush. He paints the darks of the waves in the middle distance and in the right fore-ground with this same mixture, containing much less water. But most of the foam is still bare paper at this stage.

Preserving the White Paper

When you paint surf, you must plan the painting so that you keep the white paper untouched—a process that's often called "reserving the lights" or "reserving the whites":

1. Notice how the artist carries the sky to the edges of the foam, carefully working around the white shape so that the contours of the foam are clearly defined.

2. He paints the sky wet-in-wet so that the edges of the foam shape are slightly blurred.

3. But you should also try painting the sky on *dry* paper, stopping at the edges of the foam, and then touching those edges with a few strokes of clear water—so you have some hard edges and some soft ones.

4. And you should try painting the sky around the edges of the foam with drybrush.

EXPRESSING THE POWER OF SURF

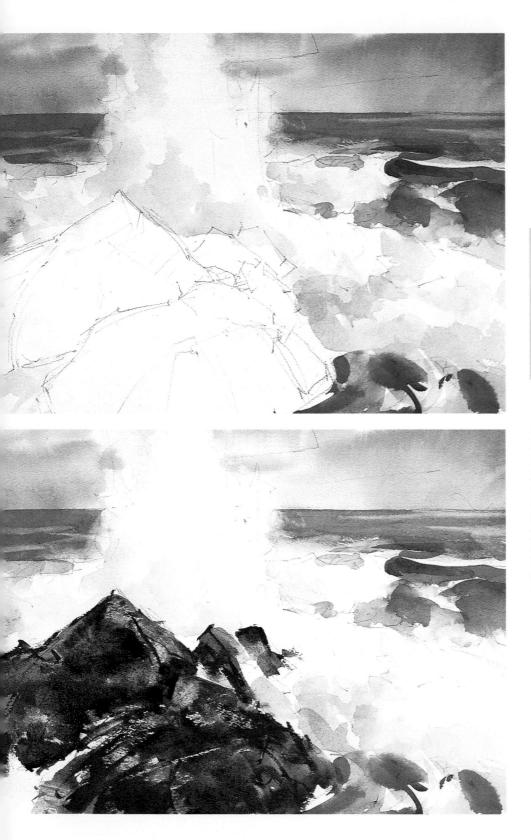

Step 4. All the major shadow areas of the foam are now painted with Payne's gray and a little yellow ochre. The strokes are short and ragged, often applied with the side of a round brush, reflecting the movement of the foam. The artist softens the edges of some strokes with a stroke of clear water—you can see this in the shadow to the left of the big burst of foam.

Catching Surf in Motion

Exploding surf moves even faster than waves. Make sketches. Then work from sketches *and* from nature at the same time. If time and weather are a problem, start your painting on location and finish it at home—from your sketches and color notes.

Step 5. The artist paints the dark shapes of the rocks with rough, rapid strokes of burnt umber, Hooker's green, and ultramarine blue. The strokes vary in tone, some containing more burnt umber and some containing more blue or green. While the paint is still damp, he scrapes it with a knife blade, which leaves some lighter patches and some irregular scratches that express the rocky texture.

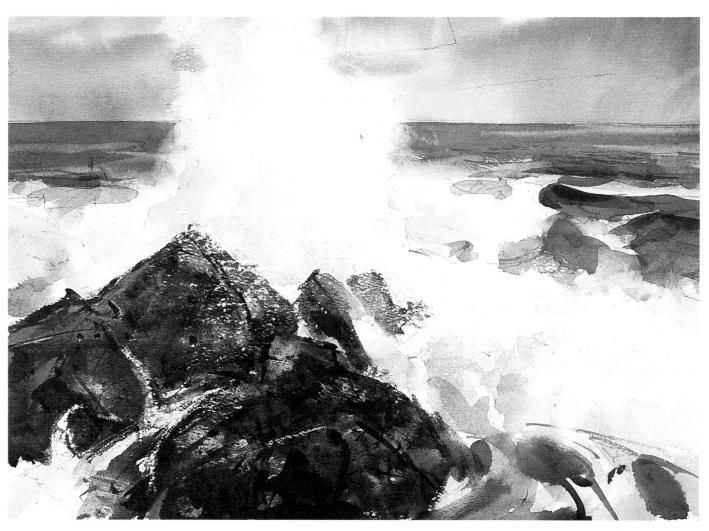

Step 6. When the rocks are dry, the artist uses the tip of a small round brush to add dark lines and dots—a mixture of alizarin crimson and Hooker's green. Now the rocks have the usual cracked, rough surface. Then he uses the same brush to add some thin strokes of Payne's gray and ultramarine blue in the upper right section of the painting to define the distant waves more clearly. Now he lightly carries a sharp knife—not the tip but the sharp edge—over the surface of

the rocks and the foam in the foreground, gradually lifting away some bits of color from the high points of the paper. Where these flecks of color are removed, dots of bare paper begin to show through. Now flecks of foam seem to be flying over the rocks and into the air. Notice how the artist uses the tip of the knife to scratch a white line next to the dark crack in the rock to the extreme left, so that the crack seems deeper and more threedimensional.

Foam Has a Shape

Foam is *not* a shapeless puff of smoke. It has a distinct shape, which tends to repeat itself each time the water hits the same rock formation. And it isn't just gray and white, either:

1. Watch that shape again and again before you draw it.

2. When the shape is fixed in your mind, draw it precisely. Then paint it.

3. Pay special attention to the light and shadow areas. Each has its own shape.

4. Make color notes on your sketches. The light and shadow planes are full of subtle color.

TIDEPOOLS: A STUDY IN CONTRAST

Step 1. This painting will have a lot of curves and angles that must be well defined in the drawing. The artist carefully draws the shapes of the tidepools left behind by the receding water, the big forms of the rocks, and the headland on the distant horizon. The sky is covered with a wash of yellow ochre, followed by strokes of Payne's gray, applied while the yellow ochre is still wet. The artist paints the distant headland with a darker wash of vellow ochre, cerulean blue, and Payne's gray, lightened here and there by touching it with a paper towel. He carries this mixture down into the rhythmic shapes of the beach. Notice how the mixture gradually changes as it comes toward the foreground, where there's much more vellow ochre. The rocks and water are still bare paper.

Step 2. The shapes of the sand are darkened and defined more clearly with strokes of Payne's gray, yellow ochre, and burnt sienna. The sand in the lower right section is painted with drybrush strokes to suggest a pebbly texture.

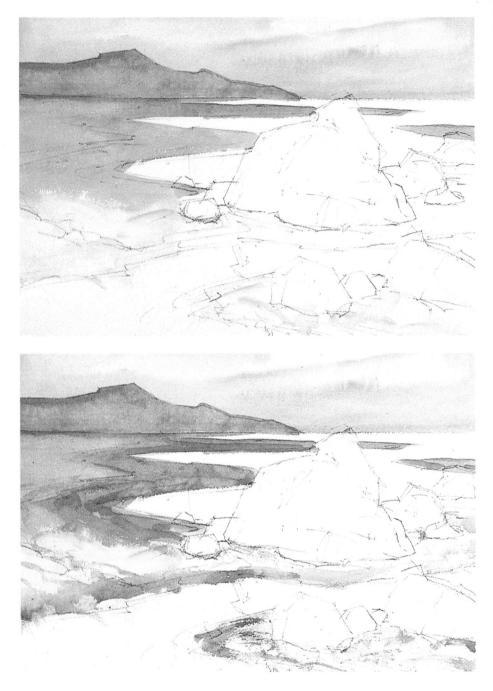

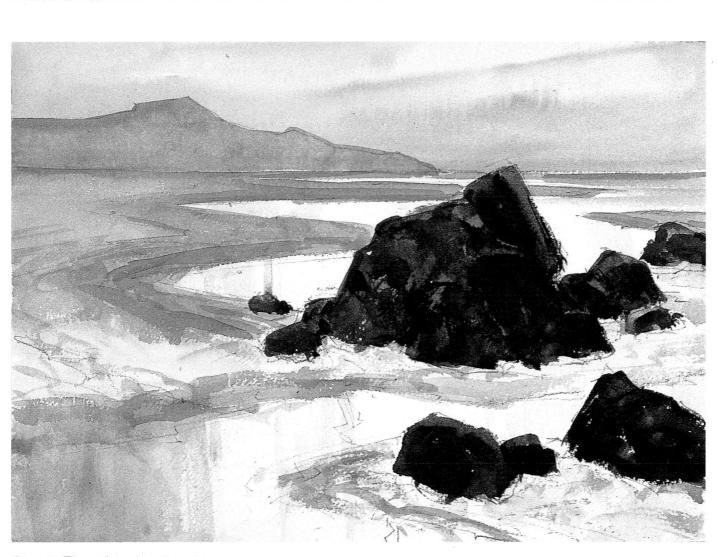

Step 3. The artist paints the still water of the pools with a flat brush, applying vertical strokes of Payne's gray, cerulean blue, and yellow ochre that suggest reflections from the sky and from the edge of the sand. He paints the distant water in the upper right section with horizontal strokes of the same mixture. Then he paints the dark tones of the rocks with mixtures of alizarin crimson, Hooker's green, and burnt umber, applied with overlapping strokes, some darker and some lighter. While the color is still wet, he scrapes away some lighter areas with a blunt knife.

TIDEPOOLS: A STUDY IN CONTRAST

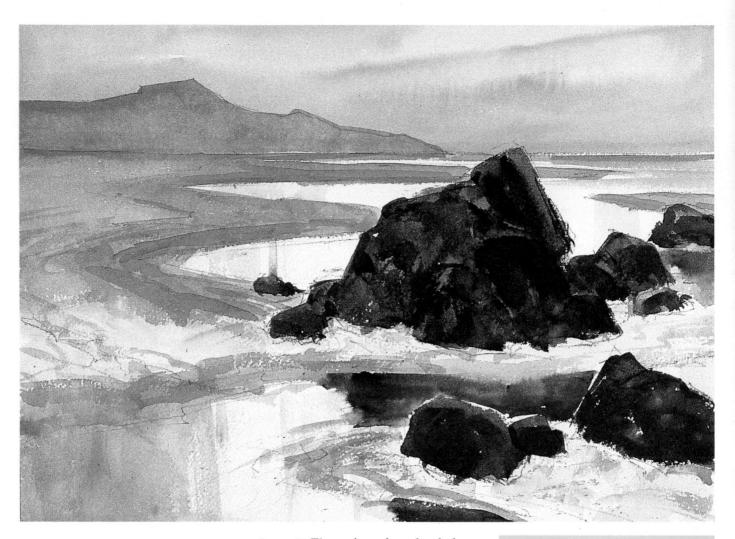

Step 4. The artist paints the dark reflection of the biggest rock with the same mixture of Hooker's green, alizarin crimson, and burnt umber, using a small round brush to move carefully around the edge of the smaller rock beneath. He blurs the top and left side of the reflection with strokes of clear water. He paints the reflections of the small rock at the extreme right and the rock at the bottom of the picture with the same mixture.

Remember These Steps

1. The artist paints the sky wetin-wet: dark clouds over a lighter background tone.

2. He paints the headland with a flat wash, then lightens it with a touch of a paper towel.

3. He paints the shape of the beach with an irregular graded wash that grows paler and more colorful in the foreground.

4. He restates the beach with darker strokes to emphasize the shape.

5. He paints the pools with vertical strokes that suggest reflections.

6. He paints the rocks with thick color-scraped with a blunt knife and lightened at some spots with a damp bristle brush.

7. He adds final details with small brushstrokes and spattered color.

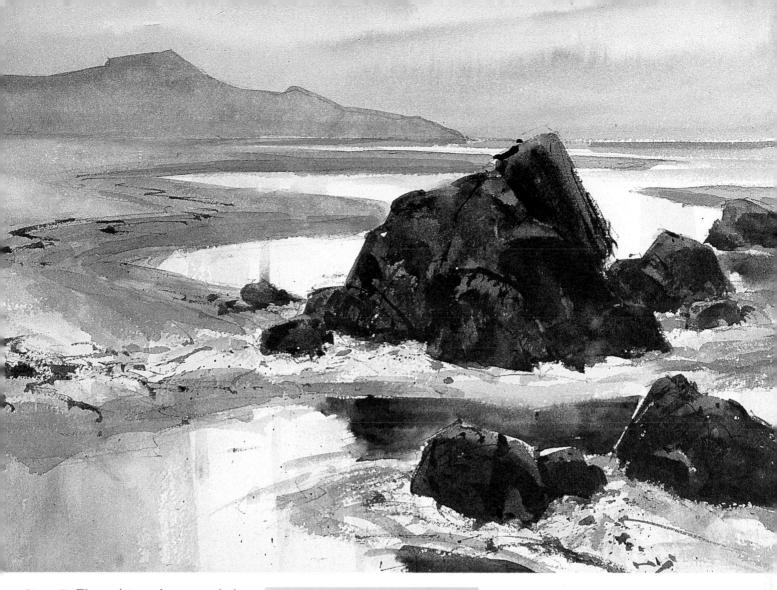

Step 5. The artist carries more dark strokes around the edges of the water-mixtures of Hooker's green, Payne's gray, yellow ochre, and burnt sienna. He textures the sand beneath the biggest rock and in the lower right corner with more strokes of burnt sienna and Hooker's green. He scrubs the tops of the rocks with a wet bristle brush and blots them with a paper towel to lighten them a bit. He loads a small round brush with a dark mixture of cadmium red and Hooker's green; the tip of the brush adds dark strokes to finish off the rocks. The same mixture is used for dark drybrush strokes to suggest seaweed on the sand. Notice how the seaweed follows the curve of the shore into the distance. The brush is flicked at the sand, spattering dark droplets that look like pebbles and other debris.

Aerial Perspective

This painting is a particularly dramatic example of aerial perspective: The darkest tones, the strongest contrasts, and the most detail are in the foreground, while the palest tones and least detail are in the distance.

SIMPLIFYING THE DETAIL OF A MARSH

Step 1. The sea invades the land to form a salt marsh, where thick patches of marsh grass grow to create islands and peninsulas. The shapes are ragged and spiky; therefore, all you can do is indicate them very roughly with pencil lines. The important thing is to establish the overall shapes of land and water. The sky begins with a pale wash of yellow ochre and alizarin crimson, followed by strokes of cerulean blue and Payne's gray, applied while the underlying color is still wet.

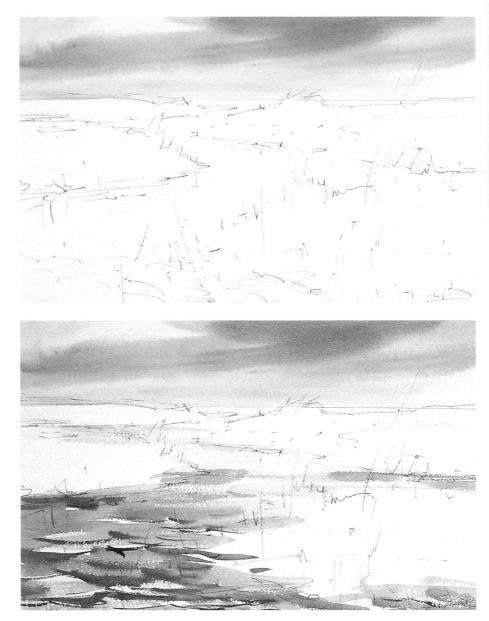

Step 2. The artist paints the water the same way. First, he covers it with horizontal strokes of alizarin crimson, yellow ochre, and a bit of Payne's gray, leaving breaks between the strokes to suggest light on the water. Before this warm wash is completely dry, he adds the darker strokes in the foreground and middle distance -amixture of cerulean blue and Payne's gray. The strokes curve slightly to express the ripples of the water.

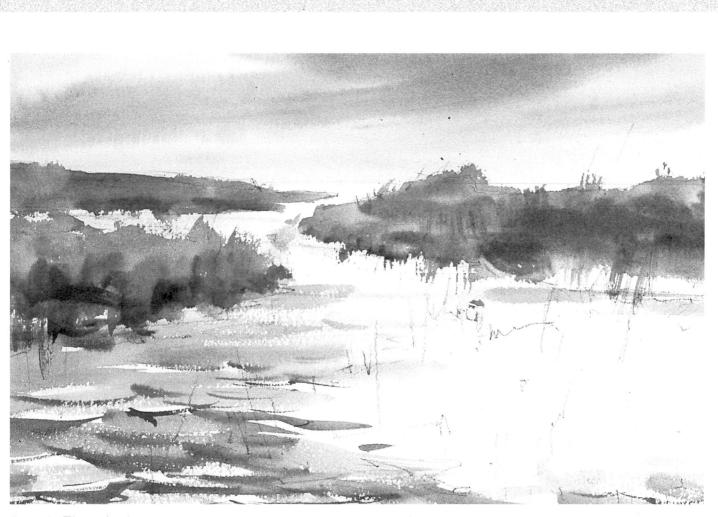

Step 3. The artist first covers the shapes of the marsh grass in the middle distance and along the horizon with a warm mixture of burnt sienna and cerulean blue. While this is still wet, he brushes in a darker, cooler mixture of Hooker's green and burnt umber with ragged strokes, leaving some lighter gaps. He carries the strokes downward into the water to suggest reflections.

Analyze the Brushwork

1. The artist paints the sky with long, leisurely sweeps of color, wet-in-wet, to suggest the movement of the cloud shapes.

2. The brush carries lots of wet color as he paints the masses of marsh grass with broad strokes, both horizontal and vertical.

3. He paints the water with horizontal strokes, some straight and some slightly curved, to indicate the very gentle movement of the inland water.

4. Drybrush strokes leave ragged gaps of bare paper in the water to suggest reflected light.

5. While the darker grass in the lower left is still moist (but not sopping wet), the artist creates some detail with the tip of a blunt knife.

SIMPLIFYING THE DETAIL OF A MARSH

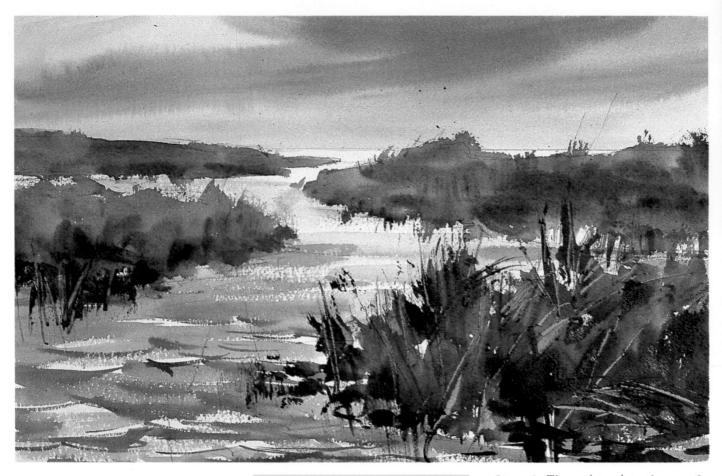

Less Is More

1. Paint the masses of marsh grass as big, simple shapes. Avoid detail at the beginning.

2. When you get to the details of the marsh grass, leave out more than you put in! Don't paint every blade and stalk. A few will do.

3. Paint just enough detail to make the viewer *believe* that the whole picture is full of detail. Then stop.

4. Concentrate your details, such as ripples and grass, in the fore-ground. Keep the distant shapes as simple as possible.

Step 4. The artist paints the marsh grass in the foreground with the same colors as those in Step 3, but with less water; thus the tone is darker. While the color is still damp, he uses a blunt knife to scrape away some light lines to suggest pale stalks. You can see that the strokes of the brush vary in tone, some containing more brown and others containing more blue or green. A similar patch of grass is painted in the section at the left.

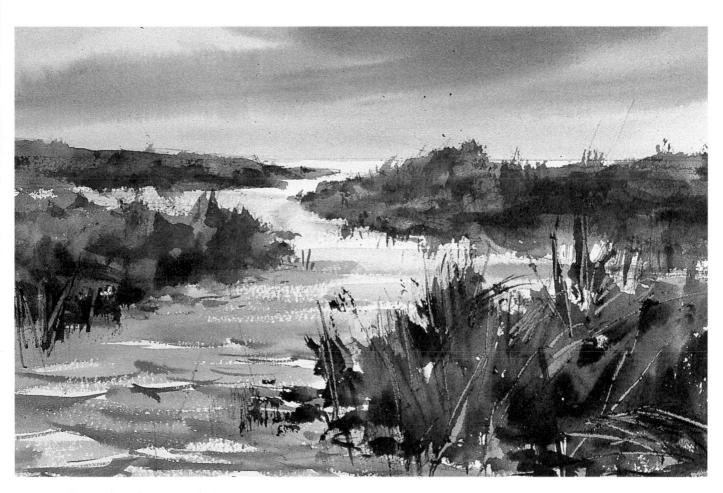

Step 5. The artist adds more darks to the marsh grass in the distance with a mixture of Hooker's green, cerulean blue, and burnt sienna, applied with a small round brush. Now the shapes of the marsh grass seem to have distinct lights and shadows, although these are painted very loosely.

Water Reflects the Sky

When painting a marsh, remember that the water reflects the sky. So paint them both with the same color mixtures. The water is shallow. You'll see ripples more often than waves. Observe the pattern of the ripples.

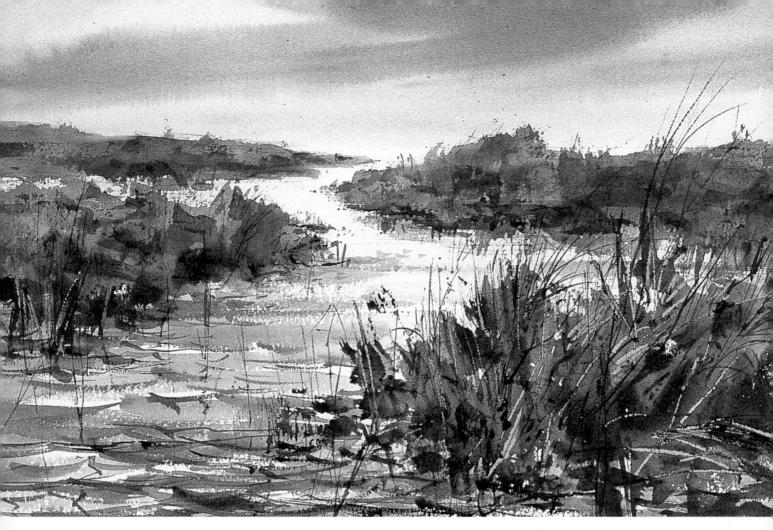

Step 6. The artist adds more detail to the marsh grass in the right foreground using the tip of a small brush (a rigger would be helpful here). The dark lines are a mixture of Hooker's green and burnt sienna. The artist adds blades of marsh grass to the water and a wiggly reflection beneath one of the stalks toward the left. He uses the tip of a small round brush to add dark ripples to the water in the foreground and dark reflections beneath the clump of marsh grass to the right. These curving strokes, which express the movement of the water, are a mixture of Hooker's green, Payne's gray, and burnt umber. He adds more blades of grass made with Hooker's green, burnt sienna, and alizarin crimson. If you look carefully at the lower left section, you'll see reflections of the grass – slender, zigzag strokes. More light lines are scratched out of the grass to suggest individual stalks caught in sunlight. With so much intricate brushwork in the foreground, it's important to keep the shapes in the middle ground simple, as you see here. And it's equally important to have a simple sky.

CAPTURE THE MAGIC OF MOONLIGHT

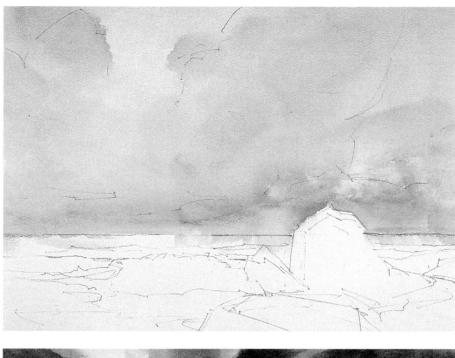

Step 1. Because this will be a dramatic sky, painted wet-in-wet, only a few big cloud shapes are defined in the pencil drawing—and these will certainly disappear as the color begins to flow. It's more important to define the horizon line clearly and draw the solid shapes of the rocks. The lines on the sea divide the light areas from the dark. So that the sky won't be too cold, it's covered with a warm mixture of yellow ochre and alizarin crimson.

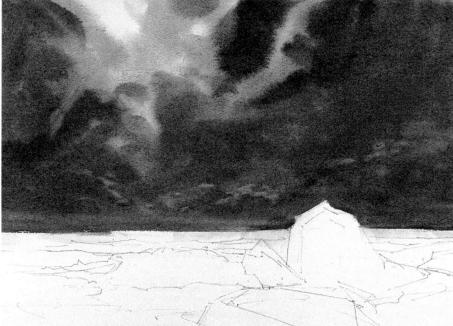

Step 2. While the warm undertone is still wet, the artist floods dark strokes of Hooker's green, ultramarine blue, and burnt sienna onto the shiny surface of the paper. He doesn't completely cover the paper. One large gap and some smaller ones are left for the moonlight.

You Can Fix It

While the dark sky is still wet, you can use a paper towel or a cleansing tissue to blot away some dark color if it gets out of hand.

CAPTURE THE MAGIC OF MOONLIGHT

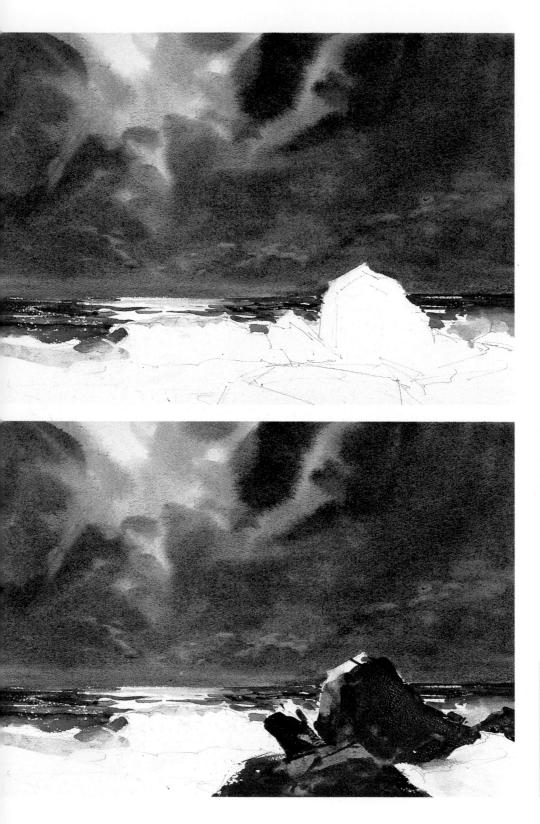

Step 3. The artist allows the rich sky color to dry. Now he paints the darks of the water with a mixture of Hooker's green, ultramarine blue, and burnt sienna. He makes horizontal strokes with the tip of a small round brush, leaving a large gap of bare paper, plus some smaller flecks of white for the moon shining on the sea. Paler strokes of this same mixture are used to darken some parts of these light patches and are carried toward the foreground. The foam and the rocks are *still* bare paper.

Step 4. The artist paints the dark shapes of the rocks with burnt umber, alizarin crimson, and Hooker's green. A lighter wash of this mixture goes on first, followed by darker strokes, some containing more brown and others containing more green. He leaves the top of the biggest rock untouched, suggesting a patch of moonlight.

Moonlight Is Colorful

Don't believe the poets who tell you that moonlight is always blue or silver! Paint the colors you see not what you think you see. A moonlit picture isn't all just black, gray, and white, but can be full of rich color.

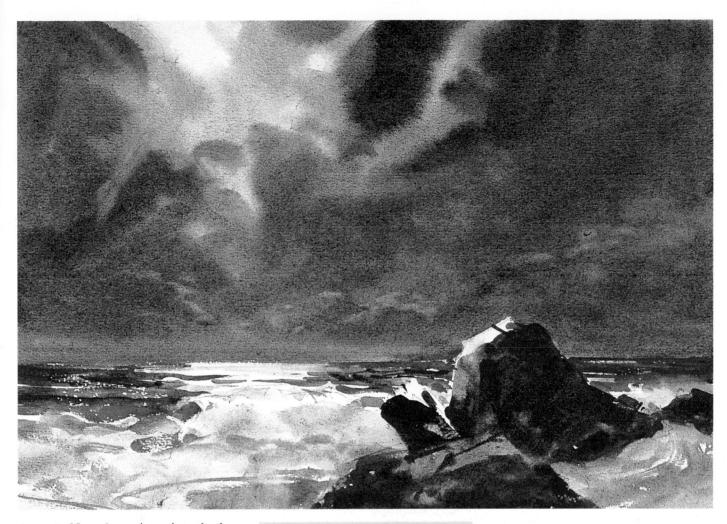

Step 5. Now the artist paints the luminous shadows of the foam in the foreground with mixtures of burnt sienna, cerulean blue, and yellow ochre. The wet strokes blur into one another. He paints a dark pool next to the foreground rock with cerulean blue and burnt sienna. The top edge of the breaking wave remains bare paper, giving the impression of reflected moonlight. Notice the curving strokes in the lower right corner, suggesting the swirl of the water.

What Color Is Moonlight?

1. Depending upon weather, atmosphere (which includes manmade factors such as pollution!), the seasons, the position of the moon in the sky, and the specific time of night, the moon and its light can be almost *any* color.

2. Moonlight can be a warm color, such as orange, yellow, even red or violet.

3. Moonlight can be a cool color, such as blue or green.

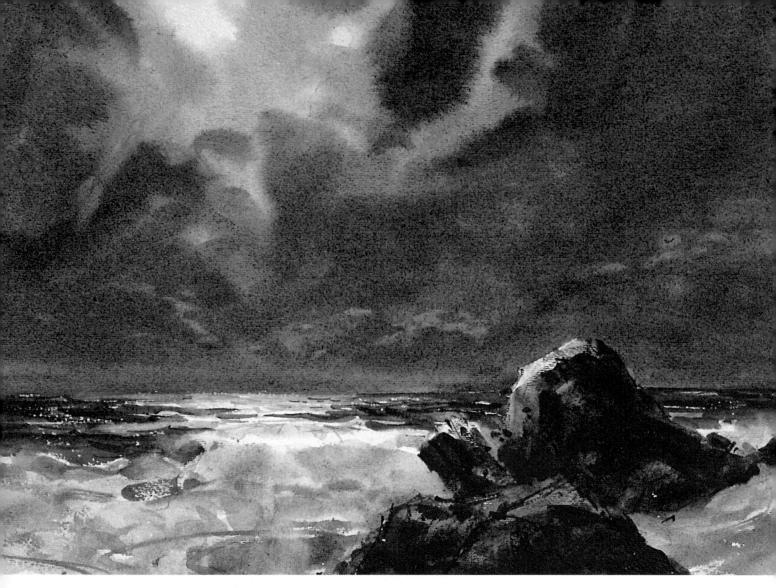

Remember:

A moonlit sky is usually lighter than the land or sea. And the color of the moonlight will influence every color in the land or sea below. **Step 6.** The artist scrubs some light tones out of the dark rocks with a wet bristle brush, then blots them with a paper towel to lift off the color. He then slightly warms the rocks with a mixture of alizarin crimson and yellow ochre, applied with a small round brush. This brush picks up a mixture of alizarin crimson and Hooker's green to add more dark strokes to the rocks, sharpening their edges and making them stand out more clearly. The artist adds small strokes of this

same mixture to the distant sea, suggesting more waves. Look carefully at the top of the foam, just below the flash of moonlight on the sea, and you can see where he's used a wet bristle brush and a paper towel to scrub away a bit more color to reveal more white paper. The moonlit top of the most prominent rock is warmed very slightly with a pale mixture of alizarin crimson and yellow ochre. You can now see this mixture very clearly in the moonlit patch on the water.

USE SUBTLE COLORS FOR ROCKY SHORES

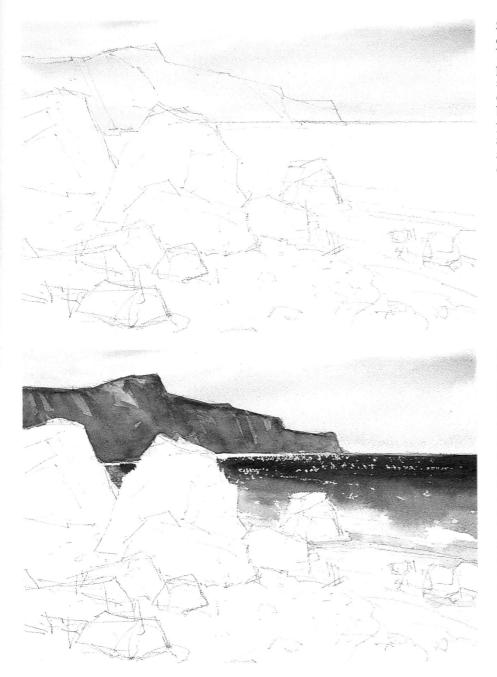

Step 1. Rocks must be studied with care and then drawn with precision. You can't just invent them. Here, the pencil lines define not only the overall shapes of the rocks, but the shapes of the shadows. The artist first brushes the sky with a pale wash of yellow ochre. Into this wet color goes a darker mixture of Payne's gray and alizarin crimson. There's a little more crimson just above the horizon.

Step 2. The artist paints the water with ultramarine blue, Hooker's green, and burnt umber. He applies the color with dark, heavy strokes at the horizon, adding more water to the mixture as he works toward the beach. He leaves some bare paper to suggest light on the water in the distance and some more bare spots along the beach to suggest foam. He first covers the headland with a pale wash of Payne's gray and burnt sienna. When this is dry, he paints a darker mixture of the same colors, with more Payne's gray, in straight diagonal strokes to create the shadows on the cliffs.

USE SUBTLE COLORS FOR ROCKY SHORES

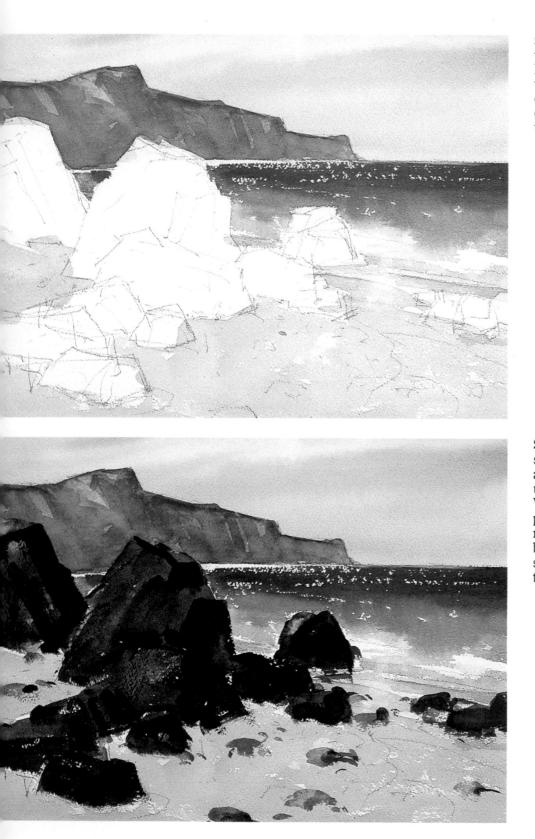

Step 3. The artist paints the sand with a mixture of yellow ochre and Payne's gray. It's no problem if the wash for the sand splashes over the edges of the rocks. The dark colors of the rocks will quickly cover any-thing underneath.

Step 4. The big rocks and some smaller stones are first covered with a mixture of Hooker's green, burnt umber, and a little cadmium red. When this undertone is dry, the artist paints the dark planes with ultramarine blue and burnt umber. He drybrushes the lower edges of the rocks so that they seem to be sinking into the sand.

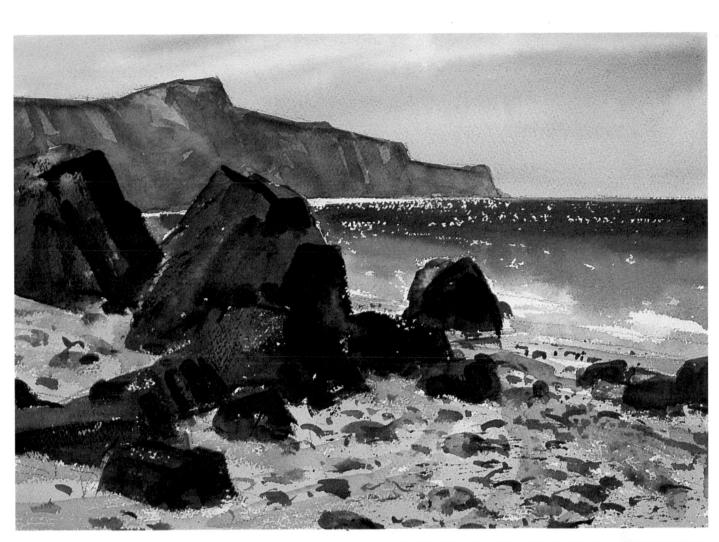

Step 5. A paler mixture of ultramarine blue and burnt umber is used to paint rocks and pebbles of different sizes, scattered across the beach. Most of these "pebbles" are nothing more than curving strokes, thin at one end and thick at the other, which you'll see if you look closely at the right foreground. Only a few larger rocks are painted completely—with a touch of dark at the right to suggest a shadow. This mixture is then spattered across the sand to suggest smaller pebbles.

Controlling the Spatter Technique

The spatter technique is fascinating, but unpredictable. Here are some tips for controlling it:

1. Mix a batch of fluid color on your palette or in some container, such as an old tuna tin.

2. Dip your brush into the color and test out the consistency by spattering a scrap of paper.

3. You can direct the flying droplets more precisely if you bang the brush handle against your finger or against another brush handle, held over the painting.

4. You can control the spatter even *more* accurately if you dip an old toothbrush into wet color and spray the droplets by pulling a stick or a brush handle across the bristles.

5. Don't overdo the spatter technique. Use it in small areas – not over the whole painting!

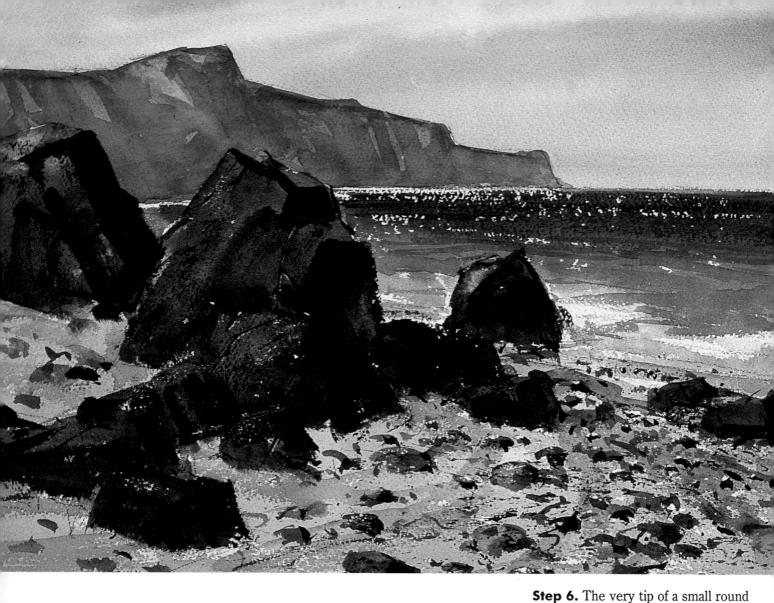

brush now adds dark lines to the rocks with a mixture of Hooker's green and alizarin crimson. This same mixture is used for touches of shadow beside the smaller rocks and pebbles on the beach. The artist adds more horizontal strokes to the water with a blend of Hooker's green, ultramarine blue, and burnt sienna. He scrapes some flecks of light off the tops of the smaller stones with a sharp blade. You also see some scraping in the lighter areas of the water, where the foam washes against the edge of the beach, and flecks of light are scraped off the tops of the big rocks. He draws the sharp point of the blade beside some of the dark lines in the rocks, throwing the cracks into bolder relief. Here's another one of those "gray" coastal scenes-actually full of subtle color.

SHAPE DUNES WITH LIGHT PATTERNS

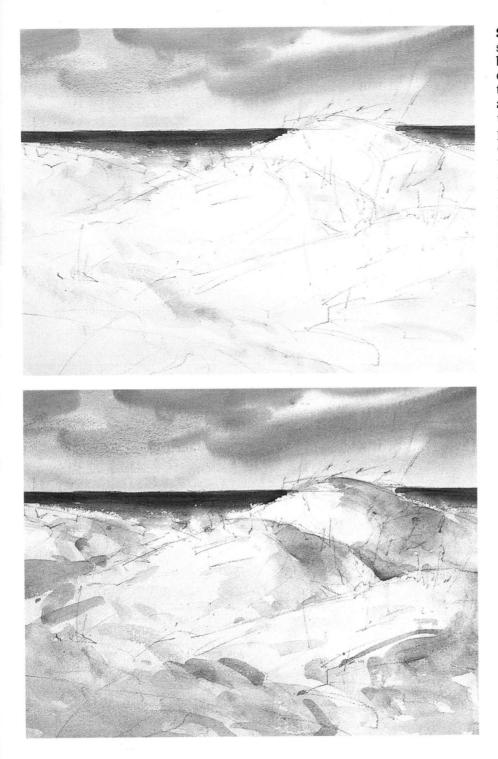

Step 1. The soft curves and subtle shadows of dunes are really impossible to render with lines. All you can do is draw the shapes of the tops of the dunes, roughly place the shadows, add a few strokes for beach grass, and then stop. Here the artist brushes a pale wash of yellow ochre with a touch of burnt sienna over the sky. While this is still wet, he adds strokes of cerulean blue and Payne's gray. He paints the strip of water with Hooker's green, ultramarine blue, and a little burnt umber, adding more water to the wash as he reaches the bottom. The colors of the sand are lightly brushed in with yellow ochre, burnt sienna, and cerulean blue. He uses a large round brush to carry soft, curving strokes over the contours of the dunes.

Step 2. When the first tones of the sand are dry, the artist strengthens the forms with darker strokes of the same mixtures. See how the strokes curve, freely following the contours of the dunes. The shadow sides of the dunes are clearly established at the right of each rounded form, and a shadowy mixture is carried across the entire foreground.

SHAPE DUNES WITH LIGHT PATTERNS

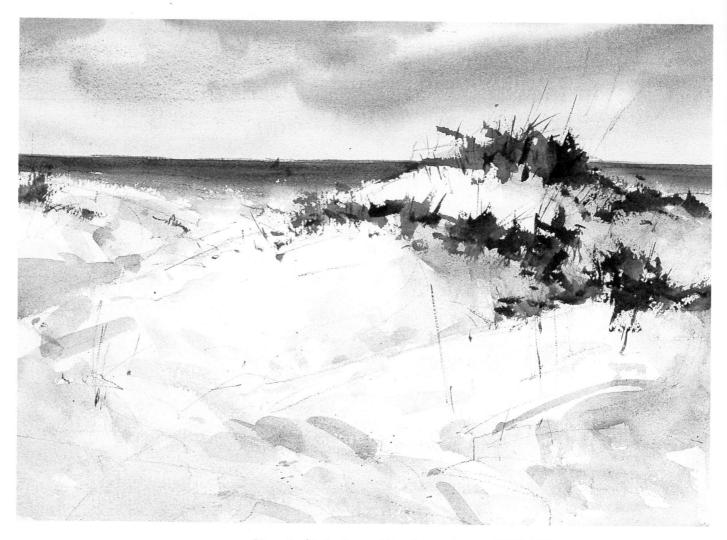

Step 3. At the tops of the dunes, the artist roughly brushes in clusters of beach grass with a mixture of Hooker's green and a little burnt sienna in the light areas, then Hooker's green and cadmium red for the darks. In a couple of spots, you can see touches of almost pure burnt sienna. He paints the thicker tufts of beach grass with the side of the brush, which leaves a ragged stroke. And he uses the tip of the brush to indicate the slender stalks. These rows of beach grass are important because they establish the curving tops of the dunes.

Let's Review Our Steps:

1. Starting at the top-as he does most often-the artist paints the sky wet-in-wet.

2. He paints the sea with a graded wash in colors that reflect the sky.

3. The colors of the sand are brushed and modeled with curving strokes that follow the forms.

4. He builds up the lights and shadows on the dunes with darker strokes that follow the contours.

5. He adds clusters of beach grass with rough, slightly fluid drybrush strokes.

6. He strengthens the darks in the dunes again – as *some* details are added with small strokes and spatters.

7. He darkens the dunes and the water for the last time, as final details are added to the grass.

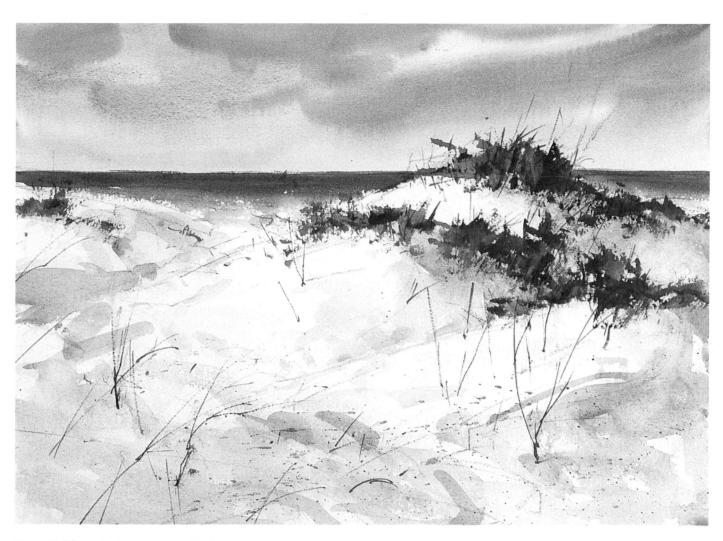

Step 4. More darks are now added to the beach grass with a mixture of Hooker's green, burnt sienna, and ultramarine blue, drybrushed with the side of a round brush. The artist adds more blades of beach grass in the foreground. And this mixture is spattered diagonally across the foreground, accentuating the diagonal tilt of the dunes.

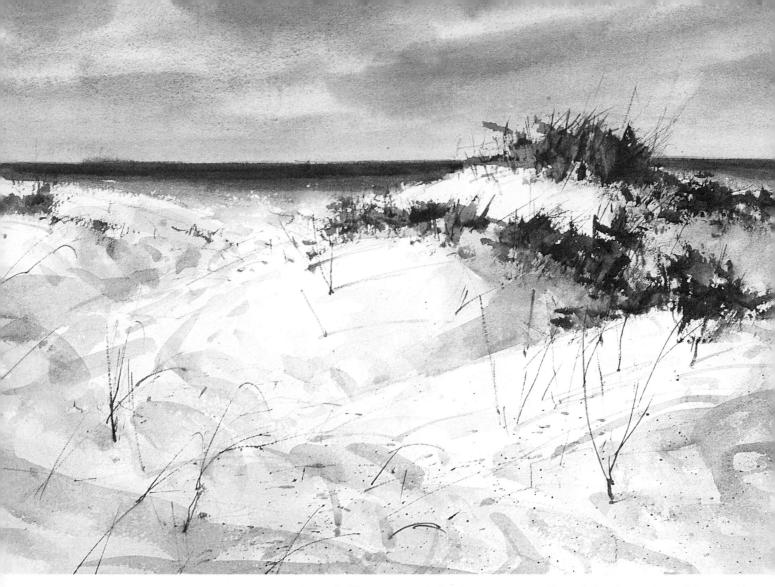

Light on the Dunes

Sand dunes are among the most difficult coastal subjects to paint. At the very beginning, it's important to establish the direction of the light so that you have a clear idea of the location of the lighted sides and the shadow sides of the dunes. Then you must paint them with pale but decisive strokes, never losing sight of the pattern of lights and shadows. **Step 5.** The curves of the dunes are strengthened with more shadows. The artist paints these with sharply defined, curving strokes of yellow ochre, burnt sienna, and cerulean blue. The strokes wind through the landscape, curving around the bases of the dunes. He darkens the shadows between the two dunes at the upper right with this mixture. And he uses the tip of the brush to draw slender lines of shadow that are cast by the stalks of grass and travel down the sides of the dunes. But this tone needs to be accentuated by a darker background. So the artist brushes the sky with clear water and deepens it with cerulean blue and Payne's gray. The new colors blur together and create no hard edges. When the sky tone is dry, he also darkens the water with more Hooker's green, ultramarine blue, and burnt umber, creating a strong contrast with the sunlit top of the dune that cuts across the horizon.

INTERPRETING THE MOOD OF THE COAST

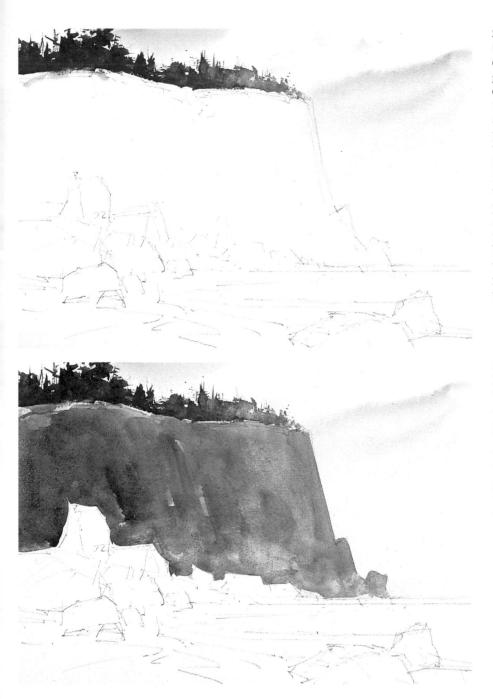

Step 1. The artist draws pencil lines to define the light and shadow planes of the rocks in the right and left foreground. He draws the overall shape of the headland and just a few lines to suggest the big shadows. The trees at the top are suggested, not drawn precisely. He covers the sky with a very pale wash of yellow ochre, followed by some light strokes of Payne's gray and ultramarine blue, which run into the wet undertone. He paints the trees with the side of a small round brush that carries a mixture of Hooker's green, ultramarine blue, and burnt umber. While this wash is still wet, he adds smaller lines for the trunks and branches with the tip of a brush.

Step 2. The complete shape of the headland is covered with an uneven wash of Payne's gray and burnt sienna. While this is still wet, the artist adds darker strokes of Payne's gray, burnt sienna, and Hooker's green to the shadows. There are gaps between the strokes, making the cliff look craggier. He leaves some bare paper along the top of the cliff to suggest a glint of sunlight.

INTERPRETING THE MOOD OF THE COAST

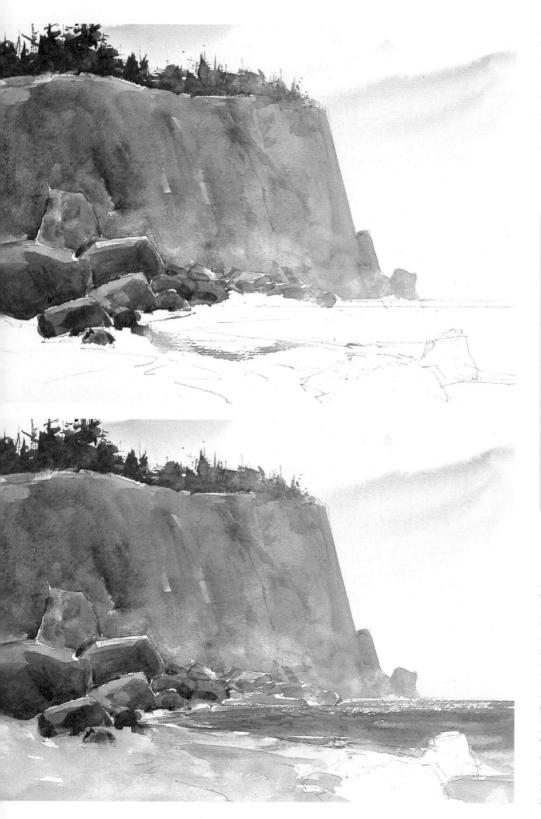

Step 3. The artist covers the rocks with a flat wash of Hooker's green and burnt sienna. When this is dry, he paints the shadows in with a darker tone of Hooker's green and burnt umber. He leaves some strips of bare paper along the tops of the rocks, as they were along the top of the cliff in Step 2.

Orchestrating Your Brushwork

Your paintings will be most interesting if they contain a variety of brushwork. Plan your strokes before you paint—and try to match the stroke to the subject. In this demonstration, notice how the artist uses broad, flat strokes to interpret the headland, while small, jagged strokes represent the trees at the top of the cliff. Observe how the sea is painted: flat strokes first; then slender, curving strokes on top of the flat color. Look at the drybrush strokes at the horizon; the wet-in-wet brushwork in the sky; the spattered color in the foreground. The whole secret is orchestration!

Step 4. The artist covers the water with a wash made of Hooker's green, Payne's gray, and yellow ochre. When that has dried, he uses the same mixture with less water applied with the tip of the brush to make some delicate lines for the waves, which you can see under the rocks at the center of the picture. The sand is freely brushed in with burnt sienna and Payne's gray. It's not a smooth, even wash. The sand is actually composed of darker and lighter strokes of the same mixture blended together wetin-wet. The rocks in the lower right area are still bare paper.

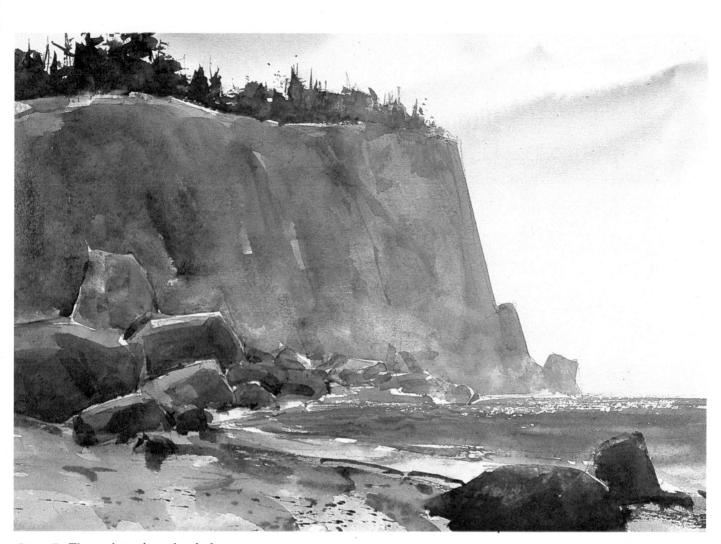

Step 5. The artist paints the dark masses of the rocks in the lower right area with a dense mixture of Hooker's green, burnt sienna, and cadmium red. While they're still wet, they're touched along the top with a paper towel to lighten the tones a bit. The tip of the brush handle scratches a white line between the two rocks. This same dark mixture is carried along the shoreline and spattered across the sand. The lower edge of the smaller rock is drybrushed, so that it merges with the sand.

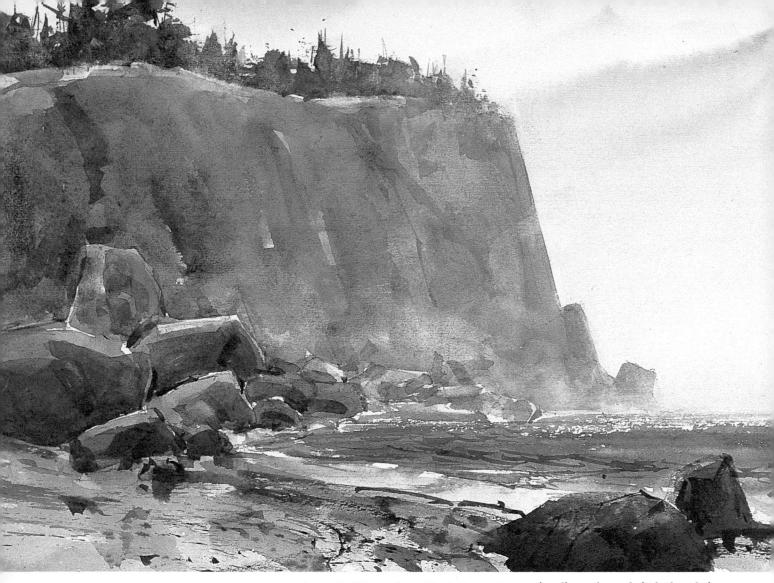

Step 6. The artist adds dark strokes to the rocks at the left with Hooker's green and alizarin crimson. These strokes accentuate the shadows and divide the rocks more clearly. He also darkens the rocks at the right with this mixture and adds some lines for cracks. He carries more dark strokes along the sand, following the curve of the beach. And this mixture is used to add more lines for waves in the nearby water. The picture almost looks finished, but not quite. The edge of the headland is too sharp, too distinct, not mysterious enough. The art-

ist dips a large bristle brush in water and scrubs along the forward edge of the cliff and down over the lower edge, where it strikes the water. He blots off the wet color with a paper towel. Now the end of the cliff seems to melt away into mist, and the rock at the base of the cliff almost disappears into the atmosphere. The horizon line, where sky meets water, is also scrubbed, blotted, and made more mysterious. Whenever you can, it's important to accentuate—even exaggerate—these atmospheric effects of the coastline.

BIBLIOGRAPHY

Here are some books you'll enjoy reading to build on what you've learned so far. Most of the titles listed below are currently available in bookstores and art supply stores. However, a few may be hard to find. So it's worthwhile to spend some time in your local library to find how-to-paint books that may be out of print.

Austin, Phil, *Capturing Mood in Watercolor*. Cincinnati: North Light, 1988. This book tackles a difficult but essential subject: how to convey the mood of a subject—and how to distill your emotional response into a successful painting.

Betts, Edward, *Master Class in Watercolor*. New York: Watson-Guptill, 1975. One of the best watercolor books *ever*, this is a must for the advanced reader. Betts focuses on the creative process of painting and opens your eyes to possibilities that might just transform your work.

Blockley, John, *Getting Started in Watercolor*. Cincinnati: North Light, 1986. This is a very different kind of basic watercolor book. The author shows you all the *usual* ways to apply color and then shows how to go *beyond* these techniques to create fascinating and unexpected effects of color and texture. An exciting, surprising book.

Blockley, John, *Watercolor Interpretations*. Cincinnati: North Light, 1987. A companion volume to *Getting Started in Watercolor*, this book explores even more of the author's offbeat ways to handle color and texture—as a means of experimentation and self-discovery. There are stimulating ideas on every page.

Couch, Tony, *Watercolor – You Can Do It!* Cincinnati: North Light, 1987. This dynamic book really communicates the *fun* of watercolor. Couch covers the basics, with particular emphasis on design. And he's especially good on the subject of the bold, fluid, spontaneous brushwork that every watercolorist hopes to achieve.

De Reyna, Rudy, *Magic Realist Watercolor Painting*. New York: Watson-Guptill, 1986. De Reyna was a master of the precise, detailed style of painting sometimes called "magic realism." This handsome volume, with excellent demonstrations by the author, is the best book on this approach to watercolor.

Goldsmith, Lawrence C., *Watercolor Bold and Free*. New York: Watson-Guptill, 1980. Beginners almost always have trouble loosening up and painting with bold strokes. This invigorating book will help you work with greater freedom and spontaneity. One of the best books for the intermediate and advanced reader.

Hill, Tom, Color for the Watercolor Painter. New York: Watson-Guptill, 1982. One of the most useful books on color, this popular volume is filled with practical advice, instructive pictures, and excellent demonstrations by the author—one of our most admired watercolorists.

Hutchings, LaVere, *Make Your Water*colors Sing. Cincinnati: North Light, 1986. Freshness and vitality are essential qualities in a successful watercolor. But they're hard to achieve. Hutchings has interesting ideas about how to inject energy into your work. He's particularly good on the subjects of light and color.

Johnson, Cathy, *Watercolor Tricks and Techniques*. Cincinnati: North Light, 1987. Once they've mastered the basic techniques of applying color, watercolorists love to explore the many offbeat methods and materials that make the medium so delightful. This lively "idea book" shows you fifty-four special effects to enlarge your technical vocabulary.

Nechis, Barbara, Watercolor – The Creative Experience. Cincinnati: North Light, 1978. The author is especially good at the splashy, fluid, free-wheeling approach to watercolor that radiates *personality*. This book will inspire you to "let go" and unlock your creativity.

Pike, John, *Watercolor*. New York: Watson-Guptill, 1973. A classic book by a master of watercolor technique, this is one of the best introductory books—with brilliant demonstrations of all the basic methods. Reid, Charles, *Flower Painting in Watercolor*. New York: Watson-Guptill, 1986. This is really two books in one. It *is* a first-rate book on flower painting—but it's also an inspiring book on the loose, spontaneous approach to watercolor for which the author is famous.

Reid, Charles, *Portrait Painting in Watercolor*. New York: Watson-Guptill, 1973. Watercolorists tend to shy away from portraiture—which looks too hard. Reid shows you how to paint superb watercolor portraits and proves that it can be done.

Schink, Christopher, *Mastering Color* and Design in Watercolor. New York: Watson-Guptill, 1987. This is an introduction to the basics of color and a practical approach to the basics of design. Design is the weakest point in most watercolors – and this book can make a big difference in your work.

Schmalz, Carl, *Finding and Improving Your Painting Style*. New York: Watson-Guptill, 1986. Once you can handle the basic watercolor techniques, how do you develop your own style? This intelligent book provides a logical approach to developing an individual watercolor "personality."

Szabo, Zoltan, *Landscape Painting in Watercolor*. New York: Watson-Guptill, 1971. One of the all-time bestsellers among watercolor books, this is a classic introduction to landscape painting by a master of the medium—and a beloved teacher.

Szabo, Zoltan, Zoltan Szabo Paints Landscapes. New York: Watson-Guptill, 1977. The sequel to Landscape Painting in Watercolor, this advanced book is notable for its highly detailed demonstrations, showing how the artist solves an amazing variety of painting problems.

Wong, Fred, Oriental Watercolor Techniques. New York: Watson-Guptill, 1983. The Chinese and Japanese masters developed a unique approach to watercolor, which can enrich your work. Wong's own work combines the best of East and West—and his book shows you how to make this combination work for you,

INDEX

A

Aerial perspective, 63, 129

В

Brushes as basic equipment, 4, 6 selecting, 87 Brushwork a close look at, 73 combined with scratching, 61 how to orchestrate, 148 in seascape, 131 varying, 58

С

Cleanup, 11 Clouds, tips for painting, 107, 108 Colors of autumn, 52-55 choosing and using, 2-3 cool and hot, 112 of flowers, 33-36 in meadows, 84 mixing, for landscapes, 69 mixing, on paper, 47 of moonlight, 136, 137 of snowy landscape, 56-59 of summer, 49-51 Composition, how to improve, 64-65

D

Details added last, 97 placement of, 83 Drybrush how to, 18-19 and paint, 90 and paper, 91

E

Edges, hard and soft, 50

F

Flat wash, 12-13

Flowers outdoors, 37-41 as still lifes, 33-36 Forms, learning to model, 24-27 Framing, 22

G

Graded wash, 14-15 L

Landscapes clouds in, 106-109 foliage in, 46-48 of hills, 89-92 of meadows, 81-84 mixing colors for, 69 of mountains, 85-88 rocks in, 98-101 selecting subjects for, 68 snowy, 56-59, 102-105 sunsets in, 110-114 of water, 93-97 Lighting analyzing, 62 for sand dunes. 146 Lines, how to paint, 104

М

Matting, 22 Mixing colors. See Colors

P

Painting dark over light, 96 Painting equipment, 4-6, 10 Paintings, correcting, 20-21 Palette as basic equipment, 5 or paintbox, 10 Paper and drybrush, 91 selection of, 7-9

S

Scraping, 60-61

Scratching, 60-61 Seascapes colors for, 117 dunes in, 143-146 effects of lighting on, 118-119 limiting detail in, 132 marsh in, 130-134 mood of coast in, 147-150 moonlight in, 135-138 rocky shores in, 139-142 selecting subjects for, 116 shape of foam in, 125 surf in, 123-125 tidepools in, 126-129 waves in, 120-122 Selective focus, 63 Shadows, 62 Shaping snow and ice, 102-105 Spatter technique, controlling, 141 Still lifes of flowers, 33-36 of fruit, 28-32 outdoors, 42-45 Studio, basics for, 10 Surf. See Seascapes

Т

Technical tricks, 60-61 Techniques, combining wet and dry, 94 Three-value system, 66 Trees do's and don't's for painting, 74 learning about, 72 See also Landscapes

W

Watercolors, preserving, 22 Waves. See Seascapes Wet-in-wet painting, 16-17 tips for, 79 Working outdoors, 111